EYEWITNESS
FOUR DECADES OF NORTHERN LIFE

I saw the danger, yet I walked along the enchanted way,
And I said, let grief be a fallen leaf at the dawning of the day.
On Raglan Road, PATRICK KAVANAGH

BRENDAN MURPHY has won all the major awards in northern press photography. In a career spanning four decades, his work has appeared in the *Irish News*, *Andersonstown News*, *Irish Times*, *Irish Press* and *Irish Independent*, as well as many European newspapers and magazines. In March 2003, he retired as picture editor of the *Irish News*. He lives in Belfast with his wife Geraldine, and works as a freelance photographer.

SEAMUS KELTERS, previously a journalist with the *Irish News*, is now an assistant news editor with BBC Northern Ireland. He is co-author of *Lost Lives: the stories of the men, women and children who died as a result of the Northern Ireland Troubles*, which was awarded the 2001 Christopher Ewart-Biggs Prize for its contribution to reconciliation in Ireland. He lives in Belfast with his wife Camilla and their two boys.

EYEWITNESS

FOUR DECADES OF NORTHERN LIFE

BRENDAN MURPHY

text by **SEAMUS KELTERS**

THE O'BRIEN PRESS
DUBLIN

First published 2003 by The O'Brien Press Ltd,
20 Victoria Road, Dublin 6, Ireland.
Tel: +353 1 4923333; Fax: +353 1 4922777
E-mail: books@obrien.ie
Website: www.obrien.ie
ISBN: 0-86278-844-7
British Library Cataloguing-in-Publication Data
A catalogue record for this title is available from the British Library
1 2 3 4 5 6 7 8 9 10
03 04 05 06 07

Editing, typesetting, layout and design: The O'Brien Press Ltd
Front cover photograph: Brendan Murphy
Back cover photographs: Brendan Murphy
Printing: Eurolitho, SpA Milan

DEDICATION

For my beautiful daughter, Michaela, who is always with me –
never more so than when on the dodgy jobs.

CONTENTS

ACKNOWLEDGEMENTS

There are many people I have to thank for my good fortune; too many to mention.

Foremost is my wife Geraldine. Not only did she develop my first roll of film, she indulged and supported my efforts to become a photographer in more ways than I can describe.

I'm glad that when my pictures started to get published my mother and father, Lily and William Murphy, were there to see my first bylines. They belonged to a generation that valued the printed word. With my aunts Kay King who lived in Lennox Street, off Dublin's South Circular Road, and Catherine Murphy who came from Whitemills at Faughart, County Louth, their encouragement knew no limit. I value the lessons they ingrained. My brothers, Gerard, Patrick and Larry, who is no longer with us, and my extended family all supported me in different ways over the years. I am in their debt.

Teachers like the late Bishop Michael Dallat and Father Frank McCorry continued to help me long after my schooldays ended. Classmates Sean Canavan and Gerry O'Hare have been constant in their friendship through the years, as have Eddie White, Alan Patten, Dessie and Magdalene Kennedy and the Louis nuns, Sisters Mona, Luca and Ann. Many and varied are the ways in which they have provided guidance.

I admire Tom Lawlor and the late Cyril Cain as photographers and as people. They showed a struggling innocent the ropes and were generous with their time and counsel. My friend and business partner, Tom Russell, also taught me much about the technique of photography. Peter Miller worked alongside us, a fine person and a fine cameraman. I am indebted to John Harrison, not only for his most generous foreword to this book, but also for unravelling the developing mystery of deep tanks.

Other photographers working for a host of papers and agencies have been consistently tough competitors, yet have always shared knowledge and friendship. Alan Lewis, freelances Bobby Hanvey, Kelvin Boyes and Richard Mills, Pacemaker's David McCormack, Willy Cherry, Stephen Davison and Stephen Wilson, as well as former *Irish News* trainees Niall Carson, Peter Morrison, Seamus Loughran, Michael Morgan, Dessie Kennedy jnr, Michael McGrogan, John Kelly, Aidan O'Reilly and Cathal McNaughton, are all talented photographers of considerable ability. I should also thank Cathal McNaughton senior, an expert guide to the Glens.

The lines from 'On Raglan Road' by Patrick Kavanagh are reprinted by kind permission of the Trustees of the Estate of the late Katherine B Kavanagh, through the Jonathan Williams Literary Agency.

There are many newspapermen and women that I must thank. Ciaran McKeown, Paddy Reynolds, Michael Keane, Alan Murray and Anne Cadwallader are all veterans of my shifts at the *Irish Press*. I mention too the former deputy editor at the *Sunday News*, Jim Campbell, along with Malcolm Nicholl, Joe Gorrod, John Hicks, Freddie Hoare and Stanley Matchett at the *Daily Mirror*. At the *Andersonstown News* there were Frank Doherty and Basil McLaughlin, at the *News Letter* Trevor Dickson, the late Brendan McCann of the *Irish Independent* and Gerry Fitzgerald and Mervyn Dowling at the *Belfast Telegraph*, as well as a legion of other photographers at those papers. All generously helped me on many occasions.

Inevitably it is those at the *Irish News*, where I have spent most of my working life, who are most vivid in my mind. Its reporters were alongside me as I took thousands of pictures. Their work had its dangers and laughs, its high and low points. In that regard I should mention that in this book I have included disturbing images from disturbing times. I believe to have omitted these would have been wrong because they show the reality of work as a journalist and, much more importantly, the reality of grief that has visited so many doors.

Without the comradeship of other journalists it would have been impossible to cope. The *Irish News* has been

blessed with reporters and sub-editors of real talent: Tom Samways, Jack Kelly, Peter McNulty, Noel Russell, Mary Kelly, Eugene Moloney, Peter Somersett, Paddy O'Flaherty, Brendan Anderson, David Morgan, Martina Purdy, Angelina Fusco, Anne Donegan, Mary Campbell, John McGurk, Pauline Reynolds, Nuala McCann, Tony Curry, Conor MacAuley, Ruth O'Reilly, Billy Graham, Barbara Graham, PJ McKeefrey, John Patten, Jim Cusack, Michael McGeary, Joe Fitzpatrick, Marion Sawey, Ann Purdy, Gerry McLaughlin, Matt Rossbotham, Cyril Thackway, Eimear O'Callaghan, Liz McPherson, Dan McGinn, Brenda O'Neill, Mark Simpson, Colin McAlpin, Chris Thornton, Seamus Boyd, Stephen O'Reilly, Barry McCaffrey, Fiona McGarry, Anna-Marie McFaul, Jim Fitzpatrick jnr, Suzanne Breen, Bimpe Fatogun, Eamonn O'Hara, Paddy Heaney, Thomas Hawkins, John Haughey, Jacqueline MacIntyre, Seamus McKinney, Jeremy Kirkir, Fergal Hallahan, Gary McDonald, James Stinson, Maeve Connolly, Louise McCall, John Manley, Liz Trainor, Sharon O'Neill, Stephen McCaffrey, Billy Foley and Anne Madden - I mention them all because they have all played important parts in my working life.

Editorial staff do not solely determine the fabric of a great paper. There are many others who have enriched my work and my days. They have included Jim Fitzpatrick, the paper's present owner, Peter O'Reilly, Matt Brown, Ray McClean, Brian Kearney, Davy Canavan, Dominic Fitzpatrick, Frankie McVeigh, Frank Bracken, Frank Mulholland, Sean Doran, Jimmy Trainor, Paddy Meehan, Geraldine Schiess, Sean Higgins, Hugh Lundy, Alan McKinley, Ken Trimble, Martina Bannon, Brendan Kerr, Sean Treacy and Joe Nugent as well as the Irish News' indefatigable front office and canteen staff.

Successive editors, Ted Gallagher, Martin O'Brien, Peter Montellier, Terry McLaughlin, Nick Garbutt and the present incumbent Noel Doran have shown me considerable latitude, friendship and support. They are courageous individuals of great fortitude.

A gentleman, George Craig was the paper's photographer when I arrived. Margaret McLaughlin and Darryl Mooney now carry on his tradition. For almost twenty years I have worked alongside Hugh Russell and Picture Editor Ann McManus. I could not have wished for better colleagues. Their talents and skills have contributed much to the Irish News. The quality of their friendship means a great deal. I am also indebted to Ann for printing most of the pictures in this book.

Kathleen Bell, the paper's librarian, suffered my many questions with consistent good humour. I should also thank my former colleague and friend, Seamus Kelters, for his work and his wife, Camilla Carroll, for the advantage of her unerring eye. Michael Toner's computer wizardry was also of invaluable assistance.

Putting together such a collection would not have been possible without the encouragement of O'Brien Press. I thank in particular in that regard Damian Keenan, Michael O'Brien, Íde ní Laoghaire, Emma Byrne and Eoin O'Brien for their ability to turn an idea into something of substance.

I should also mention one other group far too numerous to name individually - the people of Belfast's Falls Road. Their support, encouragement and kindness has always been honest and offered without a trace of begrudgery. Although I came from another part of the city, they embraced me as their own. For that I will always be grateful.

I apologise now for any omission of names or grainy details played by tricks of the memory and years. Certainly there are more I could and should have mentioned. I hope they will forgive my lapse. They know they have my thanks. The truth is also that there are others who should contribute their stories before they become distant memories and faded prints. In the meantime I hope this book will provide an insight, over a span of four decades, into the work of a Belfast press photographer.

Brendan Murphy, July 2003

FOREWORD

I first came across the man in a County Antrim graveyard around 1978. I was working for the *Ballymena Guardian* newspaper as a junior photographer. It was a high-profile, paramilitary-style funeral. Everything was erupting when I spotted this long-haired, duffel-coated guy with a Canon around his neck, involved in a fracas with the authorities. They had descended upon him, and his temper had snapped. He felt they were wrong and he was verbally holding his own.

Of course, I know now that it was Brendan, trying as ever to get the best possible shot, the best possible angle, to produce another winner for the front page of the *Irish News*. He had probably got a bit too close to the action.

Brendan arrived into photojournalism late, but the drive he applied gave him a new goal and buzz in his life. He understands people. He knows how life works. To be successful at this game you have to be able to communicate – something he does brilliantly through his pictures.

As a young photographer Brendan took me, like so many others, under his wing. He was the first on the phone to congratulate me, or to tell me that something hadn't worked but it was a good effort. There are so many photographers in Northern Ireland who are grateful to him. He helped to get them started, gave them shifts and barked at them enough to push them through. I remember once sitting in a café next door to the *Irish News*. Brendan had bought the coffees – I had no money with me. He took the change and gave it to me with a look, and said, 'Stick it in your pocket, it'll give you something to rattle.'

Brendan is a perfectionist. I have never met anyone who studies, looks at and works out a picture with the same intensity. He still has the enthusiasm of a twenty-year-old.

Unlike today's professionals who have all the new high-speed long and wide-angle lenses, he started freelancing with a camera body and standard lens at the beginning of the Troubles, mainly around the Falls Road. Others didn't know the lie of the land so well, and Brendan cut his teeth at the hard edge of news photography, getting into the odd scrape along the way. His results were excellent considering his lack of equipment, and it wasn't long before he was working for the *Daily Mirror* as well as worldwide picture agencies. In those days film was expensive, so he would shoot several jobs on the one roll.

In photographic competitions I have never met a stronger competitor. I would have walked into his darkroom to find beads of sweat running off his forehead and bouncing on the floor, as he strived to get the perfect print. Typically, Brendan was printing not only his own entries, but those of an army of colleagues. At result time, the war of words would start as we would debate who deserved to win and who didn't. It usually took a week or two to calm down – but we've never fallen out!

The look of the *Irish News* has Brendan Murphy's style written all over it. Understandably, he has been retained as a freelance. I feel there is much more to come, especially now that he is hungry again. Feature pictures are starting to flow as he has more time to strive for his perfection; time to study life and to win yet more awards.

Brendan knows what it's like to be up as well as down. He's faced both personal and professional tragedy, and seen some of the most historic and jubilant moments in this country over the past thirty-odd years. I, among many others, couldn't have a better friend and supporter than Brendan Murphy – always there when you need him.

John Harrison

INTRODUCTION:
CLOSING ONE SHUTTER, OPENING ANOTHER

'Give up the bar.' It was the only advice he could have given. I knew he was right. A hard choice it may have been, for this was something I loved – the atmosphere, the wit, the sharpness of debate, the ingrained sense of tradition and a particular form of ethics etched even into the furniture. And yet he was right. I would have to give it all up.

I hadn't been called to the bar in any legal sense – I should make that clear at the outset; let's not have any confusion. I'd started pulling pints in the 1950s as an apprentice barman in a premises owned by my elder brother, Larry. In the late 1960s, the sign above the bar remained the same: 'Murphy's'. But now, thanks to Larry, I was the owner – Thomas Brendan Murphy, publican.

The bar was in Albert Street, off Belfast's Falls Road, its customers decent, wonderful people. To this day I hold them in deep affection and high regard. If some were poor in finance, they were all rich in character. I enjoyed life there, but it took me a long time to admit to myself that there was one aspect of owning a public house I was enjoying too much. Enjoying is probably the wrong word; the truth is it was a long time before I admitted I had a problem.

Each morning, I would go in early to clean, check the orders and deliveries, and basically ensure that everything was as it should be. Serving myself a drink seemed the most natural thing in the world. By the 1970s, I was pouring the equivalent of eleven shorts every morning. Before a customer even crossed the door I'd have them lined up on a shelf below the long counter. Belfast at that time had something I've not seen anywhere else – 'brown

lemonade'. I'd have the whiskey in a half-pint glass, and pour in some brown lemonade. In this way, anyone who came in would see me seemingly sipping only a soft drink through the afternoon. No one knew, not even those closest. No one ever saw me drunk. I was fooling them, but it became harder to fool myself. In 1972 I signed myself in to Shaftesbury Square Hospital, close to the city centre. It treats alcoholics.

'Give up the bar,' the doctor told me. So I gave up the drink, got myself some help and wondered, with a wife and daughter, what the hell I was going to do.

Looking back on it now, I suppose it was the alcoholic in me that was attracted to photography. Somehow I imagined it would be easy. Alcoholics always look for something easy.

The Troubles had started. To us the Falls Road seemed the heart of the Troubles and my bar was very much in the heart of the Falls. It would be frequented by a lot of reporters and photographers, there to cover events as they unfolded. One guy showed me his portfolio – a series of eight-by-ten pictures. I was really impressed. There were soldiers and police, ordinary people and rioters. The way these photographs captured life, preserving it at just that split-second of time, gave them an incredible sense of drama. What's more, these images were taken in streets I knew so well that I could identify them from the patterns in the brickwork over their doors. It was like reading a novel set in your hometown.

Giving up the bar was hard, but in the end I had little choice. It was to be demolished anyway, in the

massive redevelopment scheme that tore the heart from the Falls. It coincided with me recognising I had to take the doctor's advice.

I had never taken a picture before. But someone asked me what I was going to do when the bar was gone, and I blurted out, 'I'm going to be a photographer.' Now I'd made a statement. I'd acknowledged something. It was like standing up and saying, 'I'm Brendan Murphy, I'm an alcoholic.' The next step was going to be harder – I didn't really know how to become a photographer. I had a vague notion that I'd start off taking pictures of people at dances and functions. Working in the bar, seeing all those wedding pictures over the years, maybe that was the kind of photography I was most familiar with.

'Aye, you can be a photographer,' said the reporter on the stool across the counter, 'You'll do okay at that.'

The reporter was Tom Samways. A legend in his day, at that time he was still chief reporter at the *Irish News*, Belfast's main nationalist, Catholic, daily paper, based in Donegall Street. Samways could be good company, happiest when he had a full pint in front of him. He was rarely without a full pint in front of him. His fondness for Guinness remained a life-long indulgence, probably costing him a Fleet Street career. For all that he drank, other reporters would watch him in awe at work; they would scrap sheet after sheet testing their intros, while Samways on his typewriter would waste no paper, flawlessly battering out what journalists call a 'nose' – the all-important introduction to a story. He had begun before the war as a copy-boy, running errands in the *Daily Mail* office, and soon became a junior reporter. He went on to work for the *Daily Mirror* in England, before returning home and finding himself in the *Irish News*.

Raised in Raglan Street, up the Falls not far from the site of my bar, Samways had no affected airs or graces. As comfortable talking to a prime minister as a punter down on his luck, he would frequently ensconce himself across the counter of my bar while waiting for news and witnesses of the all-too-frequent riots and gun-battles. Through his encouragement I bought my first camera, took my first pictures and had my first work published in the *Irish News*.

Shaftesbury Square Hospital, 1972. Picture by Pat Terrins.

It felt like a chunky metal box. Perhaps that's because it was a chunky metal box. I didn't know any better. I had handed my £22 to Samways, and he had passed it on to Paddy O'Flaherty, later a BBC reporter of incredibly rich voice and talent. Paddy had procured a Zenith B, the best camera £22 could buy. Today's auto-focus systems would have seemed science fiction. It was all manual. You first had to set the exposure, then focus and finally adjust the aperture. Completing the last of these three basic tasks you would find the viewfinder had gone completely blank and would remain so until you pressed the shutter release to take the picture. To me it possessed all the sophisticated technology that put man on the moon, and I sallied forth to photograph.

My first published picture was of a visiting Australian couple seeing the sights of riot-torn Belfast. I took a picture of them walking up Albert Place and Samways got it used in the *Irish News*. At that stage, the main Belfast morning daily wasn't noted for the quality of its print reproduction. The image itself had problems too – it wasn't sharp, it wasn't exposed properly and it wasn't well composed. Some people, I suppose, would say of my pictures that nothing's changed.

My second published picture gave me more of a buzz. The occasion was the presentation of a trophy to the winning captain of a darts team. We'd always had a team in the bar, so I knew the boys involved, but the reason I was really happy was that the picture appeared in Belfast's weekly paper, the *Andersonstown News*. At that time its reproduction was pretty good, and the print really bounced out of the paper. I felt that maybe there was a future in photography. I even strayed into print. The *Andersonstown News* needed reports from the matches to accompany the pictures, so I became their darts correspondent. It's a strong community paper, and I've always held it in high regard for helping to start a struggling photographer.

There was no doubt I was struggling. Focussing was a skill I found very hit and miss – I resorted to pacing the number of steps to the subject to set specific points on the focus ring. It seems laughable now. I would have to concentrate on every painstaking step.

I got a lot of jagged banter. Someone remarked for my benefit: 'He was all right when he was drinking, but now he's sober he's gone round the bend and thinks he's a photographer.' Another former customer asked, in an affected English accent: 'Been out on any assignments lately?' Photography wasn't as easy as I had hoped, and there was a time, early on, when I would have given up, but remarks like that kept me going. I wanted to prove wrong those people who put me down. After the alcohol, I had a second chance and wanted to be a success.

I realised, many years later, that for a long time I had thought of myself as a barman taking photographs. I always had it at the back of my mind that I had a trade to go back to if photography didn't work out. I had wandered into a new career and was stumbling around, missing picture after picture, because I didn't know what I was doing.

Taking the picture, of course, is only one half of the job. Printing was a mysterious alchemy, and it could have remained a baffling art without the help of my wife. Geraldine's degree in science was invaluable as I staggered on my way. A teacher by profession, all her skills were put to the test as she educated me in the various stages of developing film and fixing prints. Being there to press the button was to me the thrill of photography, rather than the meticulous work of the darkroom. That all changed with a trip to Dublin.

Nowadays they would call it work experience, though in my mid-thirties I wouldn't exactly have fitted the description of a typical trainee. I spent a week shadowing one of the best photographers Ireland has ever produced. Tom Lawlor of the *Irish Times* was a man without pretension. He offered advice freely and answered all my questions. 'One day,' he told me, 'it will all come together.' I had my doubts. Beyond his counsel, it was by watching him that I learned most about what it meant to be a press photographer.

Nowhere was Tom's attention to detail more obvious than in the darkroom. There he instructed me in how different grades of paper could give different results. Negatives that had once produced only dull grey prints suddenly yielded deep, rich blacks and shining whites. I realised how St. Paul felt on the road to Damascus, though it was other byways that would dominate my pictures.

Beechmount Leisure Centre, 1977.
Picture by Basil McLaughlin.

You move closer ... closer ... and then, one day, you are right beside the beast. It should never look cuddly. It is always treacherous. Paranoia can run through a crowd like the wind; otherwise calm individuals can turn vicious in a mob.

CHAPTER 1: RIOTS

Watching paint thick as treacle trickle down his face, I felt sorry for him. The IRA had tied him to the lamppost, a placard round his neck alleging something or other. Now, thirty years on, having developed a vocabulary to meet the needs of the Troubles, we would call it 'anti-social activity'.

Vocabulary at the time was more limited. 'F**k off,' he said, staring straight at me, his eyes the only points of white. He and I were inside an invisible circle. 'Keep your head down, son,' I whispered, conscious that others were watching. Then I took the picture. I remember his hair – frizzy, almost Afro, matted by paint, tatted with the feathers. No tar had been available, but this was nonetheless a very public tar-and-feathering. His father, it turned out, drank in my bar.

The following day the picture appeared on the *Daily Mirror*'s front page. It was the first time I hit the big time so to speak, so inexperienced I didn't even keep negatives. I was acutely aware that my good fortune came at someone else's expense – so much of newspaper photography, so much of journalism, is like that. That's one reason people don't like reporters or photographers – why they think of us as parasites, or vultures. There's truth in that of course. Then again, these same people buy our papers, and look at our pictures, without having to shoulder any of our responsibility.

Nowhere is lonelier than when it's just you and your conscience – except maybe when it's just you and your fear. I had watched riots in and around Albert Street when I'd been running the bar. I had been there in August 1969, when mobs came over from the Shankill. There was mayhem and shooting and deaths. Trying to make my way as a photographer, I found myself more often than not covering riots. It's one thing watching them; it's another thing entirely being in the middle. There you are nobody's friend.

It wasn't as if all of the papers wanted riot photographs. I once took a picture of a solitary boy throwing a stone at an armoured car – nothing special, but not bad on the day. I presented it to a news editor, a very decent, very Christian man. Looking at the picture – to console me he put his arm around my shoulder – he said, 'Brendan, my boy, I can't use that – there's far too much violence in it.' Some papers did use riot pictures; in my case they went to the *Daily Mirror*.

Without question, the safest place for me to be in a riot was with nationalists. That way you would find yourself taking pictures from behind stone-throwers and petrol-bombers. The only recognisable things were the backs of their heads, so there was no chance of identifying them. Even after such pictures appeared, sometimes below damning headlines, you could safely return to the

fray with little fear of being threatened. Foreign photographers and television crews understandably felt safer with police and soldiers. For myself it was never a choice. Had I stood behind army lines, I would have been identified with the security forces. My pictures would have shown faces. I would have been unable to continue working in the area. As it was, only a few photographers were among the rioters.

When you first appear at trouble you would have a checklist in your head. Every bit as important as light-meter readings, type of film and, in later years, choice of lens would be identifying the point of action, the safest place to stand to get the angle and the escape route if things suddenly changed.

Riots themselves have changed. They used to be chaotic in every respect. The probability that guns would be introduced, usually around dusk or after nightfall, made the pulse beat faster. If people cleared from the streets at any point it was always wiser to retreat – gunfire produces few good still images anyway. At some point though, probably in the 1980s, riots assumed a form of ritual. In many cases – particularly when they were attached to some anniversary – you knew when and where they would happen, how they would happen, when you could go home for dinner.

Since Drumcree – that one-time huge Orange protest in Portadown – there seem to have been more loyalist riots. Loyalists are more hostile to the media; their riots are mostly recorded from afar. It's part of the pattern since the ceasefires. We've had riots in places that have been quiet for years, and these have been altogether more dangerous. Journalists can find themselves trapped by action swirling around in unfamiliar territory.

One thing, though, has remained the same. You still have a fine gut calculation to make about the mood of the crowd. If adrenalin is running high, it is usually better to start at a distance. You approach gradually, almost creeping – if that is the right word. It always reminds me of wildlife cameramen, filming a particularly dangerous species. You move closer ... closer ... and then, one day, you are right beside the beast. It should never look cuddly. It is always treacherous. Paranoia can run through a crowd like the wind; otherwise calm individuals can turn vicious in a mob.

The army don't like you; the RUC in particular don't like you; and, depending on mood, the crowd probably don't like you. You could be threatened by any of them. You never answer anyone back. If someone shouts something, you suddenly become deaf. You never turn around. You never confront anyone. You maybe move further away, hoping they will forget about you. Mostly that works.

One day, early on, I got it wrong. It was Easter, and I was covering a parade on the Falls. Everything was overcast, laden with tension. In my ignorance, for three years I worked with a 50mm lens. This is useless at any distance, so I had to be in close. There weren't many other photographers about. The mainstream press tended to view our story as something that happened in July and August; they would arrive in those months with the regularity of migrating birds.

Out of the blue there was a shout: 'He's a "brancher", he's Special Branch.' It seemed they'd spotted an undercover policeman. Turning to look for the accused, the first blow hit me below my right ear. Immediately there were more. I was being punched and kicked from all sides. All I could see were feet, shod with Doctor Marten boots, aimed at my legs. I curled in a ball around my precious £22 camera and tried to stay on my feet.

'Leave him alone, leave him alone!' It was a woman's voice. I raised my head. There were actually two women. One fetched a young lad a clout with an umbrella. 'That's Brendan Murphy. He owns that bar down Albert Street.' It was over, as nice as you like. One of those who'd been kicking me helped dust me off. 'Sorry about that, we thought you were Branch. No harm, eh? Can't be too careful.'

I took a few more photographs – bravado. Sitting at home an hour later, I was still shaking. A few bruises and a cauliflower ear left me sore, but I'd come away with a lesson. Since then I've never underestimated what can happen when the blood is up, when the crowd is looking for someone to blame, or it is just bored. I never thanked the women that day; I was too shocked. So I'll thank them now.

GIVING A PUSH

January 2002

During riots at Alliance Avenue in Ardoyne, the crowd surrounded a Land Rover. I snapped off a few shots before we were warned to leave the area. I like this picture because it seems as if some bizarre tug of war is going on.

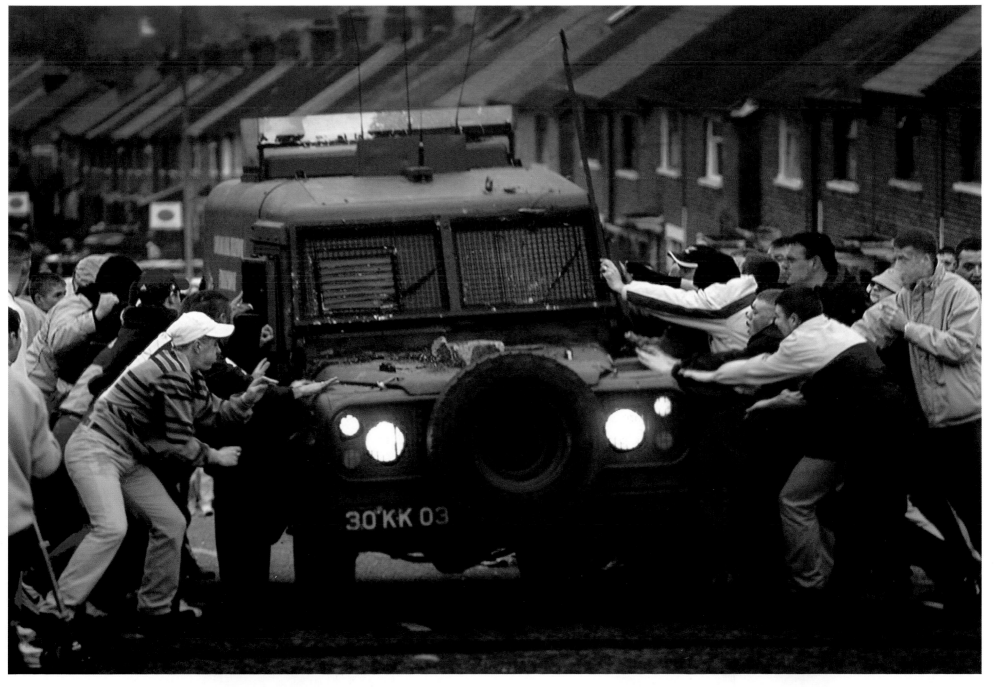

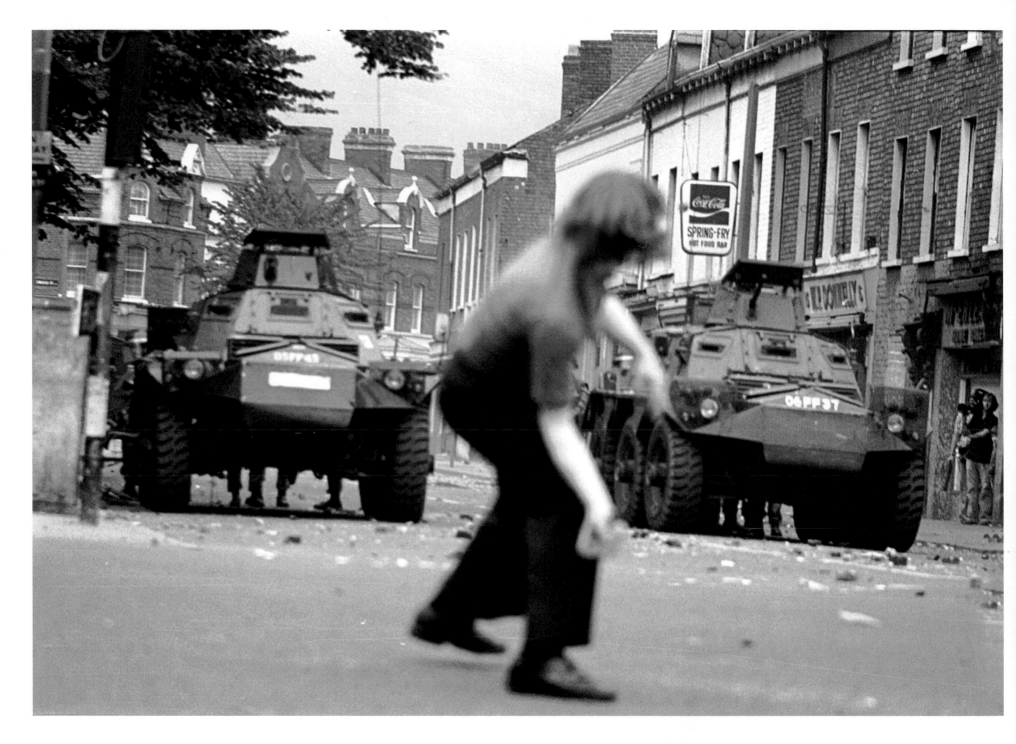

'YOU AND WHOSE ARMY?'

August 1978

After taking this picture I was hit by a rubber bullet. The riot had
been going on for hours. Standing out of the firing line,
I thought I was safe. But a soldier lost patience with my presence.
His rubber bullet bounced into my ribs. I was bruised, but it was
nothing compared to the horrific injuries suffered by many others.
And, of course, rubber and then plastic bullets killed so many
people, among them children.
On that day, only the soldier and myself knew what had happened.
Afterwards, looking at this picture, I knew there would never be a
clear-cut winner. The youngster throwing the stone might have
grown older, but there was always one to replace him.

INJURED POLICEMAN

July 1986

An RUC officer is led to an ambulance on the Garvaghy Road in Portadown. As a precaution, the dart fired from a crossbow was left firmly embedded in his neck until he got medical treatment. Tension was beginning to mount in the Garvaghy Road area. It built up over several years, culminating in confrontations between nationalists, loyalists and police during the late 1990s, when a series of clashes surrounded the annual Orange protest at Drumcree.

JUBILEE STREET PARTY

August 1977

One of my first attempts at art – the EIIR on the Royal Mail van mirroring the banner carried by the protestors. Riots marked a royal visit. 'Will Lizzie visit H-Block?' was the graffiti painted on one wall. This stretch of the Falls has changed. The one landmark that remains is the Rock Bar, just visible in the background.

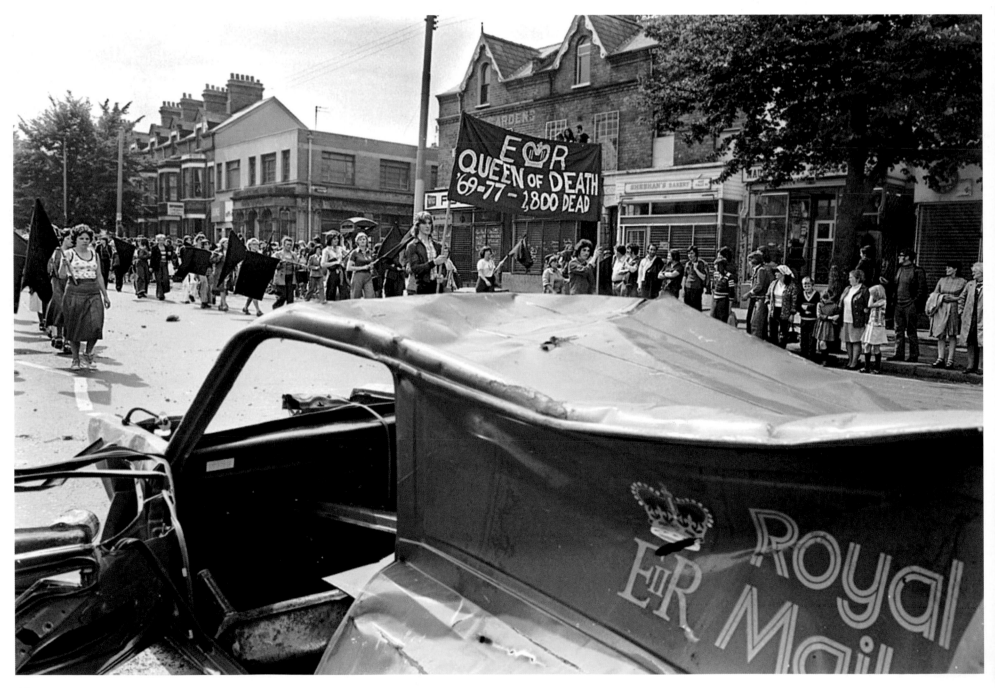

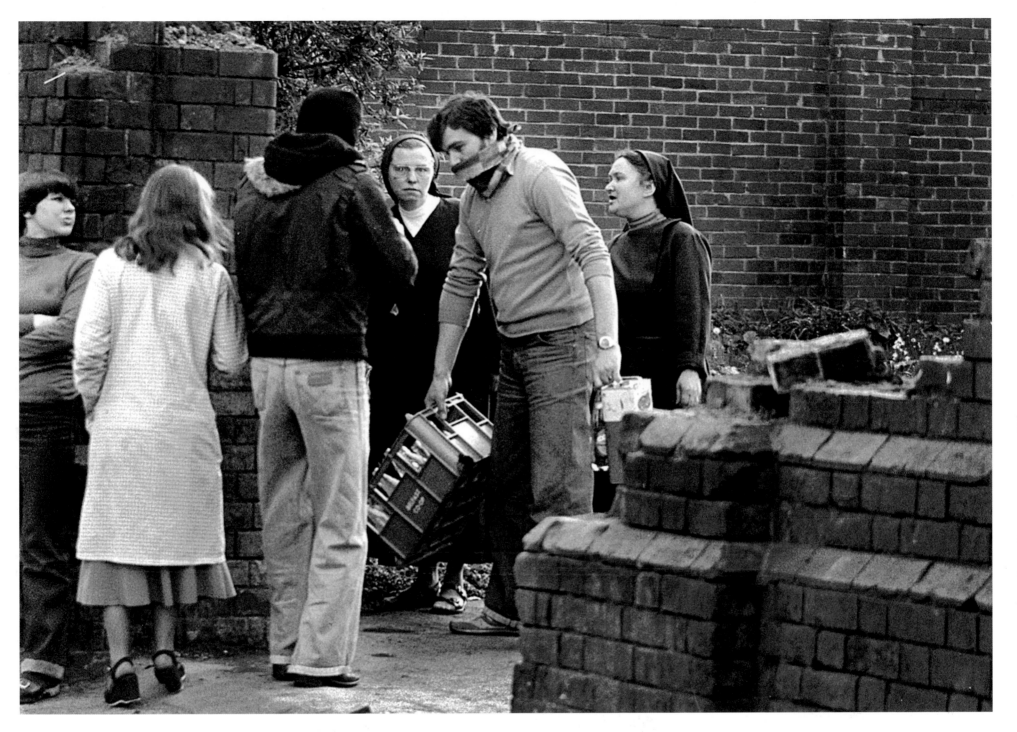

NUN, BUT THE BRAVE

August 1980

Adoration Sisters at the gates of their Falls Road convent
refuse to let young men store petrol bombs in the grounds.
Outside a riot was in full swing, but the young woman on the
left appears more interested in the exchange at the convent.

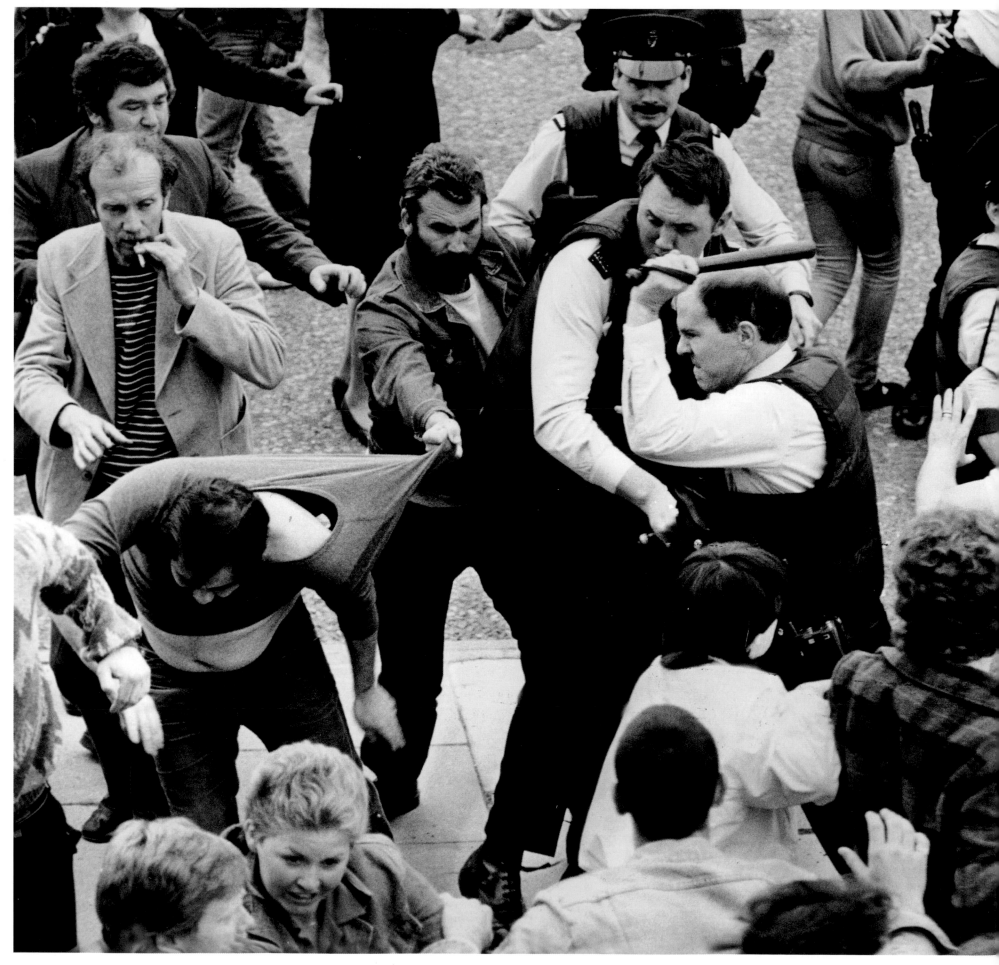

OBINS STREET
July 1985
Police and nationalists clash as the final Orange parade is allowed through a flashpoint known as 'the Tunnel' into the nationalist Obins Street area of Portadown. This photograph quickly became dated, as police soon adopted head-to-toe riot gear.

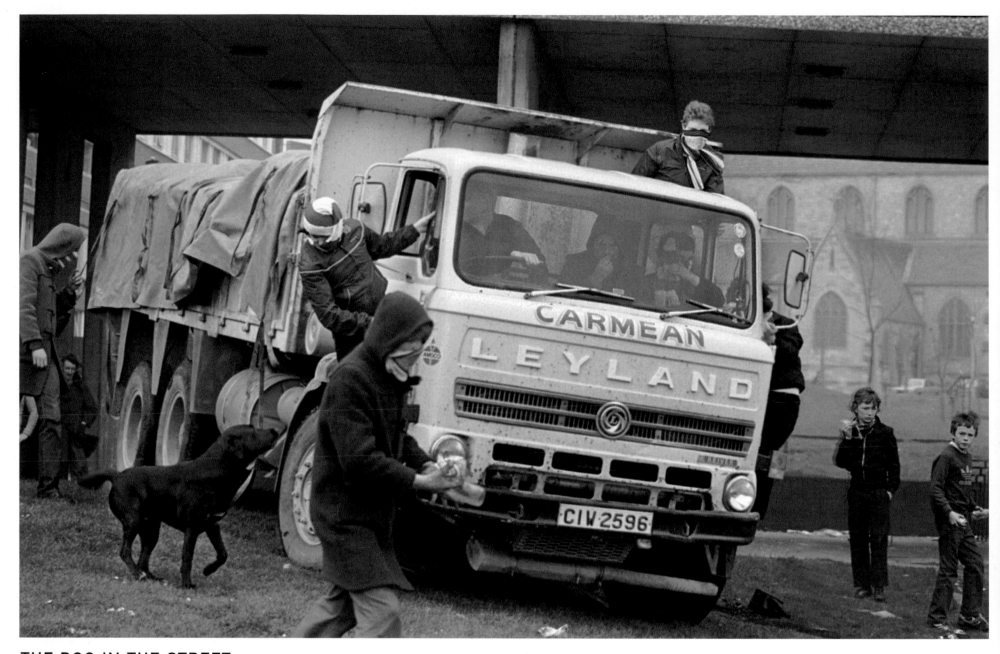

THE DOG IN THE STREET

June 1981

Watched by children, masked youths hijack a lorry, forcing
its driver onto open ground in the Divis Flats complex,
where they promptly set it on fire. There was always
a dog somewhere in the riot.

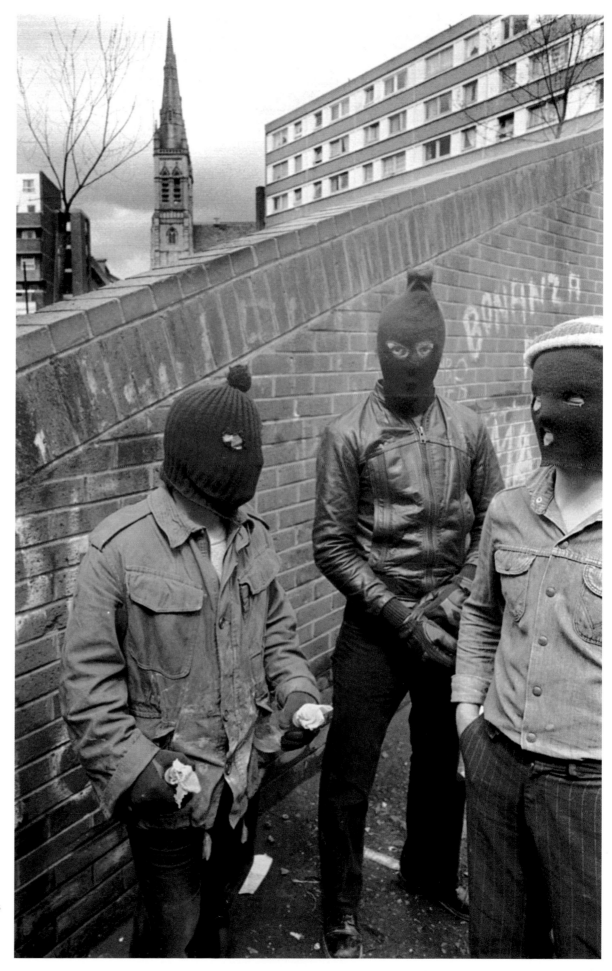

GOING OUT FOR THE NIGHT

May 1981

They had no problem with me taking the picture as long as they were masked. A trio of youths in the Divis area prepare to attack the army with petrol bombs, after the death of Bobby Sands on hunger strike. What was odd was that the youth on the right stuck on a Celtic hat to top off his makeshift balaclava.

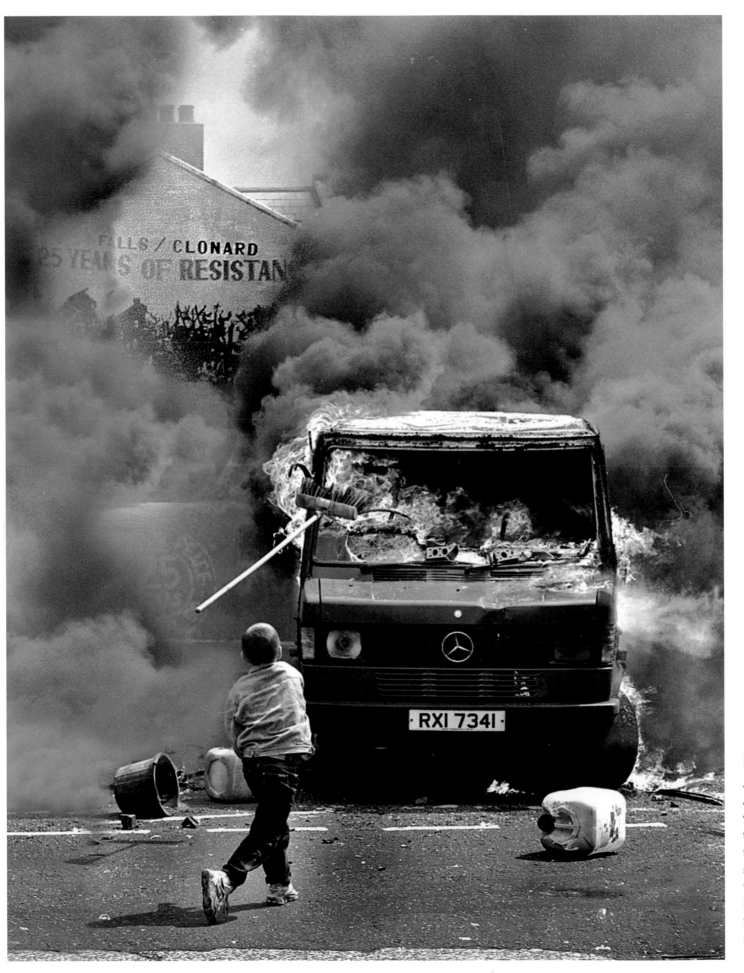

BRUSHING UP

June 1995

A young boy stokes the flames. The lorry was hijacked following the announcement that soldier Lee Clegg was to be released from prison. The paratrooper had been sentenced to life just two years earlier for murdering a teenage girl, shot dead in a stolen car. He was allowed back into the army and promoted. He was subsequently cleared of murdering the girl.

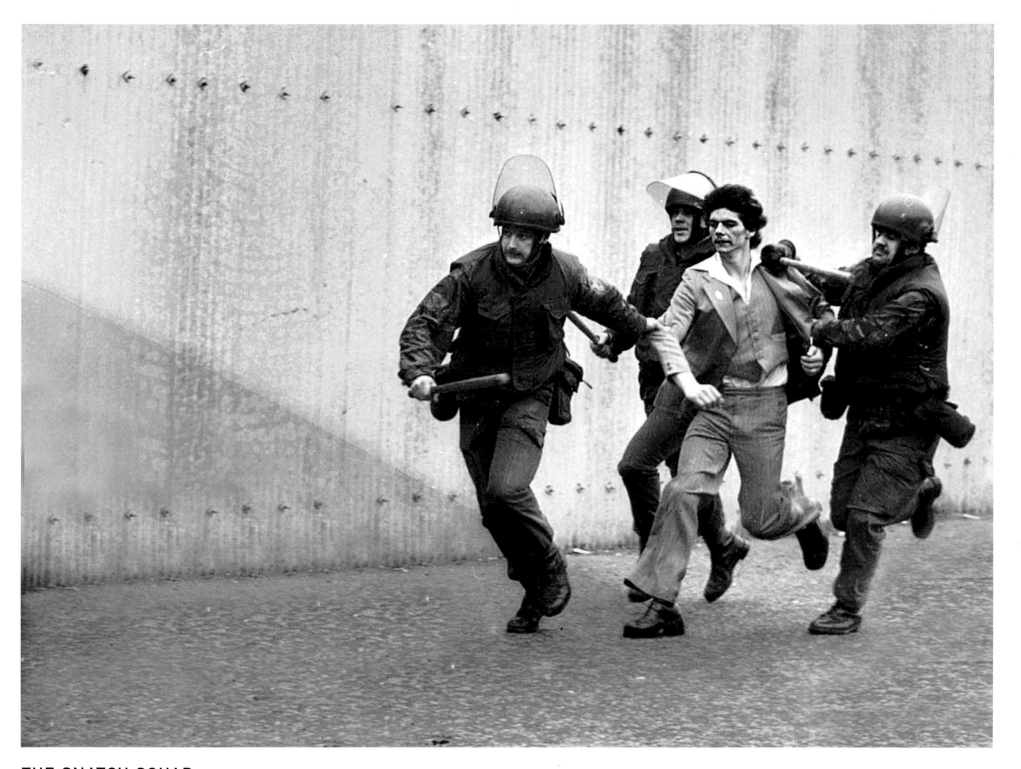

THE SNATCH SQUAD

April 1976

On the sixtieth anniversary of the Easter Rising against
British rule in Ireland, three soldiers arrest a man outside
Andersonstown Barracks. He is wearing a three-piece suit,
on his way to attend the annual republican demonstration on
Easter Sunday. Normally the snatch squad was made up of
younger squaddies, but this trio seem in worse physical
shape than their quarry.

'Where do you want us?' one of the women asked in a broad Belfast accent, a smile in her eyes. She pointed a revolver straight at me. I quickly concentrated on the job in hand.

CHAPTER 2: TRAINING CAMP

'Jesus, I'm going to die here.' That was all I could think. 'Oh my God I am very sorry for having sinned against Thee.' Even though I'm not particularly religious, in my terror I found myself murmuring a very imperfect Act of Contrition. Around me lay people with guns. They were scared, no doubt. I knew if one of them squeezed too hard on the trigger we were all dead.

This was an hour spent at an IRA training camp. I thought it would be my last.

Weeks earlier I'd put out the word. That's how I'd have described it then and I'd still describe it now. I wanted to photograph the IRA. They were a weird organisation in 1975 – on the one hand clandestine and secretive, yet on the other everyone in working-class districts seemed to know who they were.

Before the Troubles, the only brushes I'd had with republicans were literal. On a Saturday night a young lad would come into the bar selling *The United Irishman*, a republican paper. Most people bought it but, as it was written in Irish, few could actually read any of its stories. They would wait until the lad left, then surreptitiously discard the paper. By the end of the night I'd have to sweep it off the floor, along with the cigarette packets, butts and pigs' feet that had been brought in to supplement the nourishment of stout. That seemed to me the extent of republicanism in the lower Falls, but the Troubles changed everything. By 1975, the Provisional IRA were a force to be reckoned with and, more importantly for a

struggling photographer, pictures of them training would sell. So I put the word out, mentioning here and there that I'd like to get a few pictures.

Three weeks later, on the fringe of a rally, I was told to be at a certain spot at a certain time the following day – the kind of offer that only came once. Refusing wasn't an option. The following day I stood there on the Andersonstown Road, trying my best not to make the camera obvious, trying my best not to look suspicious. I waited for an hour before deciding it was not to be. As I walked away, a man came out of an alley behind me. 'Get in the back of that car,' he ordered, pointing to a motor in a street across the road. I got in. Two others were already in the front. 'Keep your head down,' one of them shouted. 'Look at the floor,' said the other. It wasn't comfortable. I half lay across the back seat, discovering to my surprise that I was breathing hard.

Lying there, I thought about what film to use and worried about the light. Driving south to a training camp would take some time. I was worried too about getting stopped at the border, but assumed that these men would know a back road or two. In any case, it was unlikely they were armed. I stretched out for a long journey.

Within ten or fifteen minutes there seemed to be a lot more bends in the road than I'd remembered. We turned onto what had to be a country lane. I was becoming more alarmed with every pothole. Suddenly the car stopped. 'Get out.'

We were obviously still in the North. In fact, we were not far out of the city. Worse still, by my reckoning, depending on which turn we had taken, we had to be within a couple of miles of one of two big army bases. This was clearly a bad joke, and I didn't find it funny. I looked around, squinting against the light. We were next to an almost derelict farmhouse. When I turned to ask the men what they were playing at, the joke turned serious. They had donned balaclavas. More startling was the emergence from the house of three women, also masked. More worrying still, each carried a very large Armalite rifle. I felt the odd one out.

I was relieved to see another man who wasn't wearing a balaclava. I hadn't time to concentrate on his face, but he seemed to be an instructor. I was told in no uncertain terms that he wasn't to be pictured. I remember thinking: 'How under God did I get into this?' I was getting very jumpy.

'Where do you want us?' one of the women asked in a broad Belfast accent, a smile in her eyes. She pointed a revolver straight at me. I quickly concentrated on the job in hand. They posed for about half-a-dozen pictures – aiming the rifles, holding the guns, rolling out a wire drum that wasn't actually connected to anything. Then it happened. The army helicopter arrived.

There was no order – there didn't need to be. Everyone dived into bushes. We hadn't heard the rotors from a distance; they abruptly crashed overhead. I lay flat in a ditch, water trickling unpleasantly along my leg. I hoped it was just water in the ditch. The chopper was perhaps just forty feet above us, and the downdraft was incredible. Bushes all around shook violently to and fro, as if caught in a hurricane. Here, at the eye of the storm, all was not calm. One woman lay near me. I could see fear in her eyes and noticed her finger was on the rifle's trigger. I almost went into cardiac arrest. People say, 'My heart was in my mouth,' and now I knew exactly what it meant. I couldn't breathe. I couldn't talk.

Whether the army had spied something suspicious or not, I don't know. It lasted all of thirty seconds. Now, nearly thirty years later, just thinking about it produces a cold sweat. When the helicopter pulled away everyone scattered. The men shoved me in the back of the car again and drove off. En route they weren't happy; they argued about whether it had been worth the risk to bring me there. I was thinking the same thing myself. I also wondered if male IRA members could have held their nerve in the same way as those women. By not firing, I've no doubt they saved all our lives.

I was dropped off where I'd been picked up. After a little while, I noticed I could breath again and took a gulp of air. For a long time afterwards I was in a state of anxiety. It was a week before I developed the film, and the images appeared a month later in a European magazine. They say every picture tells a story. Sometimes I'm not so sure.

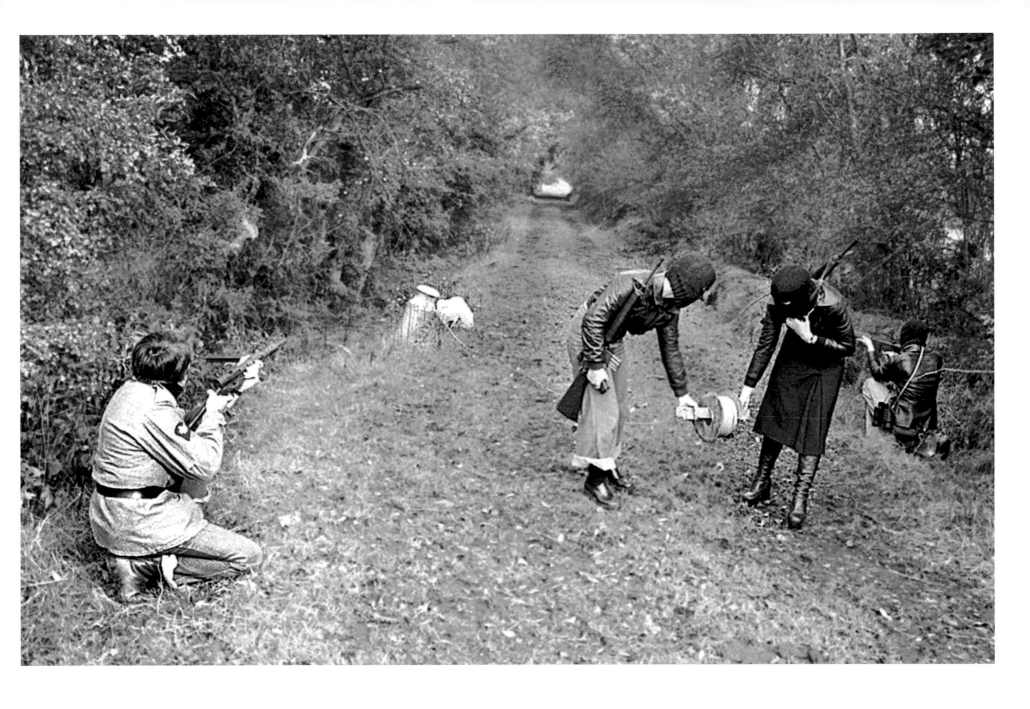

CUMANN NA mBAN TRAINING
June 1975
One of the scariest moments of my working life,
photographing women IRA members at a training camp.

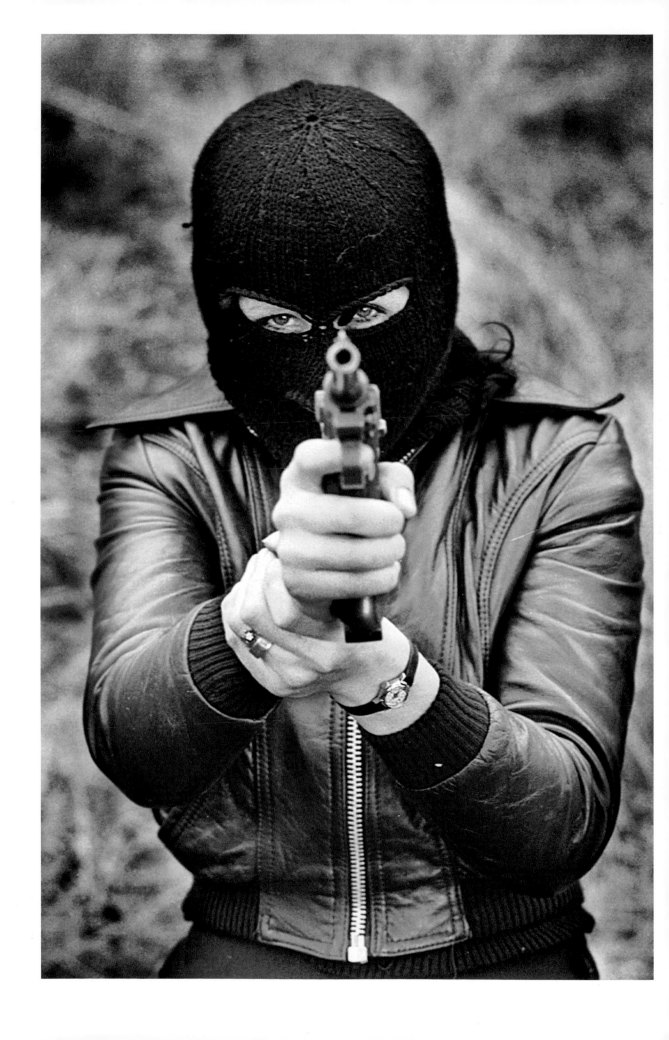

GUNGIRL

June 1975

I was nervous at someone pointing a gun at me.
She had cracked a joke a few minutes earlier. I never saw
her face. Her eyes were young but she was very calm,
clearly the leader of the group.

TAKING AIM

June 1975

They were happy to pose for pictures until the army
helicopter arrived. Then everyone scattered.

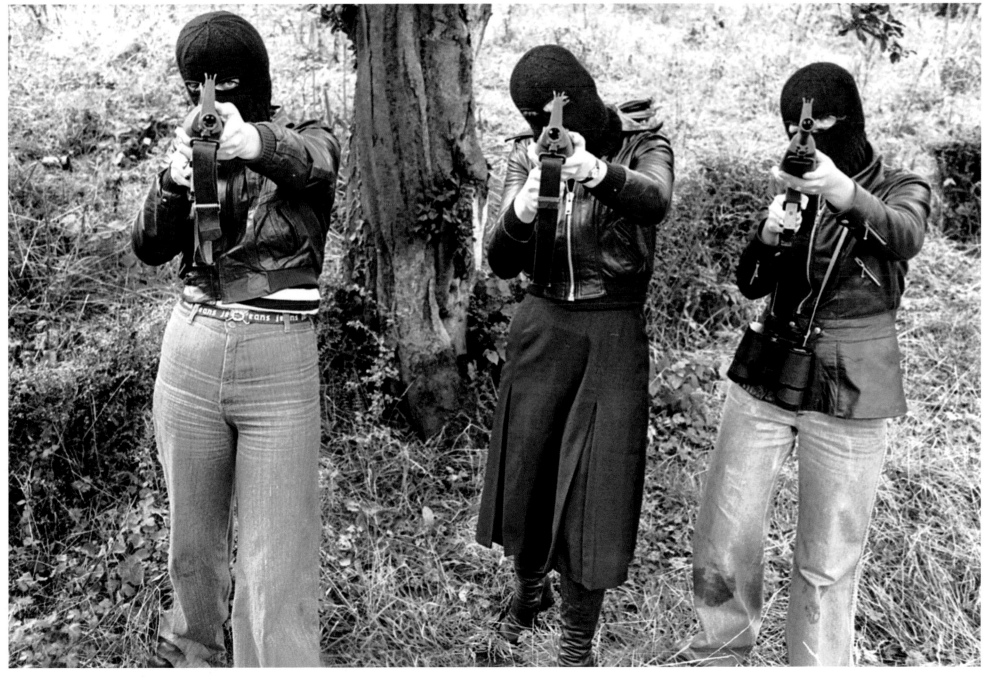

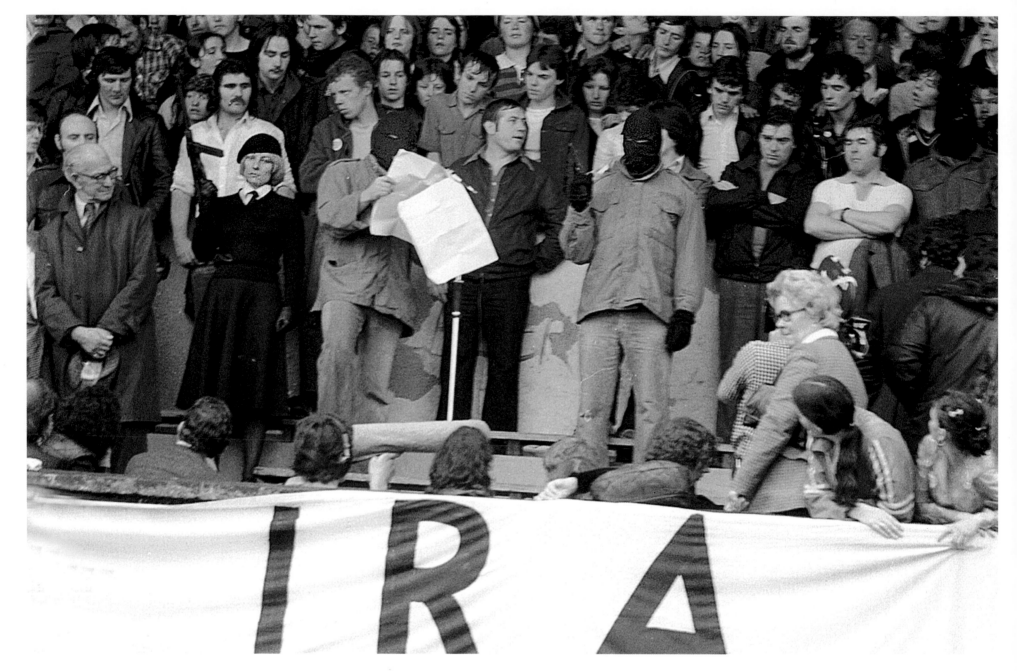

ABSOLUTION
August 1977
Republicans accused me of taking a picture they didn't like, and questioned me. I denied taking the picture. Subsequently the word on the grapevine was that if I tried to cover a certain funeral I was to be 'made an example of'. This was the first time I went back to a republican rally after the threat.

UFF GUNMEN

September 1993

These guys scared me. With republicans, you've a good idea what they're going to do. Usually, they'd pose with guns only when safe to do so. Loyalists are less predictable. You never know what's going to happen. I was on my way to a news conference in the Shankill when this pair appeared. They ran out from an entry. I didn't know if they were going to shoot me or I was going to shoot them. Taking the pictures calmed my nerves, slightly.

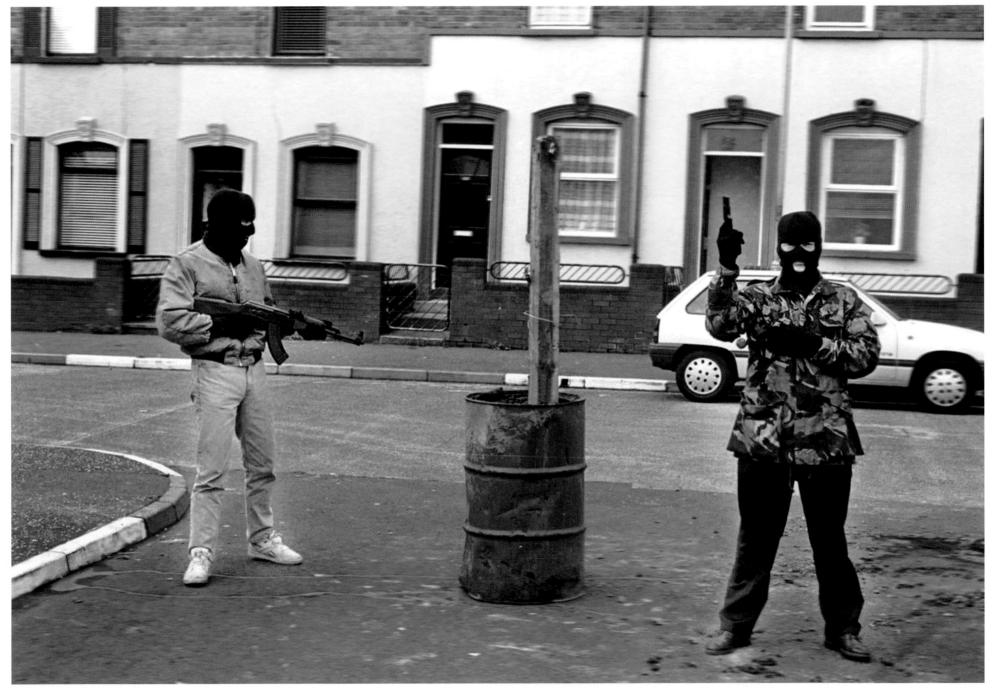

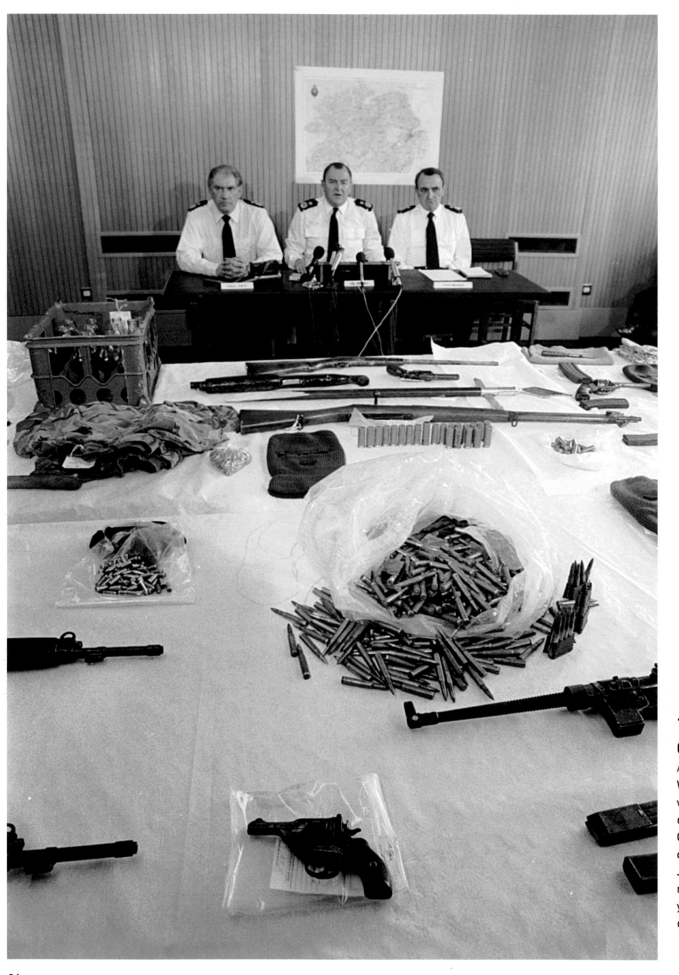

'I KNEW HIM BEFORE HE WAS CHIEF CONSTABLE'

April 1986

When I owned the bar, a district inspector new to the area was fanatical about enforcing licensing hours. 'You are a disgrace,' he told me once, 'not fit to run a bar.' My crime? Customers had taken twenty minutes to drink up. The officer was none other than future RUC Chief Constable Sir John Hermon. At one of his first news conferences, a reporter told him: 'Small potatoes now compared to when you were tormenting Falls Road publicans.' Here he is displaying weapons found in loyalist and republican areas.

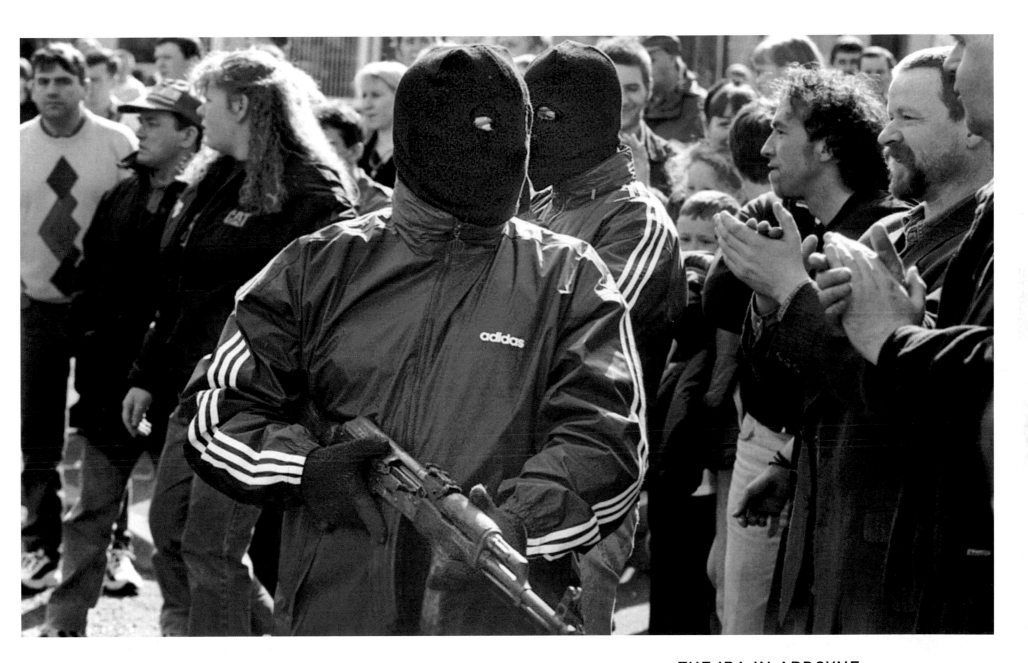

THE IRA IN ARDOYNE

March 1996

It was Easter, at the annual republican commemoration in the heart of a republican community. The gunmen appeared and left quickly. There was no shortage of support.

THE IRA IN ANDERSONSTOWN

August 1980

They showed up at a 'Troops Out' rally. They were obviously young and enjoying posing. Displaying guns always made a crowd behave as if it was at a rock concert. I remember thinking the mother of the guy on the right wouldn't have been too impressed with the uneven way he'd cut his eye-holes out.

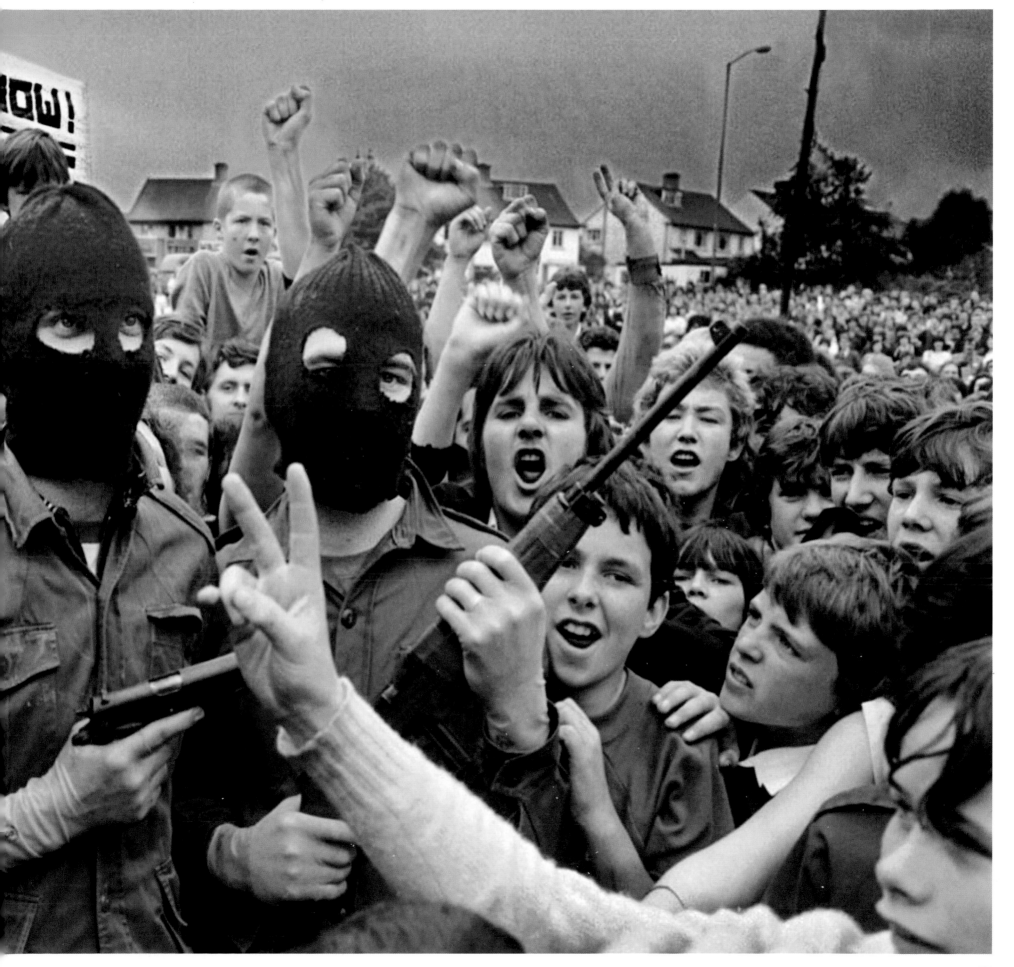

'ITEGRATED EDUCATION NOW'

October 1975

I always thought the misspelling in the poster ironic. The Official IRA's youth wing took over a school to demand that Catholic and Protestant children be taught together. It was the first time I'd ever seen anyone campaign for integrated education. Most people at the time wouldn't have known what it was about. Only a television reporter, the young Jeremy Paxman, and myself got the story.

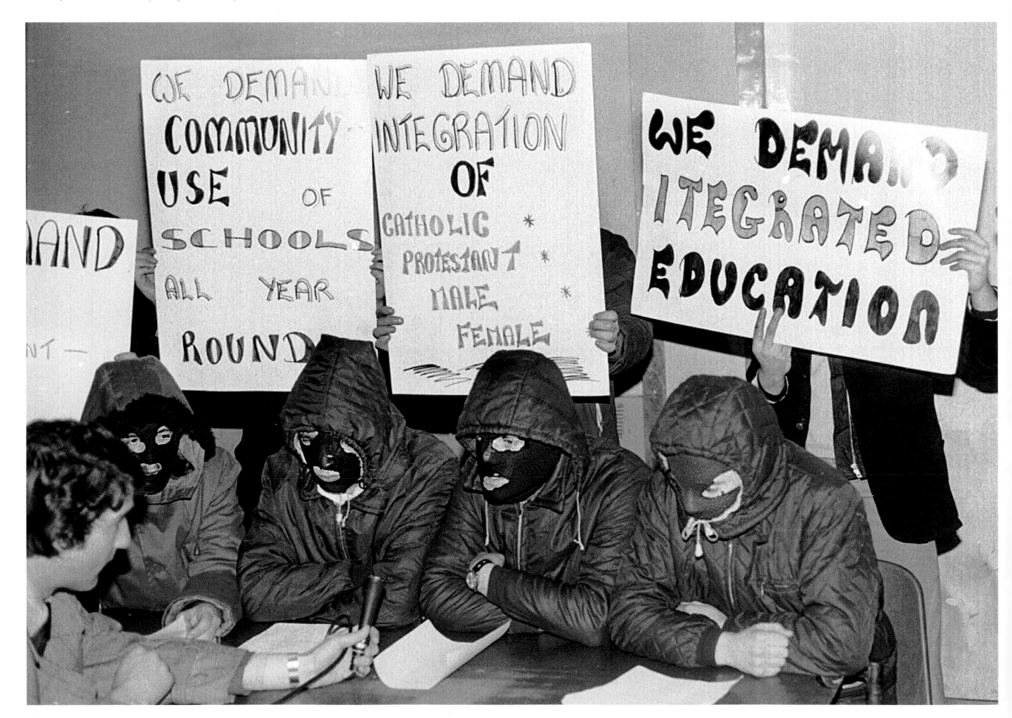

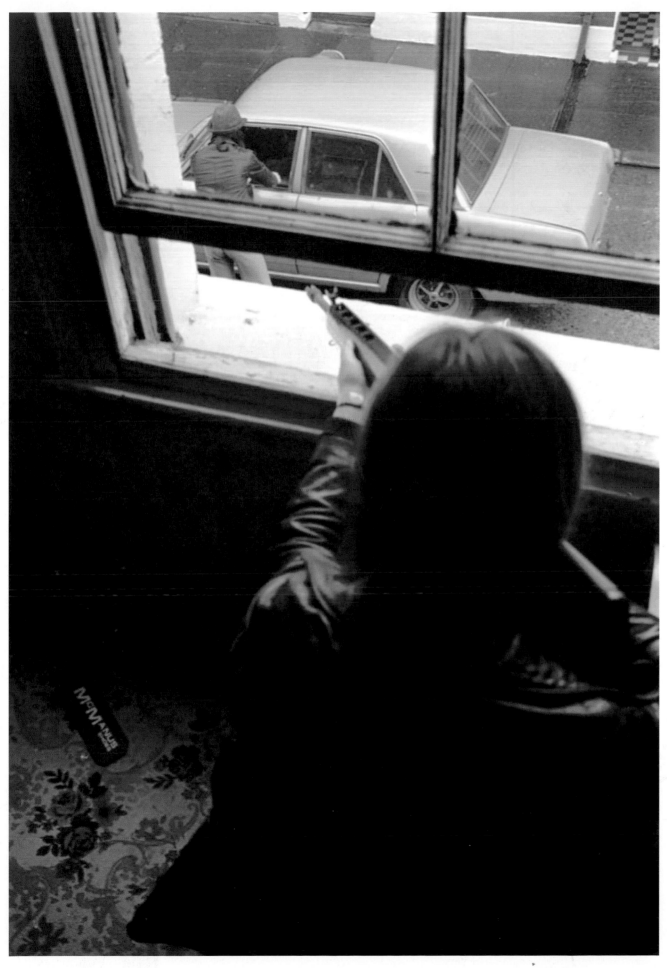

OFFICIAL IRA CHECKPOINT
August 1975

I heard the IRA had set up a roadblock near Leeson Street, off the Falls Road. The Officials claimed police and army weren't doing enough to stop loyalist killers entering the area. I went there and was allowed to take this photograph of a woman covering others from the upstairs window of a house. A reporter wrote that she was aged just nineteen.

About thirty yards away on the track were two bodies. They lay, partially covered, across the laneway, making no sound. As I pressed the button, the camera's motor drive exploded with noise, a violent crash going off with every frame.

CHAPTER 3: THE DEAD AND THE DYING

It was July 1983, a high summer day's sunshine baking the fields. I stood in a lane on the south Armagh border. The chug of a tractor engine in a field about two miles away was audible on the light breeze. Louder was the buzz of insects in the hedgerows and the singing of birds. About thirty yards away on the track were two bodies. They lay, partially covered, across the laneway, making no sound. As I pressed the button, the camera's motor drive exploded with noise, a violent crash going off with every frame. Real violence had already happened, although not at this place where the bodies had been dumped for the likes of me to stumble upon them. I calculated exposure and speed, studied every detail of the ears on the long stalks of grass growing from the ditch and took the picture.

Arriving at a murder scene, if there's a police cordon, the body is maybe 200 yards away. Often it happens at night – a good time to kill someone but, even on a 300mm lens, poor from a photographer's narrow view. The victim might be inside a car or house, or around a corner. You take a general picture, probably just showing a couple of cops and the white tape police barrier. It will still make the front page, because this is news in its rawest form. People want to know.

Depending on the area, it can take police and soldiers some time to set up cordons, and sometimes I've arrived first. Most journalists, certainly most photographers, will have that experience during their careers. On those occasions the choices you make are more difficult.

That day on the border lane, there was a police cordon. Other photographers and reporters were around. I was glad. I wouldn't have wanted to be alone with those recently dead men's bodies. Part of me wanted to go forward, to remove the blanket or whatever it was that was covering them. There was the natural urge to help. Full well I knew they were beyond help. So instead I went about my work, as much part of the ritual of death as any post mortem.

I know how I continually dealt with that and coped. I stopped thinking of them – anyone who had been killed – as people. I just did not think of that object on the ground as a person. It was a job I had to do; go out and take the picture. That was my way of dealing with it. I had to turn off any emotion. This must have developed over the years, because at first when I wandered into press photography it was much more difficult. I would find taking pictures of bodies very upsetting. Images would stay with me for days and nights. I remember a young solicitor shot on the Andersonstown Road. The IRA mistook him for an undercover soldier. I couldn't get what had happened out of my head. Even today when I pass that spot – which now looks very different – I still sometimes see him lying there in my mind's eye.

Reporters and photographers are at a lot of murder scenes. The more experienced fall into a kind of rhythm of covering death. There'll be an attempt to talk to witnesses. Police press officers and local councillors will tell you what happened. If the body is still at the scene, you will wait to get a picture of it being removed. Having heard the news or a rumour, sometimes relatives – wives and daughters, sons and fathers – show up at the tape barrier. That could be incredibly distressing. There'd be blood-curdling screams. You would photograph them if you could take a photograph. You tried not to think of what was going on. You tried to remain in the background.

People assume journalists become hardened, inured to violence. I'm not so sure that's true. I don't think it was true in my own case, and I certainly don't think it got easier. It was never easy. Within a few years, though, photographing bodies had somehow become part of the job, and an important part at that. You were always conscious that the victim lay on the other side of the white tape. Nothing better illustrated the waste of life, the horror of violent death. There was no question but that you would take the picture. You didn't ask should these pictures be taken or published. That came later.

On another day, I went to a scene where loyalists had shot a workman dead as he ate his lunch. He lay on the pavement covered by a blanket but, as I looked through the viewfinder, a policeman removed it. It was Easter time, and the sun was shining on his face and his small beard. To me he looked like Jesus. I pressed the button and the motor drive whirred away. That was my first mistake. Back in the office, I made my second – showing the picture to others. I suppose it was egotism – I had got the picture, of this poor unfortunate man who looked like Jesus. There was a heated debate over whether or not it should be published. The split was even. One side did not want to use the image, wishing to spare a family pain. Others argued that publication would show what had happened without sanitising it. Perhaps it could even indirectly save lives, they said, by shaming the killers. At the very least, it would put pressure on them, so that they would be unable to kill again for a while. Someone had to take the decision. Someone did, and I was overruled. The image was used on the front page.

I respect the person who took the decision. Indeed, I appreciate that he was willing to accept the responsibility. It was not the first such debate, nor will it be the last – in my experience every such decision is carefully weighed. That is not to say they are all correct. Perhaps the voyeur lurks in all of us, and these high-minded debates we have are simply ways of excusing the inexcusable.

Over a year later, along with thousands of others I was standing at the border at Carrickdale, waiting for the victorious Down team to arrive with the Sam Maguire Cup. A relative of the victim whose picture had appeared on the *Irish News* front page approached me, very angry. 'Are you Brendan Murphy?' I replied that I was. Her family, she said, had been left with the image of their brother, uncovered, lying on the street. I made no excuses. That's all they would have been. The fact was, I took the picture, the paper printed it and that could not be undone. I apologised. I'm still sorry. I left ashamed and embarrassed, with her words clashing in my mind.

I've been at murder scenes since. There have been uncovered bodies. I haven't pressed the shutter release. I believe that it's important for a photographer not to sanitise in any way what has happened, or is happening. But it is a difficult balance, one I'll always wrestle with in my conscience. Other photographers, journalists and editors do the same.

In this book I have used the pictures of bodies covered. All have already been published. Republicans and loyalists shot people. Pictures of republicans and loyalists also appear in the book. I do not believe it right to show those pictures of people with guns, or for that matter the security forces, without showing the other side of what happened.

There are photographs in this book where the dead and the dying are clearly visible. One is of Sean Downes, hit at close range by a plastic bullet fired by an RUC officer. The security forces also killed many people. Another is of Thomas McErlean in his coffin. He was shot during a gun and grenade attack on republican mourners in Milltown Cemetery. Thomas's family invited me to take the picture to show the reality of a very brave young man's death. To me it remains a powerful image. A photograph of two INLA men providing a guard of honour to a dead comrade was taken on another occasion when I was invited to take the picture. The guard of honour was a feature of republican funerals for a long time. Interpreting pictures such as these, I feel, always remains very much up to each individual.

The *Irish News* once published a picture, full length on its old full broadsheet front page, of an alleged informer lying in a border ditch. His face was turned away and therefore not visible, but to me it was an image horrifying in its brutality. It was a Saturday and I was in the office, with no one else on duty. There were maybe 200 complaints that day. People were angry, frustrated, wanting to vent. Because these people were so enraged, when answering the phone I pretended I was a doorman who knew nothing. I eventually stopped lifting the phone. But not one of the complaints was about the picture. The clues in the popular weekly prize crossword, it turned out, had been somehow mixed up. This was what was incurring the wrath of our readers.

Any photographer or reporter would like to think their work has power. We have a commitment to truth and context, and perhaps that's our reason – or excuse – for doing what we do. But that day, when not one person mentioned the picture of a human being's body on the front page, made me uncomfortable. Could it be that the people looking at our pictures and reading our stories are every bit as hardened as we are? I like to hope that could not be true.

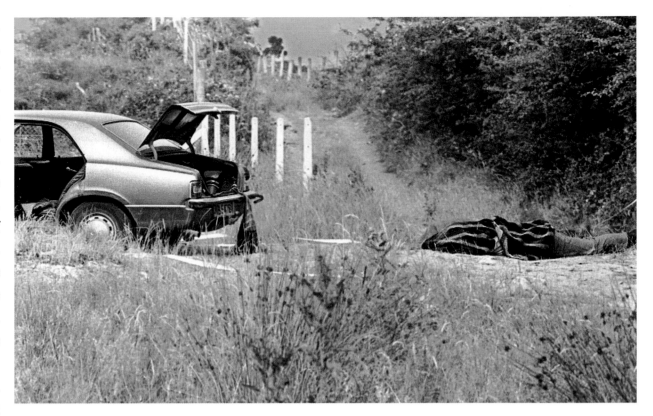

BORDER LANE

July 1983

Side by side, two bodies lay on this laneway. It was eerie, in sharp contrast somehow to a beautiful summer's day. Soon after taking photos like this, I would find myself back working on some other job, maybe photographing a celebrity or a function of some kind. It was difficult to adjust.

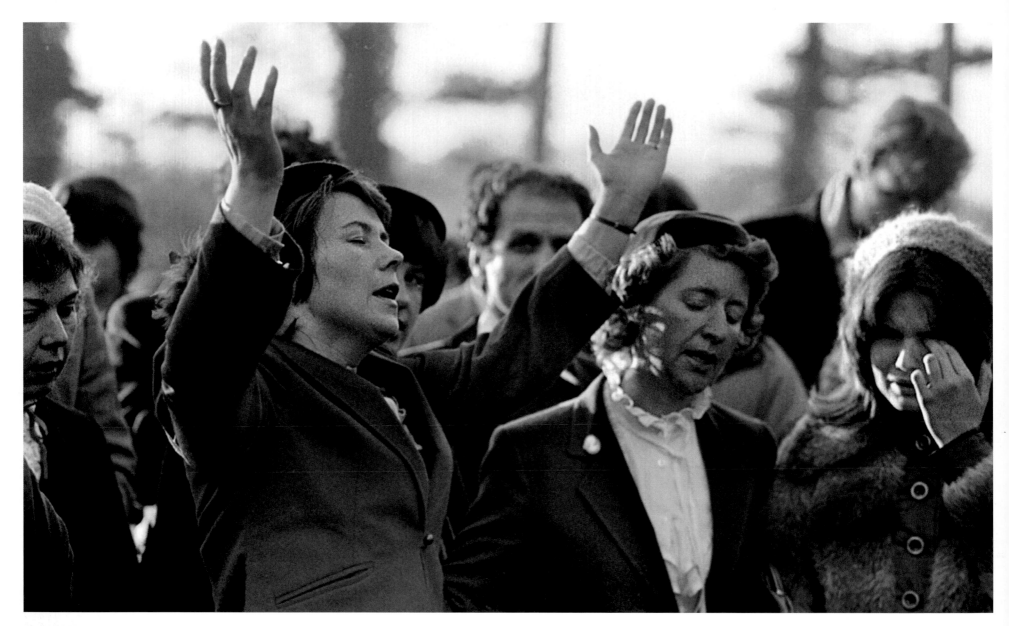

DARKLEY

November 1983

The widow of thirty-nine-year-old John Cunningham prays
at his graveside. The INLA shot three men dead during a
Sunday evening service in a Pentecostal church in County
Armagh. I talked to Pastor Bob Bain, who'd been taking the
service. I was really impressed by his Christianity and
willingness to forgive.

MISTAKEN IDENTITY

October 1979

He was a junior solicitor who rode out of Andersonstown RUC station, where he'd been delivering a summons to a policeman. The IRA thought he was a plainclothes soldier and opened fire from the back of a van. I was on the scene very quickly. It shook me. He was just twenty-three years old.

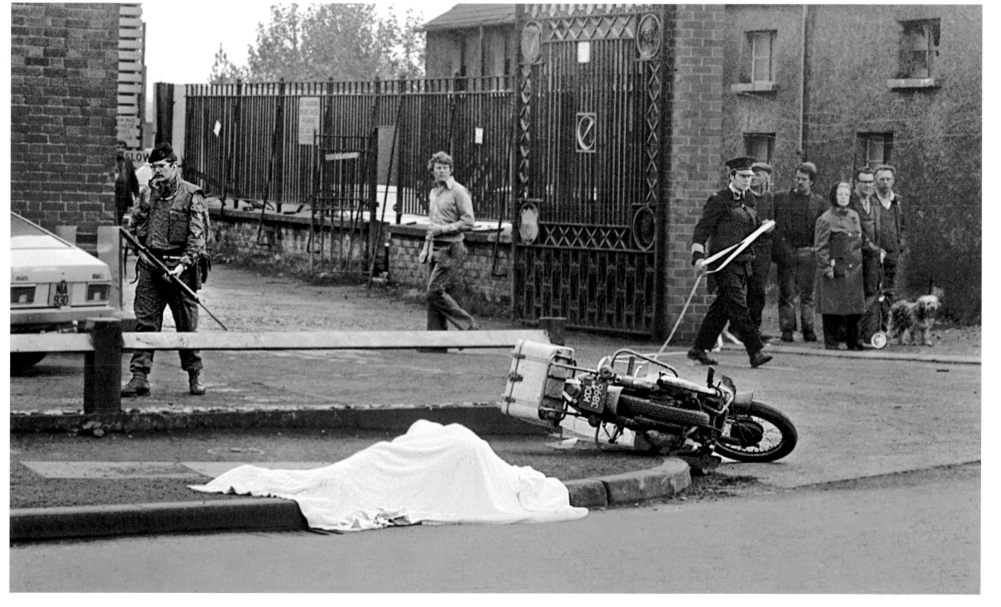

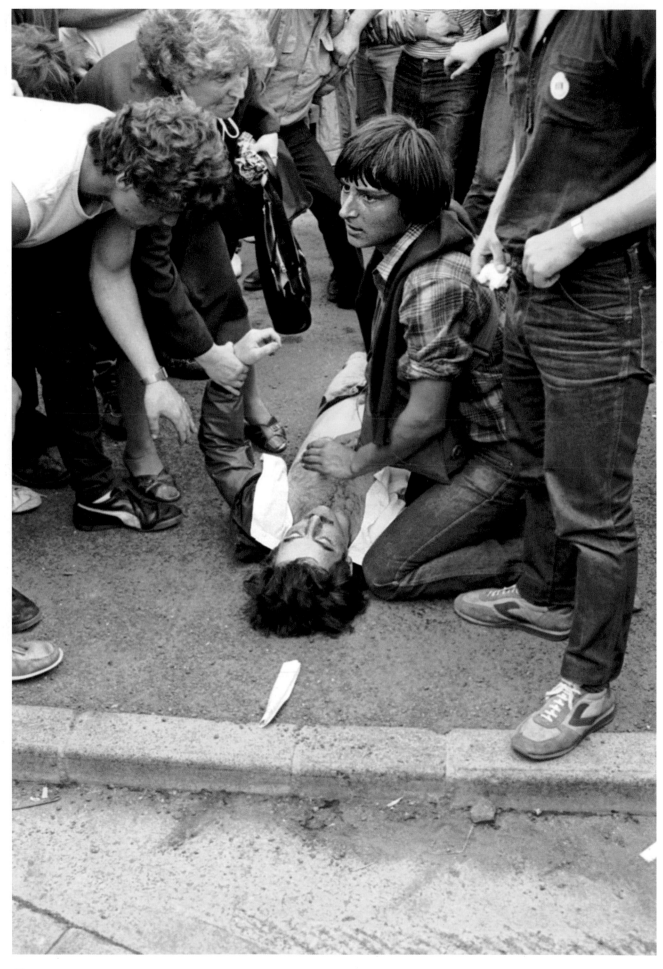

THE DEATH OF SEAN DOWNES
August 1984
It was just another internment commemoration rally until Martin Galvin appeared on the platform. The director of Noraid, a Sinn Féin support group in America, he had been banned from entering Northern Ireland. When police tried to arrest him, there was mayhem. Sean Downes was hit at close range by a plastic bullet.

IN THE NAME OF THE FATHER

January 1980

The funeral of Giuseppe Conlon. I had known him when I ran the bar. A quiet man, he wasn't a regular customer. He was wrongly convicted of being part of an IRA bombing campaign, along with members of the Maguire family, his son Gerry and the rest of the Guildford Four. A feature film was later made about the father and son's story. For me it did not capture the sorrow of the family on this day. Few media were present, but the dignity of widow Sarah Conlon stood above all else.

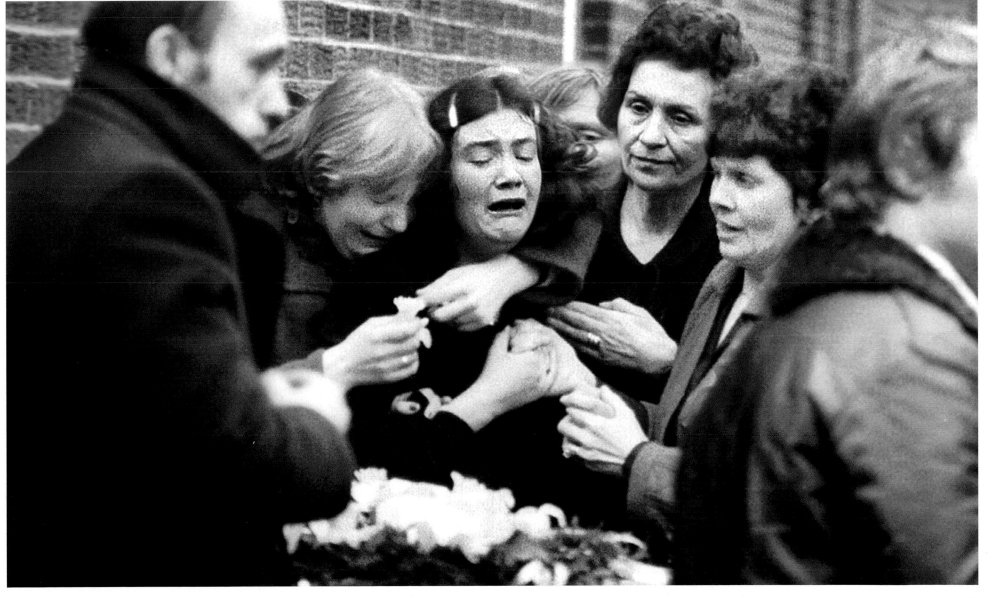

HUNGER STRIKE FUNERAL

May 1981

The funeral of IRA hunger striker Bobby Sands was the biggest I've ever seen. Photographers from all over the world were there and, as usual, were jostling for position. Such was the size and sombre mood of the crowd, that I think we were more subdued than usual. For one brief moment I glimpsed his family, as gravediggers moved in with their shovels.

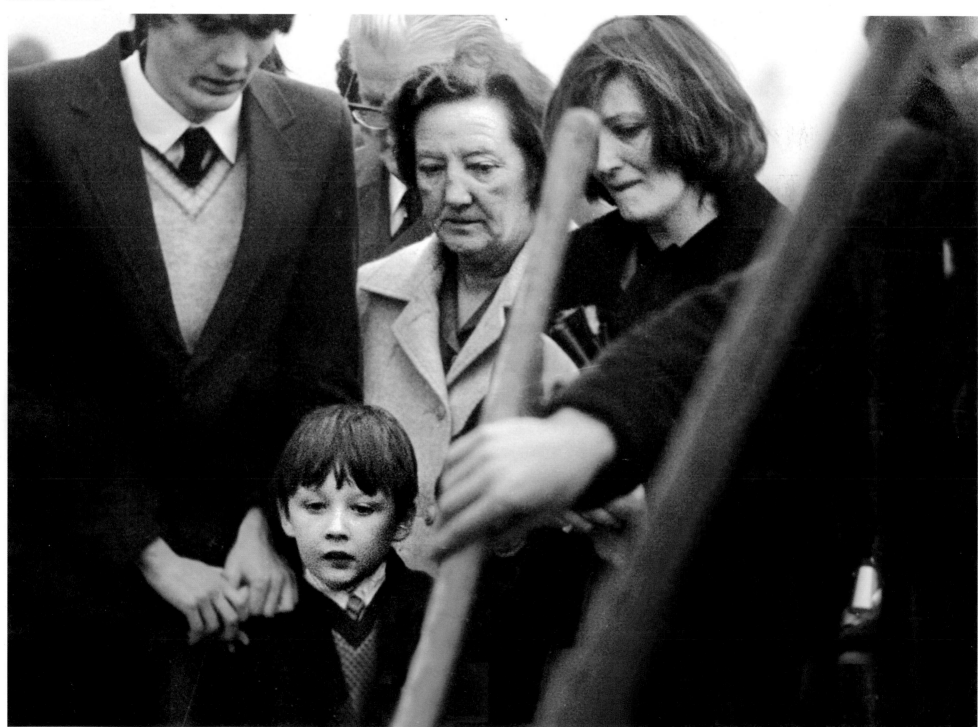

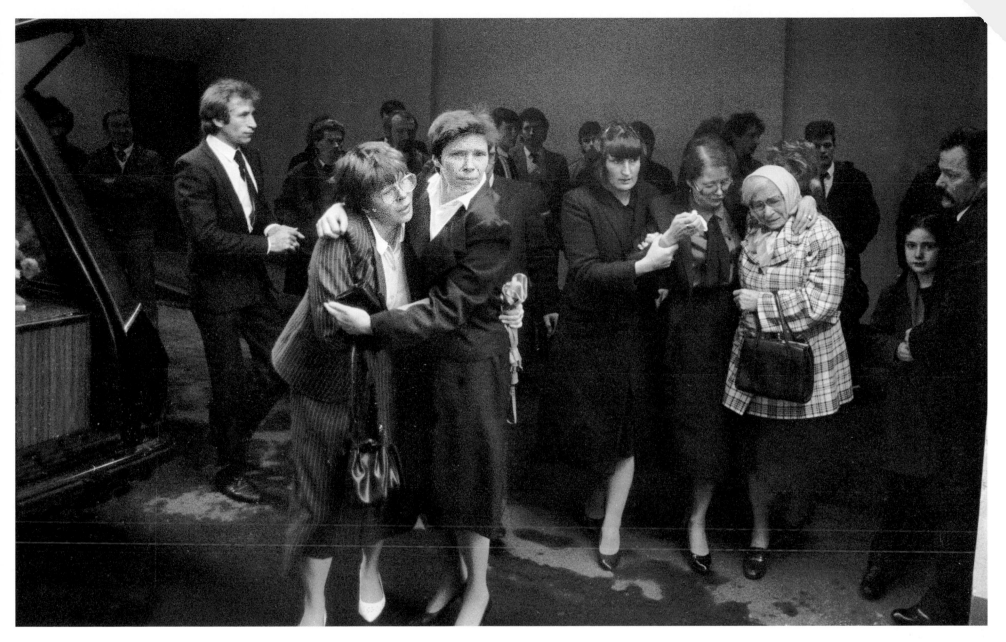

FAMILY AT FUNERAL

December 1986

A UDA gang beat him with pool cues in a bar in Lisburn. Charges against several men were dropped. None of the dozen or so people in the pub at the time provided any evidence. Among those at the thirty-year-old Catholic's funeral were his wife and his mother – an almost overwhelming image of a family's grief.

GRIEF

March 1998

The grief of relatives is always harrowing. At the funeral of
Belinda Harte, a young woman murdered in Newry, tears
streamed freely down the face of her sister.
It was heart-rending.

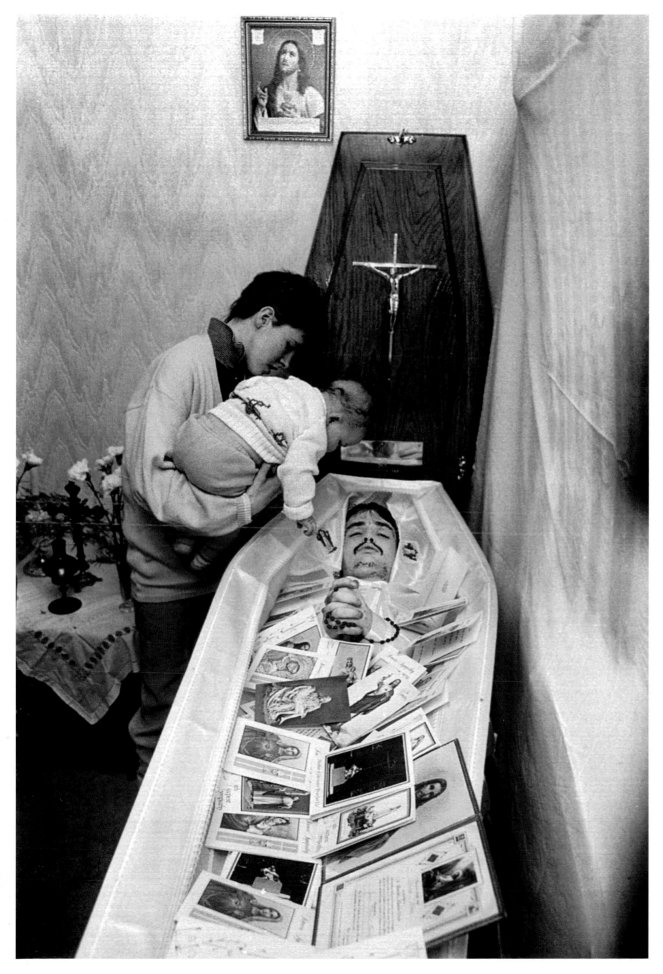

BABY AND COFFIN
March 1988

Thomas McErlean was just twenty when he was shot dead at Milltown Cemetery, during a loyalist gun and grenade attack on a republican funeral. He was married with two children, and his family allowed me to take a picture as he lay covered by Mass cards in his coffin. They wanted to show the reality of his death. As I went to take the photograph, his baby leaned towards him. I find this a deeply haunting image.

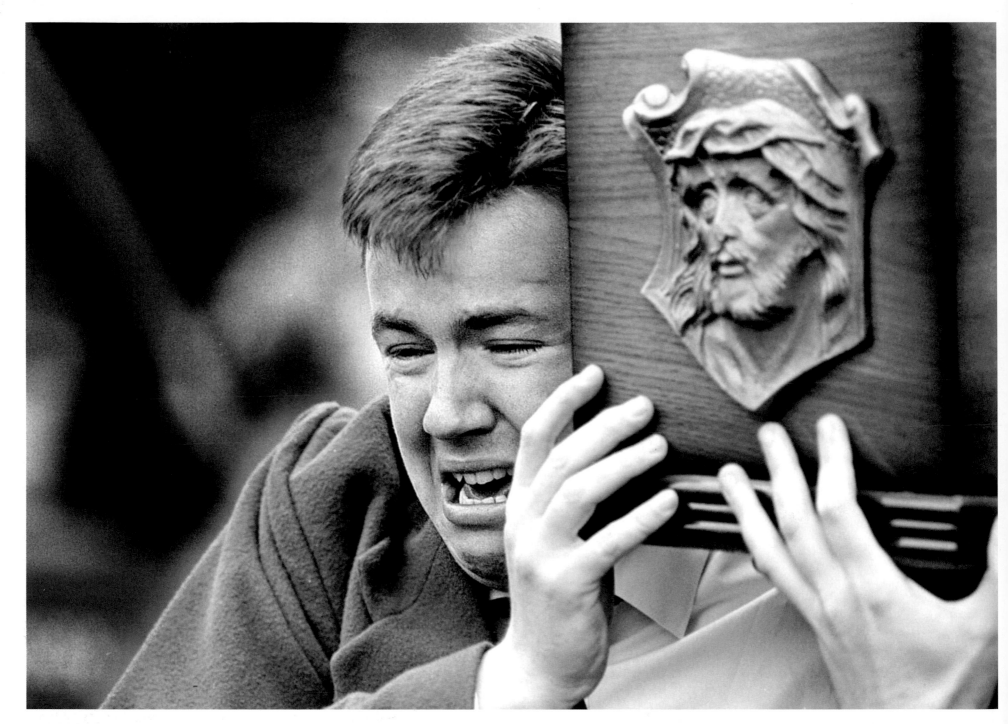

SUFFERING

October 1993

Sometimes the frozen image etches feelings much more powerfully
than moving pictures. This was the funeral of one of two workers shot
by loyalists in a council waste disposal yard. The pain in this man's face
was very powerful, very moving.

McGURK'S BAR MEMORIAL
December 2001
In December 1971 a UVF bomb exploded at McGurk's Bar, killing fifteen people, among them the wife and daughter of the owner. This was a commemoration, at the site of the bar at North Queen Street, on the thirtieth anniversary. Many of the people there had lost relatives and friends in the explosion.

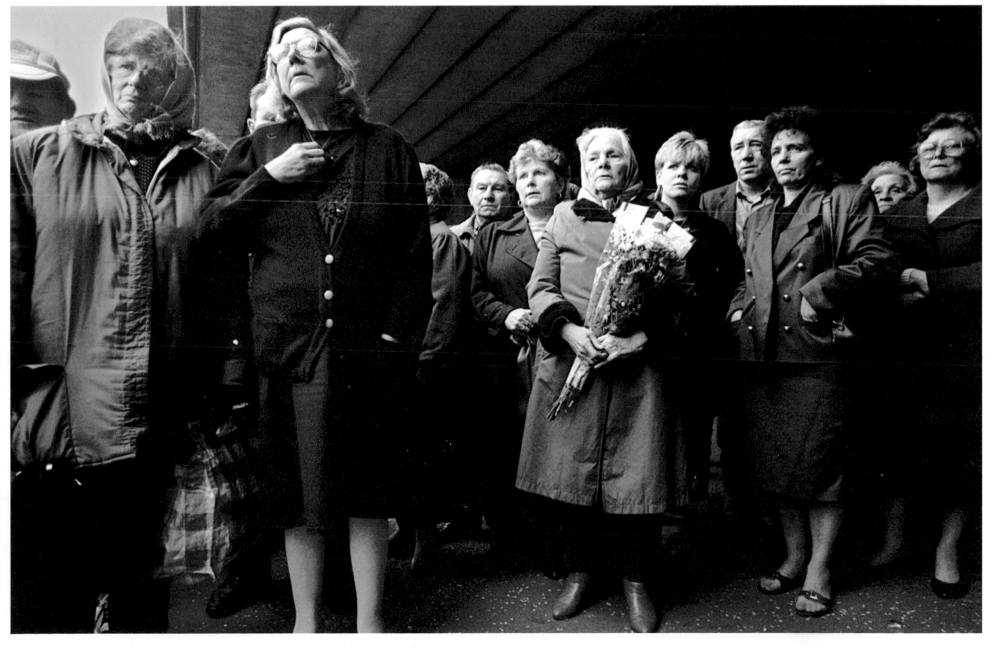

HEARING THE NEWS

November 1992

Mrs Mary Burns learns of the death of her husband Francis Burns, one of three men killed in a UFF gun and grenade attack on a betting shop in north Belfast. He had warned his sons against going into the bookmakers because of the risk, but had gone there himself. One of his sons later asked, 'What harm could they have done anybody?' He said his father was 'just in the wrong place at the wrong time'.

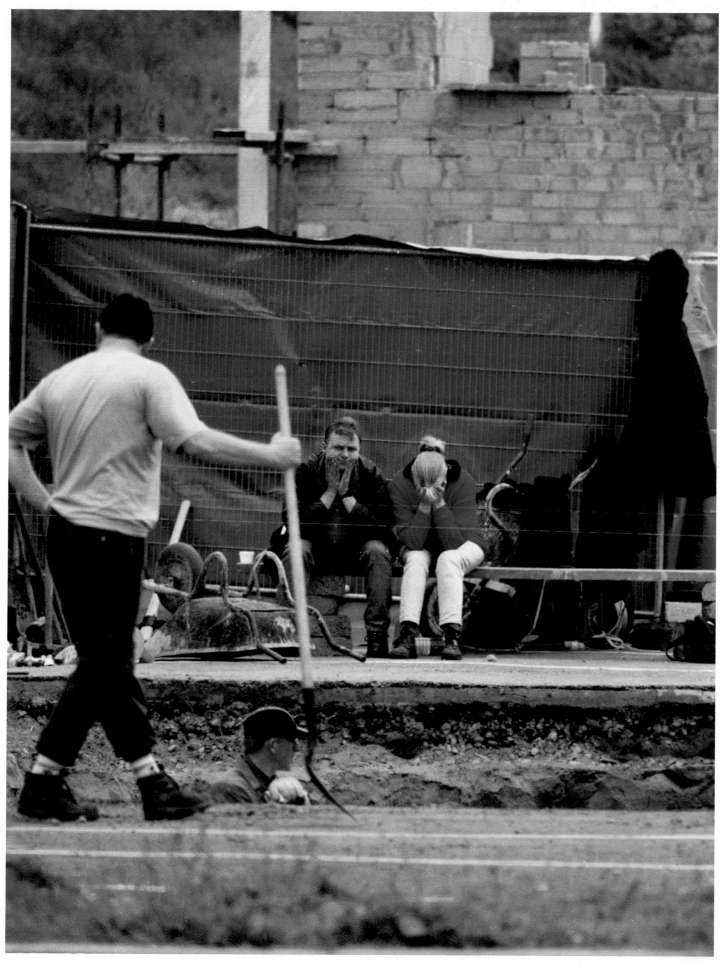

WAITING

June 1999

Falls Road mother of ten Jean McConville was abducted by the IRA in 1972. She became known as one of 'the disappeared' – people whose bodies were not returned after they were murdered. The IRA eventually said Mrs McConville had been buried at a beach on the shores of Carlingford Lough in County Louth. Here her daughter and son-in-law wait while digging takes place. The dig was abandoned when nothing was found but, at the time of writing, the family were waiting for confirmation that remains discovered on a nearby beach were those of their mother. A post mortem found the victim had a bullet wound to the back of the head.

I have photographed some children who frankly did not, when it came to looks, fall far from the tree. In the first few months, I'd dread parents picking up pictures. As they walked in, I'd stand quaking as I revealed pictures that in a different culture could have been used to ward off evil.

CHAPTER 4: CHILDREN

Our daughter and only child, Michaela, died at the age of eight-and-a-half. She had been diagnosed with leukaemia three years earlier.

Afterwards I went into a depression, sitting numb in the house in almost physical paralysis. It lasted months. It was Geraldine's idea to open the photographic studio. It would get me out, she said.

A house on the Falls Road was for sale. It was in a prominent spot, and easily converted. Around the same time, I was introduced to Tom Russell. In his early twenties and just out of art college, he was a lot younger than me, but we got on well and decided to go into partnership. Having a fondness for films, we called ourselves Oscar Studios, a decision I would later regret because people would shout, 'Hey, Oscar,' thinking that was my name.

Business was slow at first, but gradually picked up. Weddings were our bread and butter. I'd take two dozen photographs at each wedding. I remember them still – a single of the bride; the bride and groom; the bride with bridesmaids; the bride with her parents; the bride with her family; a single of the groom; the groom and best man; the groom with his family; the group shot; and so on. I developed a line of patter, with a joke for every picture. Ideally people would smile just as I clicked the button.

I learned early on that the bride was the single most important person. She had to look radiant in every picture – fail to make her look good and your album would be judged a failure. Forget about the groom; the next most important people at any wedding were the bridesmaids. I would make a point of paying them particular compliments, ensuring that they looked nearly as good as the bride. They were potentially our next paying customers.

Meanwhile, I continued working shifts as a press photographer. To my surprise, I found that taking wedding pictures opened up a new range of contacts. Quite apart even from the wedding parties and guests I got to know a whole range of people, some of whom would later be very helpful as I covered stories for the papers.

The studio work didn't involve just weddings. A lot of time was taken up with First Communion sittings, Confirmation portraits and baby pictures. I have photographed some children who frankly did not, when it came to looks, fall far from the tree. In the first few months, I'd dread parents picking up pictures. As they walked in, I'd stand quaking as I revealed pictures that in a different culture could have been used to ward off evil. To my utter amazement, all I would ever hear was, 'Oh, doesn't wee Johnny look lovely,' or, 'Isn't wee Mary beautiful.' It never ceased to astound me. If you had to be careful photographing brides, then the opposite was true of children. It was impossible, in parents' eyes, to take a bad photograph of a child.

In the same way that you developed a routine to take wedding pictures, there were techniques for dealing with children sitting for portraits. You had to

capture their attention just long enough to get the shot. It was a more controlled situation – they were in the studio, after all – so in many respects it was easier.

One day, a young boy was determined to make my life difficult. His mother brought him in for a First Communion portrait. He was no angel. No matter what I'd ask, he'd refuse, insisting instead on pulling faces each time I tried to take a picture. Worse still, he was continually moving, making it impossible to focus. His mother was not one of life's strict disciplinarians, having seemingly given up trying to get him to behave. I decided the nice-guy approach would not work.

'Why don't you wait in the hall?' I said, smiling benignly to his mother, 'I think he might be just a little bit distracted.' When she left the studio, I turned to see this eight-year-old terror almost kick over my lights. That was it. 'Now listen, you brat,' I hissed in my most menacing tone, 'You do what you're told or I'll put my toe so far up your arse you won't sit 'til your Confirmation.' After that, everything went without a hitch. His mother arrived to pick up the portrait the following week. 'Oh, he looks beautiful,' she said. 'You must have a great way with children.'

By 1980, I found that press work and the studio business were conflicting. Papers would want me to work shifts on the same days that I was due for a studio appointment – Murphy's law. Knowing I had to make a choice, I carefully examined pros and cons. The studio work was increasingly lucrative. Our reputation was good, word had spread and we were constantly busy. Of course, we were restricted to covering Catholic weddings – no Protestant couple was going to hire a Falls Road outfit to record their nuptials, but at least we were covering more weddings. It wasn't that greater numbers were getting married, so much as they were getting married on different days. Catholic weddings for a long time all seemed to be held at 11am on Saturdays. This somewhat limited the number we could cover in a single week. By 1980, however, things were changing. Couples were starting to book midweek ceremonies, and our earning power rose proportionately.

But I had to face facts. My patter at weddings was boring even me. Making bridesmaids giggle was no longer a satisfying challenge. Press photography provided variety. Working for newspapers, I was travelling all over the north, and meeting a wide variety of people. One day I would be covering a cheque presentation or rock group, the next I'd be in the middle of a riot or talking to some political leader. Ultimately there was no real choice. By mutual agreement, Tom and I decided to dissolve our partnership. We remain friends. He's now a successful and respected commercial photographer.

The lessons I'd learnt from Tom and at Oscar proved valuable. My prints and composition had improved. I'd built up a range of contacts, often meeting a client from the studio when covering news stories.

I'd undoubtedly learnt more about how to deal with kids. Out on the streets with a camera, you become a pied piper. Invariably as you try to focus on something, a youngster will jump up in front of the lens. 'Take my picture, mister!' they shout. I learned not to bark at them, but rather to distract them. 'See that man over there?' I'd point to the nearest television cameraman. 'He'll get you on TV.' Off they'd run, and I would watch as their latest victim tried to fob them off on some other unfortunate of the press corps.

On one occasion it didn't work. It was a hot summer's day, so warm I was wearing open-toed sandals for comfort. The job – reporters call it a 'marking' because it is 'marked' in the office news diary to be covered – was at a west Belfast leisure centre. There wasn't another camera in sight. No one else was interested. This fourteen-year-old kept jumping in front of me, acting the 'eedjit'. 'Take yourself off,' I snapped, doing my best hard man impersonation. 'Just because I've a camera doesn't mean I'm a sissy – I'm from the Falls Road and tougher than you, kid.' He looked me up and down for a moment before replying: 'Wearing those f**king Moses sandals you aren't.' I laughed for five minutes solid.

I've taken many pictures of children over the years. That's basic work in any newspaper, recording the triumphs of youngsters. We document the opening of their schools, their sporting achievements, their moments of distinction. They seem so much more active now than when I was their age, and have much wider horizons. Sometimes yet, I catch myself focussing on one youngster – the little blonde girl. That's because she reminds me of another child, another child who is always with me. It's really true. You can't take a bad photograph of a child.

SCHOOL'S OUT

May 1981

Soldiers were always relieved to see kids about, because they were less likely to be shot at. Some claimed they timed their patrols to coincide with school bells. Certainly the crew of this armoured car were well covered.

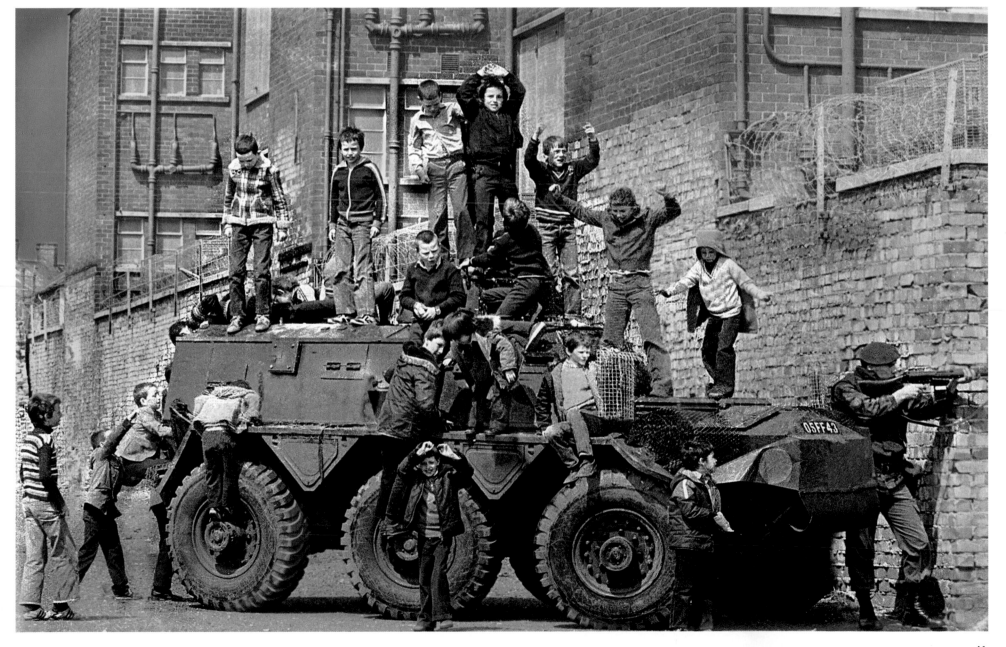

TYING THINGS UP

May 1998
Voting day on the referendum on the Good Friday Agreement.
I couldn't see a picture until I noticed this young girl on her
way to First Communion. She and her mother thankfully
stopped right next to the graffiti.

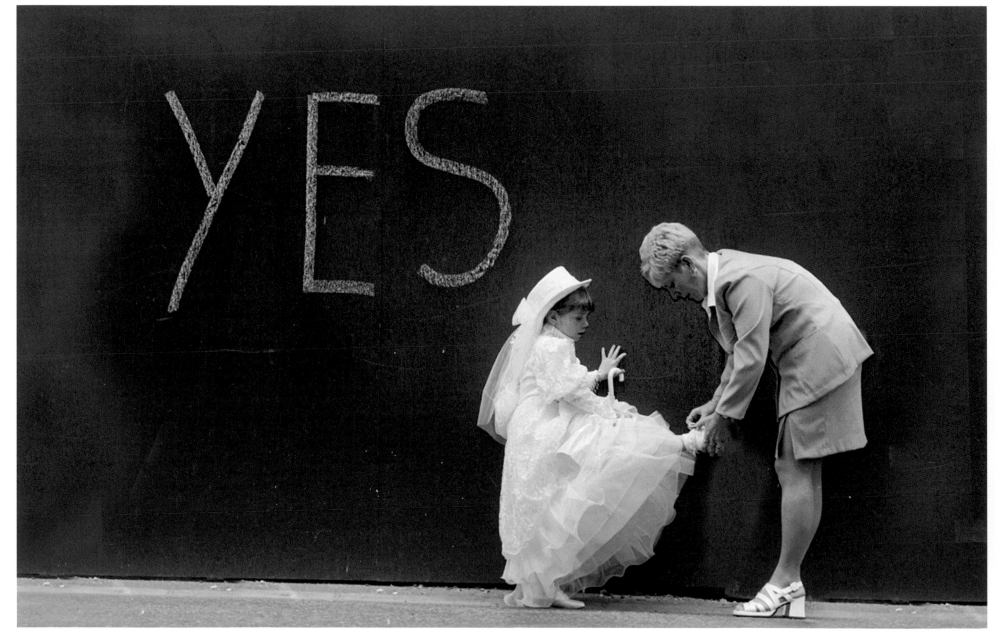

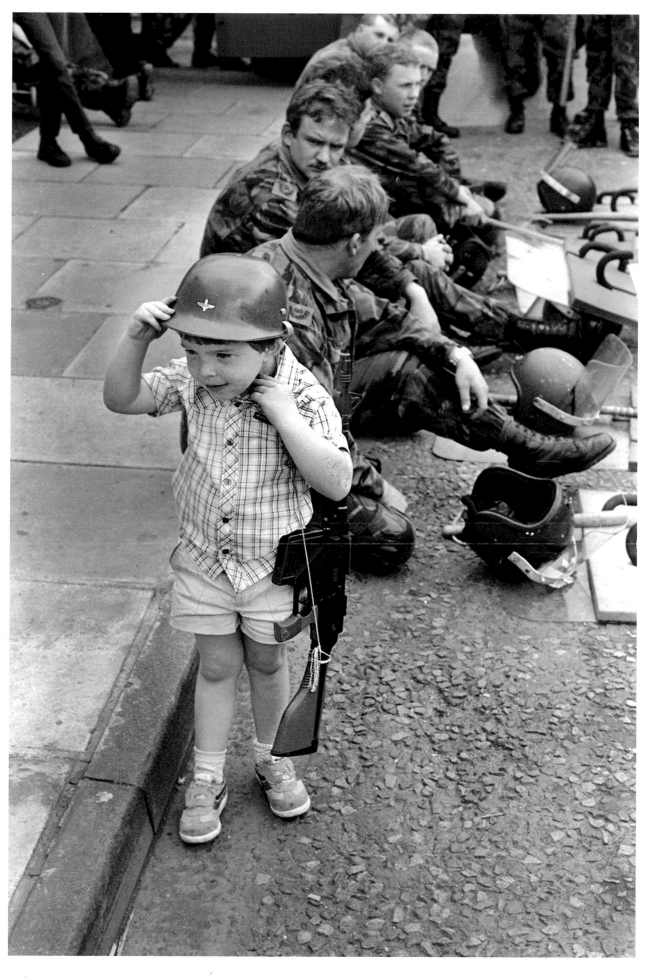

ALL GROWN UP
July 1985
Youngsters regularly mimic in their play what is going on around them. Here a child in a nationalist area stands alongside soldiers resting during riot duty, at Obins Street in Portadown.

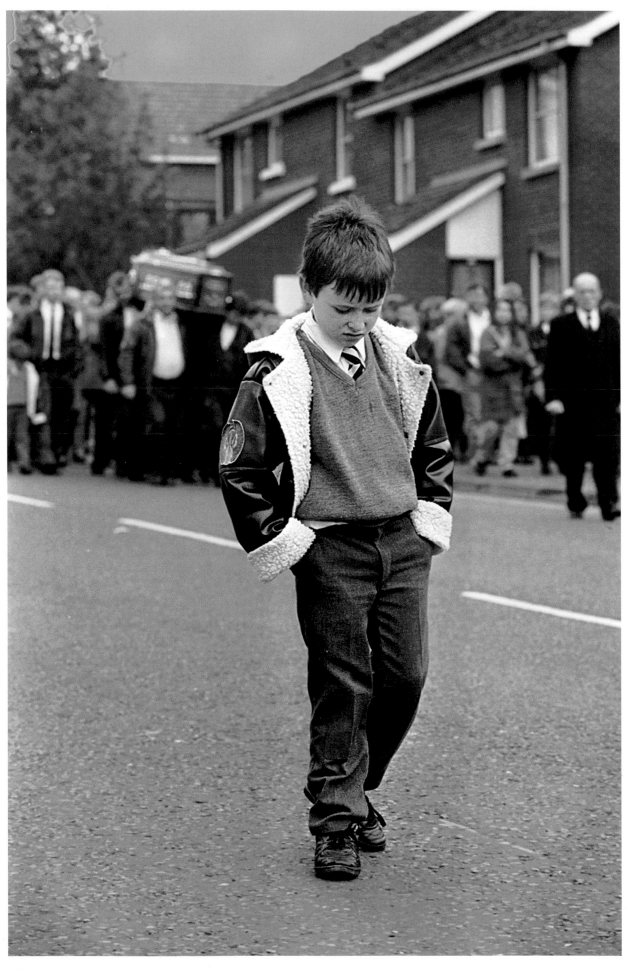

BOY MOURNER
April 1994
Loyalists shot dead his grandfather, Joseph McCloskey, at his home in the New Lodge area of north Belfast. The young boy, also called Joseph, walks ahead of the cortege. Who knows what goes through children's minds? At the wake, a friend of his grandfather had said, 'I wonder who'll be next,' only to be shot dead a few days later by loyalists.

DECOMMISSIONING

May 2000

The IRA announced it was going to decommission weapons. It was a historic move, and everyone wanted to photograph Sinn Féin president Gerry Adams. He was going to be at a west Belfast social club. While waiting, I noticed these two boys playing with a toy gun and concentrated on them. Just as Adams arrived in the background, one boy reached to take the gun from his playmate. There was a certain symbolism.

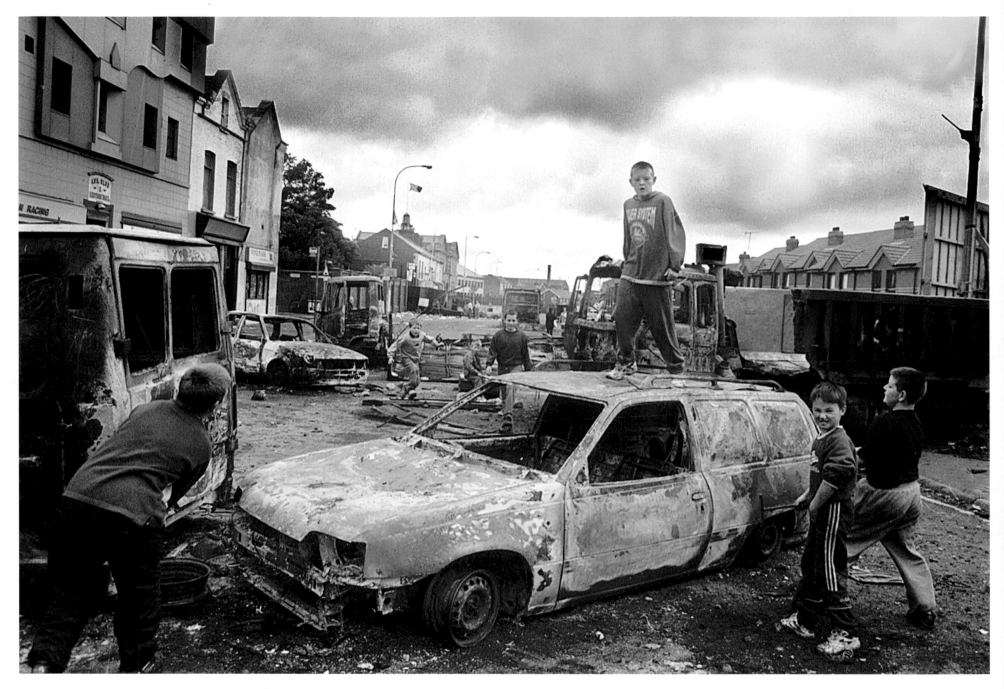

A PLAYGROUND WITH A DIFFERENCE
June 1995
The aftermath of a riot on the Falls Road. When a soldier was freed from jail, this was the response – every few yards there was the debris of a burnt car or lorry. It looks more like Beirut than Belfast.

FACE IN THE CROWD
December 2000
A horrific number of people have been killed by so-called 'joyriders', and this was an anti-car-crime rally in north Belfast. It was held following the deaths of a mother and son, knocked down by a stolen car just before Christmas. I noticed this young lad in the crowd. He seemed older than his years.

A guy in a three-piece suit would interest no one. Someone who had a beard, features etched by painful experience, straining against the wind made a much better subject. It was as simple and as complicated as that.

CHAPTER 5: EVERYDAY LIFE

The character of everyday life is a fascination of mine. There is an otherworldly quality to ordinary things I've always wanted to be able to capture on film. Through experience I've realised it is often the most mundane image which holds most value for people; a park they once played in, the street where they were born and images, however bland, of people they know.

I took a picture once of children swinging from a street lamp. That's something you don't see much of now. Maybe there are other sources of amusement today beyond an old bit of rope and the street. Maybe new lampposts aren't as user-friendly for youngsters. It used to be a common game in Belfast and I'm sure in other places as well. A rope would be tied to the post and for hours kids would swing around in decreasing circles. I took this photograph of two children swinging round a lamp in a city street and as it developed I noticed, for the first time, a car in the background. At the time I cursed myself for not spotting the car – it made the picture look awfully modern for me, devaluing it as a record. Now, fifteen years later, it is the car that looks old-fashioned and dates the picture – an example of how the mundane can become interesting with the passage of years.

The picture was what I like to think of as a 'stand-alone' – an image that, on a quiet news day, is strong enough to be used by itself, because it gives a little snapshot of life. Slightly more 'arty' in content these pictures may be, but I began taking them for one reason and one reason only. When I first worked for the *Irish News*, it didn't have a wire machine to receive pictures from elsewhere. On quiet days, which did occasionally happen even in Belfast, subeditors would demand pictures to fill space. I would go out and simply photograph what was in front of me – people going about their daily business. At one stage John Foster, an imaginative senior subeditor, created a space called 'Murphy's Eye'. For a couple of years, stand-alones appeared under that title every Saturday.

As a photographer, I am always looking for the character in people. I once received a letter from a postgraduate student who wanted to interview me. I had taken some pictures of people who were sleeping rough, and this student felt I was some wonderful left-wing photographer who wanted to portray the hardship of the Belfast poor. Dearly I would have loved to be able to say she was right, that I had a high vocation, or that deep down maybe my battle with alcoholism had prompted me to picture what I might have become. Instead my reply was more candid. I took pictures of people who interested me, I wrote. A guy in a three-piece suit would interest no one. Someone who had a beard, features etched by painful experience, straining against the wind made a much better subject. It was as simple and as complicated as that.

A picture I took of one character probably became better known than any other, yet it was never published in any newspaper. It was simply a moment of inspiration. If things were ever slow in the photographic studio I'd peer out through the window, observing life unfold. Patterns of the local community became as familiar as the schedules of the buses that pulled up at the stop outside. I would see people going to the shops around the same time each day and could set my watch to children's chatter as they made their way to and from school. More intently than any of these, I would watch a great man passing. He was Joe Tomelty.

BBC Radio Ulster listeners of a certain vintage will remember Joe Tomelty from 'The McCooey's' – the most popular local radio soap ever. He was, however, much more than that to the people of the Falls. He was a theatre manager, a playwright, a novelist and a sublime actor, who appeared in a host of films alongside the likes of Ava Gardner, Gregory Peck and Charles Laughton.

And every day Joe Tomelty, this great man, would walk by our studio door. I had taken his picture a few times while working for newspapers. Eventually Tom and I excused ourselves as he passed. 'Joe, would you mind if we took your portrait?' An absolute gentleman, he agreed on the spot and accompanied me into the studio. We chatted and, as we talked, I took a few pictures. When I developed the prints I was pleased at the way they turned out. With such a rich subject it would have been difficult to take a bad picture. I sent a few prints up to the man himself. Then I was struck by more inspiration. I had one negative printed onto a twenty-by-sixteen canvas. It looked spectacular. The shock of grey hair and craggy features of the Falls's favourite adopted son were unmistakable. The portrait was given pride of place in the front window. It was the best advertisement the studio could ever have had.

People would stare from buses and black taxis, mothers would point it out to their youngsters and older folk would refer to it as they stood gossiping. Oscar Studios was on the map.

Soon after this, though, I noticed that Joe was no longer passing by the front door. I watched him for two weeks, studying his route more intently than before. It might have become a preoccupation, but it was not my imagination. He was crossing the road well above Oscar Studios and recrossing again well below. He was avoiding my front door. To me he looked almost furtive.

It dawned on me that he did not like the picture. This troubled me, and I resolved to approach him again. Braving both the black taxis and Joe Tomelty's wrath, I ran across to the far side of the road as he walked past. There was no beating around the bush. 'Did you not like the portrait, Mr Tomelty? I couldn't help but notice you're not walking past the front door any more.' His eyes twinkled as, to my relief, he smiled. 'Ah son,' he said, touching my arm to reassure me, 'I can't. Sure if I did, people would only think I was walking past to look at my picture.' True simplicity, true humility, true greatness – in everyday life.

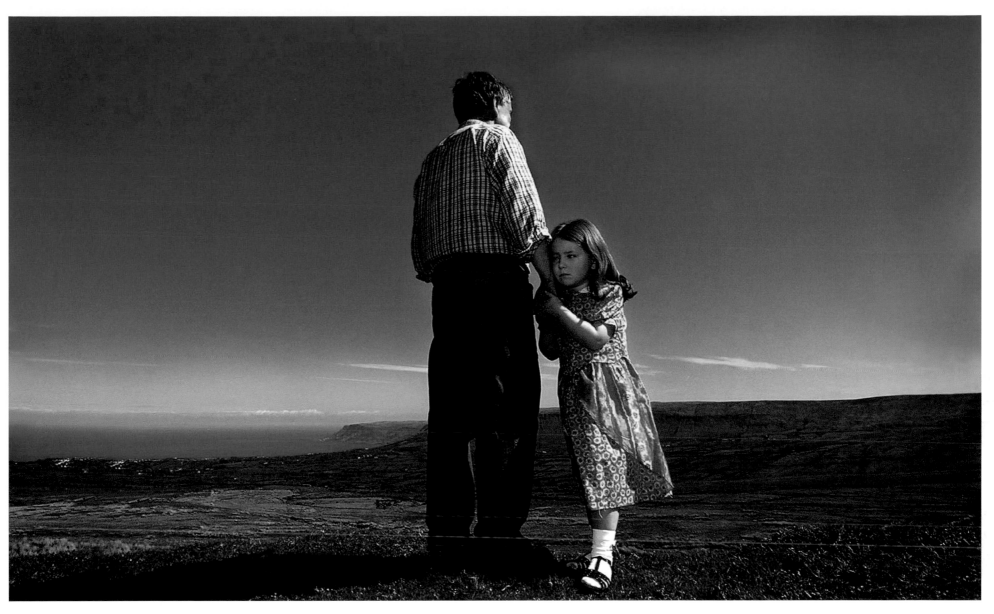

THE SILENCE OF THE LAMBS

June 2001

A hill farmer and local councillor, Oliver McMullan, surveys his land following the foot-and-mouth outbreak. With him is his daughter Aime. All the animals in the glen had been culled – 25,000 in a one-square-kilometre area.

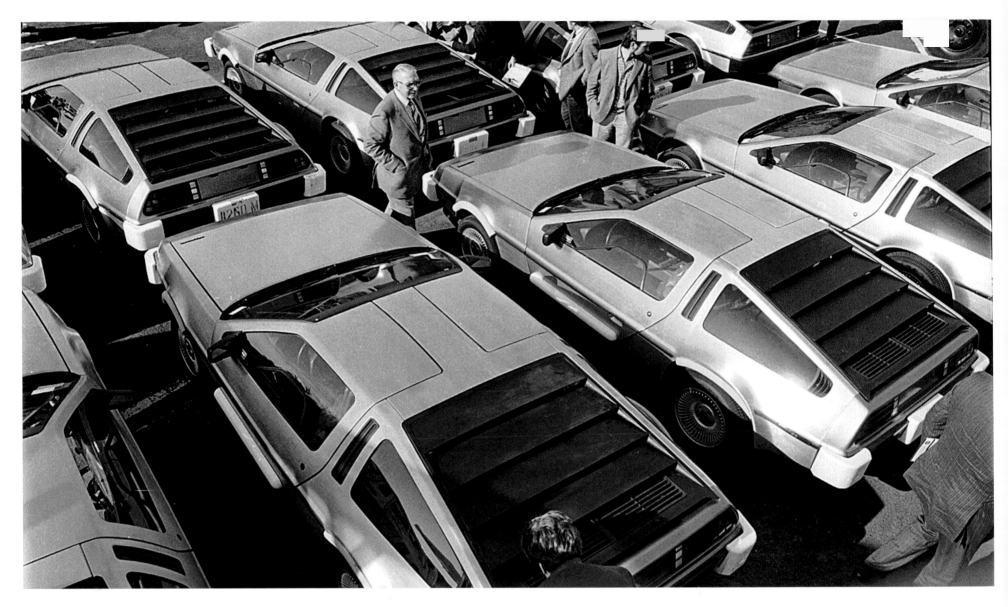

BACK TO THE FUTURE

September 1982

John DeLorean arrived with the promise of creating a world-class sports car. In a way, I suppose he succeeded. When the dream turned into a nightmare, this was the final sell-off of the factory models from the Dunmurry plant. Now they are much sought-after, so these would-be buyers might not have been as crazy as they seemed at the time.

TEDDY BOY REVIVAL

June 1978
Throughout the Troubles, young people continued with their lives. On this particular night, a rock 'n' roll band, Flint, took the stage in the Lake Glen Hotel in Andersonstown.

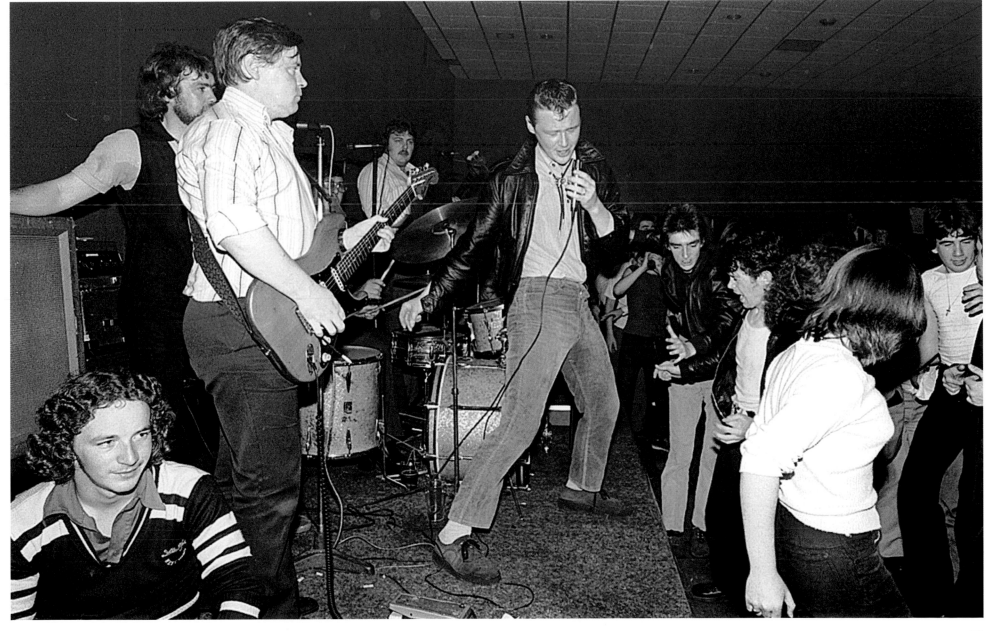

I COULD HAVE DANCED ALL NIGHT

May 1994

They were dancing a waltz. It was the Northern Ireland Ballroom
Championship at Belfast City Hall, part of that year's festival.

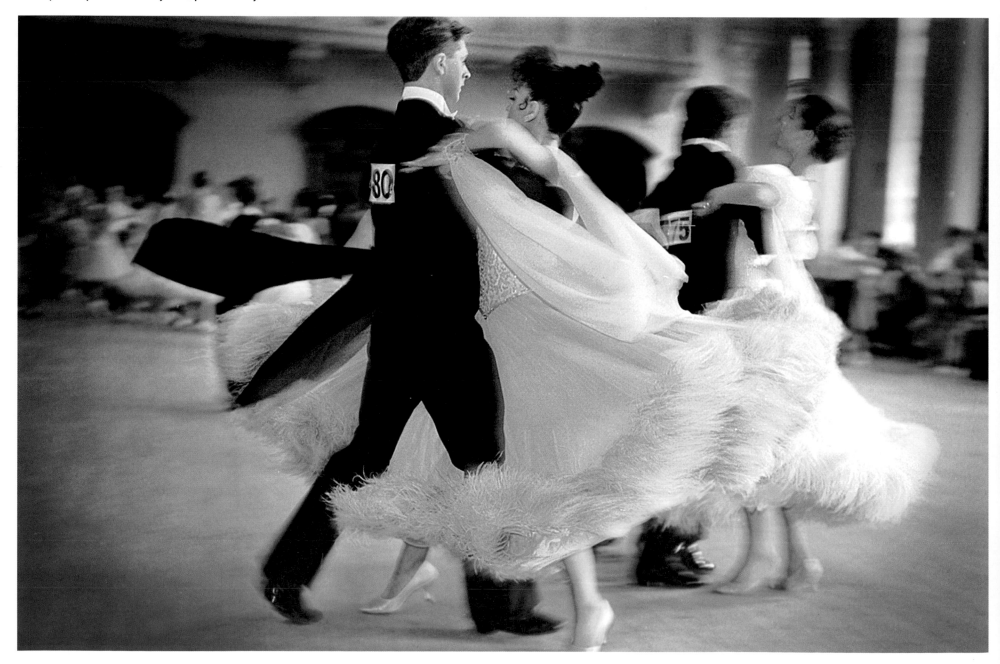

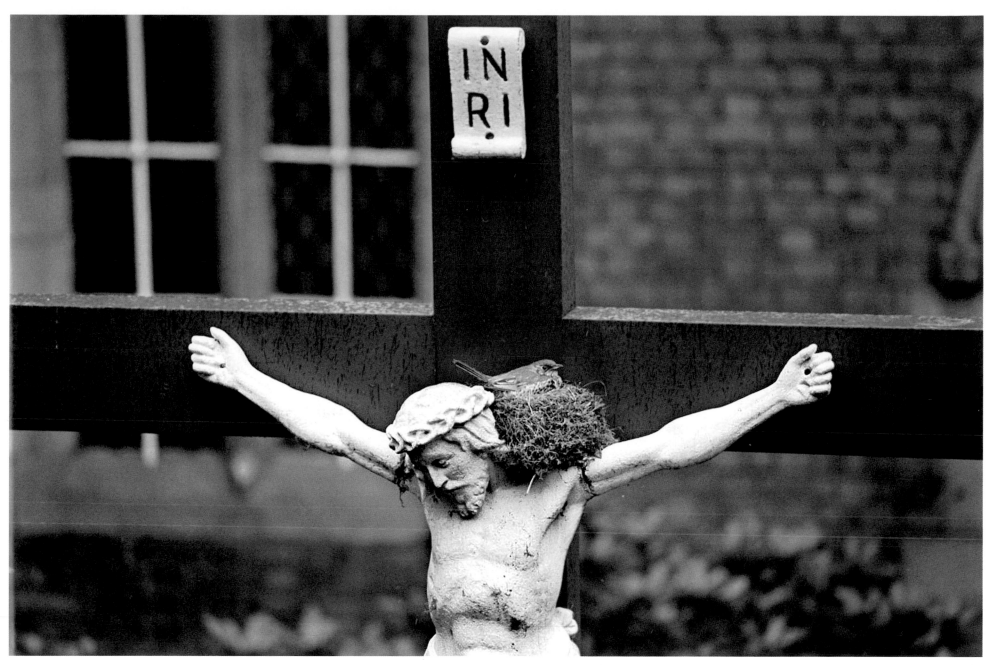

EVEN THE BIRDS OF THE AIR ...

March 1988

An Easter picture – someone tipped me off about this unusual nesting place in the grounds of a convent.

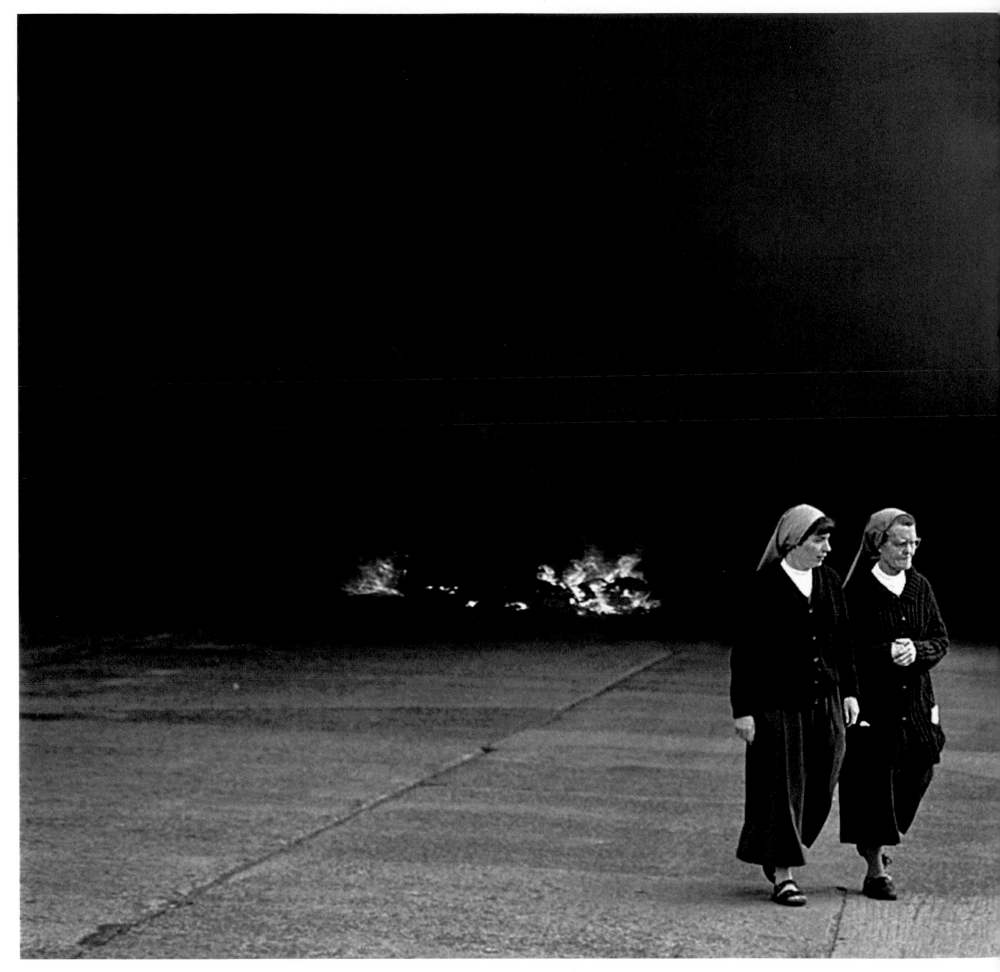

A NUN'S STORY

August 1988

Rioters burned dozens of cars and lorries when an IRA man was extradited from Dublin to Belfast. These nuns, well used to such scenes, were going about their business in Clonard Street, off the Falls Road, seemingly oblivious to the thick black smoke and flames behind them.

WHEN APPLES STILL GROW IN DECEMBER

December 2000

I actually took this picture in my garden. The climate seemed so confused that year, with balmy days in winter and flash floods in summer. The combination of the robin and snow and the apple on the tree seemed to sum up the bizarre environmental changes.

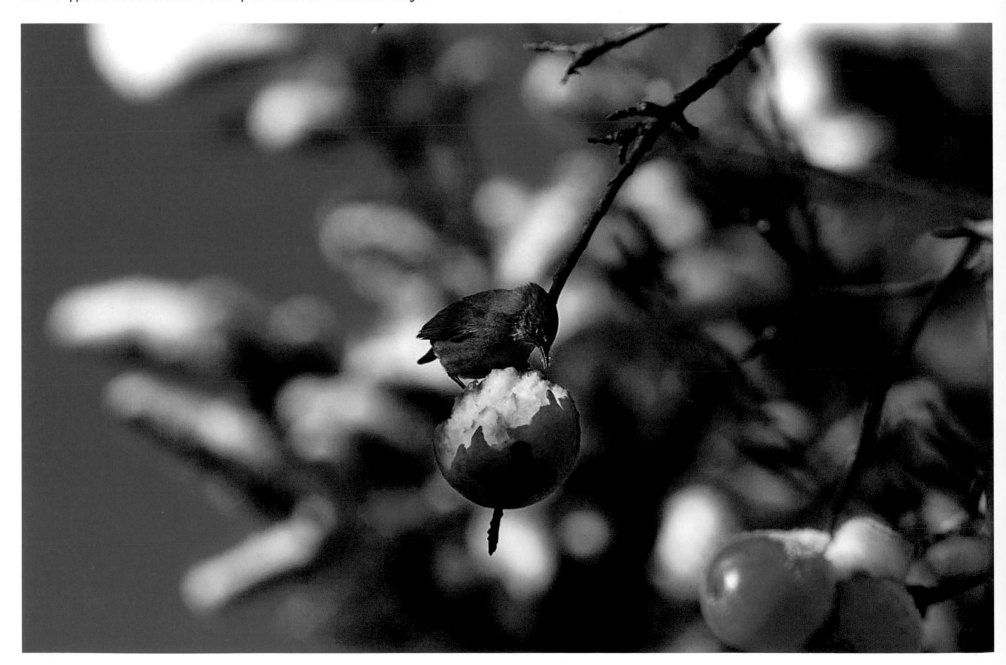

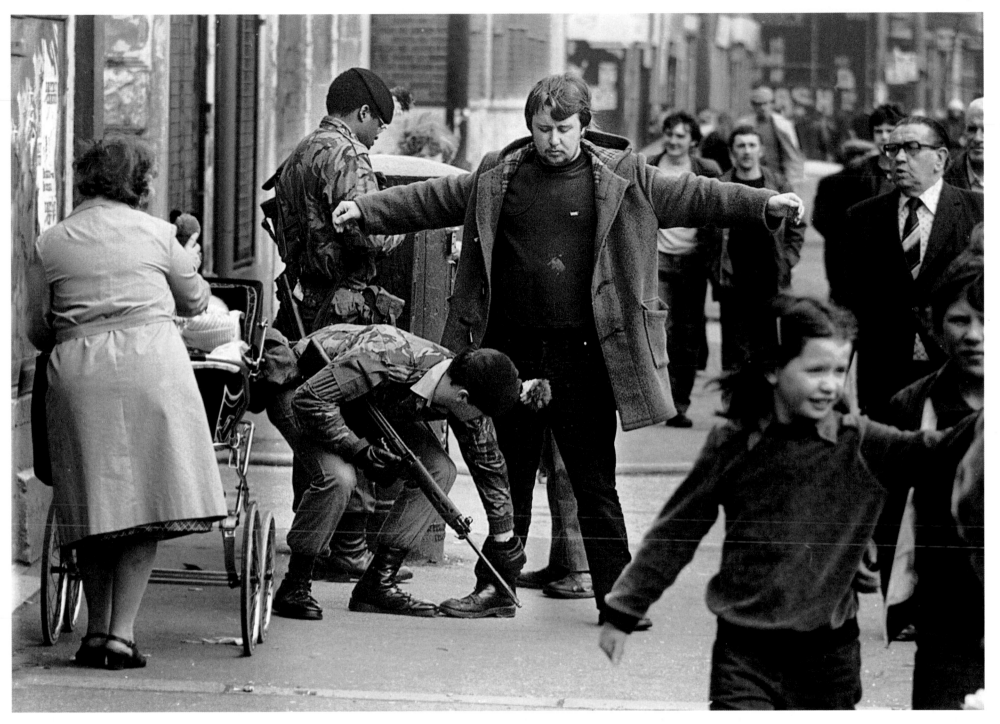

SEARCH

April 1984

Often the most seemingly mundane pictures are later those which tell most about a period. This was an everyday scene in Belfast – a man being searched on the Falls Road – but what strikes me now is the way people continued going about their business, hardly seeming to register the fact that it was happening.

WHAT'S ON THE MENU?
November 2000

A lot of *Irish News* staff patronise Paul's Café in Donegall Street. I was having a cup of tea when I noticed this woman peering through the window. The colours struck me as being like those of an American diner from the 1950s, so I fired off a frame.

GRAVEYARD HUMOUR

September 2000

Someone tipped me off about the location – Clifton Street Cemetery, one of the oldest graveyards in Belfast, just a few hundred yards away from the *Irish News* office. Whoever did it took pride in their work. It was typical of the city's black graveyard humour.

There was nowhere to go. I tried to get comfortable, taking a couple of pictures out of bravado. I kept my head down, and had time to reflect on the words of Cyril Cain, one of the classiest photographers in Belfast. 'Only Houdini catches bullets in his teeth,' he had said.

CHAPTER 6: 'HARD NEWS'

I walked into Divis Flats, but I crawled out on my belly. Bullets lifted chunks out of the ground around me and pinged off the balconies. I got one mediocre picture.

It was 1975. I was in the *Daily Mirror* office when we got a call that there was shooting in Divis. I knew the area well. My bar had been flattened to make way for the flats. Some streets were still standing, and I knew how to navigate my way without venturing on to the main Falls Road. I left my car and walked towards the flats – hexagonal slums-to-be, surrounding a rectangular block that towered over everything. There was some shooting, but it was far off, from the direction of Ballymurphy.

The balconies were quiet. Someone recognised me and warned me to be careful, explaining that an initial encounter between the IRA and loyalists on the other side of the peaceline had turned into a three-way gun battle involving the army. I was pointed to one balcony where, I was told, a man had been shot.

I climbed a stairwell to discover a wounded man being bandaged. He had been hit in the arm. As I lifted the camera to take a picture, a woman shouted, 'Get that f***ing photographer out of here.' Suddenly those who had been tending to the wounded man seemed to want to tend to me. I didn't have time to marvel at the fickle nature of the crowd – one day it would be, 'Show the world what's happening here,' and the next, 'Yer man's trying to take a photograph, get him.' I got a couple of frames. As I was jostled, there was a burst of gunfire. We could hear the 'thunk' of the bullets hitting, somewhere close overhead. Everyone went flat.

Bizarrely grateful for the distraction, I retreated down the stairwell. At the bottom I stopped. I had a choice – I was pretty sure I had a picture of a wounded man. It wasn't great by any means, but would keep the picture desk happy. If I stayed put, there was no way of telling how long it would take to get out. On the other hand, a quick run across some open ground to neighbouring streets would get me back to the car. From there, I knew a route I could drive that would not expose me to any real danger. There was a lull. It seemed worth the risk.

Neither quite walking nor quite running, moving half crouched, I began my bid for safety. I could not have been more wrong. 'Wham, thunk! Wham, thunk! Wham, thunk!' in quick succession. In the fraction of a second between each round it was as if my brain raced faster than a motor drive. 'Wham, thunk!' I couldn't see a thing. 'Wham, thunk!' They were close. 'Wham, thunk!' At least I could hear the shots – I'd always been told you wouldn't hear the shot that killed you.

I dived behind a huge stone bollard that had been placed to prevent car bombs being driven into the area. In my mind it was a cat-like movement,

reminiscent of one of my silver-screen idols. 'Keep down, you eedjit,' someone shouted from the cover of another stairwell. 'They're on top of the mill.' It was sage advice. Andrews Flour Mill overlooked Albert Street and the area around St. Peter's Pro Cathedral. Many of its workers once drank in my bar. Now, it seemed, someone was using it as a sniping position. A sub-machine gun chattered back nearby.

For the next two hours I stayed behind the rock, getting to know well its every grain and contour. I promised God if He'd just get me out of this one I'd live a good life. Bullets kicked up the ground around me. By the sounds of the various guns, I slowly identified positions from where I thought people might be firing. The sub-machine gun owner seemed to be at the corner of a street just beyond my view. Every so often he'd make a contribution. At least four, possibly more, riflemen were moving about on the ground and on the balconies. Those weapons had a hell of a roar. Every so often there was the crack or pop of pistols.

There was nowhere to go. I tried to get comfortable, taking a couple of pictures out of bravado. I kept my head down, and had time to reflect on the words of Cyril Cain, one of the classiest photographers in Belfast. 'Only Houdini catches bullets in his teeth,' he had said.

Eventually, during a lull, I made a move, crawling quickly across the waste ground. As I reached its edge there was another machine gun burst nearby. I got up and ran to the cover of a wall, the ground sucking up every step as the soldiers this time returned fire. Was it my imagination or did the earth shake? I don't know how close any of those bullets came. I don't want to know.

It took me four hours to get back to the office. 'Where have you been?' was the first question when I walked through the door. 'What have you got?' was the second. I waited for the roll to be developed. There was one badly composed picture of the man being bandaged. It made the front pages – there

must not have been much else going on. Also on the roll were a couple of low-level shots of the patch of waste ground. I took the pictures because, when my life seemed dependent on the thickness of a rock, I had wanted to record the moment. To call those few frames nondescript would have been generous. A staffer eyed me curiously. 'Not much in that then,' was his verdict.

He was right. To anyone but me those pictures meant nothing. Provisional and Official IRA members, I found out later, had jointly taken part in one of the biggest gun battles for many years in the city. I was scared, but I learnt an important lesson that day about hard news: Covering a gun battle with a stills camera is like fishing for shark with a safety pin. Wounded people make hard news pictures. That's an unfortunate fact. The actual moment of them getting wounded in a gun battle, however, more often than not looks like damn all to a stills photographer.

A television cameraman, in Divis that day, won an award for his coverage. The sound of the shooting was vivid and sharp, and there was drama in every jerky movement. It's rare that a picture of people being shot or shooting makes a powerful still image. The people who take those photos are rarer still. They are hard news photographers of unique genius, courage and quality.

I am a press photographer and in my twenty-five or more years only once have I taken a picture of someone firing a gun in anger. The context? Within days an Orange march was due to pass along the Ormeau Road in south Belfast past nationalist streets. In previous years, to allow the marches to go by, a large number of police prevented residents leaving those streets. On one notorious occasion those taking part in a parade gestured as they passed a betting shop where loyalists had killed five Catholics from the district. This time, a few days ahead of the proposed parade, objectors organised a protest rally. Tension in the area was palpable. Reporters, cameramen and photographers were there

to cover the protest. They stood around in small groups speculating among themselves and sounding out locals.

I chatted with a reporter. Behind her, across the road, something attracted my attention. I noticed a man walk from an entry and saunter towards the corner. But it was neither his gait nor the fact even he was masked that drew my attention so much as the rifle carried by his side.

For a moment you think this isn't happening, that it's a game. Then everything happens at once. Time accelerates in strange slow motion. The man raised the rifle and started firing. The reporter I was talking to remained still but just about everyone else hit the deck. I don't know where they came from – there were a couple of shouts. I fumbled for a camera as I tried to make myself small. The gunfire clattered round the streets like a metronome gone crazy. He fired off about six to eight shots. I fired off one. You can't tell from my picture that he was actually firing but he was. He strolled away, back to the entry. I could hear a heart beating and became aware it was my own.

The police were all over the scene in moments. The gunman was long gone. One alert BBC television cameraman had caught the gunman running away, and the moving pictures were beamed around the world. More importantly, they were seen at the other end of the Ormeau Road. Within hours the Chief Constable told the Orange Order he couldn't guarantee their safety. They called off the parade. The IRA announced a new ceasefire within weeks. In this respect, the man I had photographed was the IRA's last gunman.

The split-second of pressing the button was like a flashback to the gun battle of the earlier generation. I was older – I'd like to think wiser – but it was just as scary. Afterwards, my mouth was dry in the exact same way, due to the exact same fear. I was pleased that this time I had been able to get something, the luck of at least having the right angle to safely take a picture. Somehow I was still lying between that rock and hard place in Divis, a quarter-century earlier. The decisions about where you go when the streets of Belfast are your workplace never get much easier. There's a reason why it's called 'hard news'.

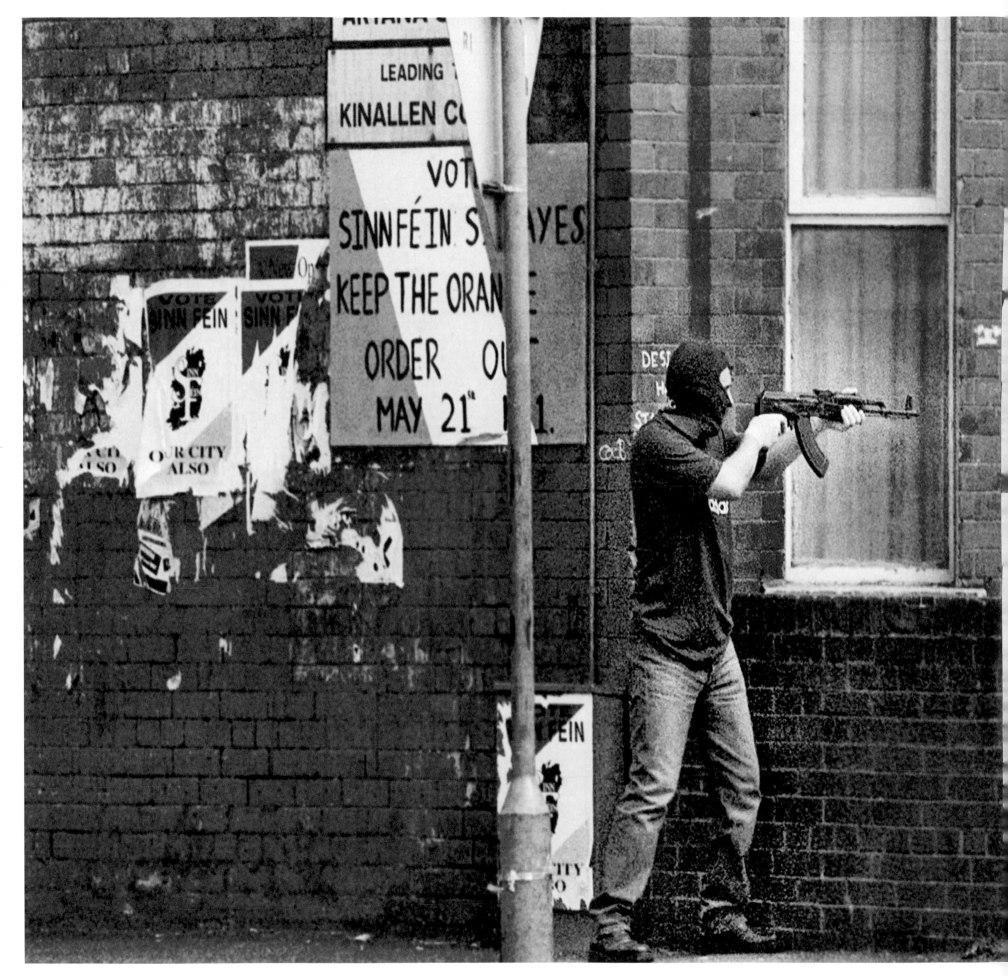

THE LAST GUNMAN

July 1997

An IRA man in the nationalist lower Ormeau area fires at police manning a roadblock on the bridge across the River Lagan. Everyone dived for cover. The gunman was the coolest person there. No one was injured. Within weeks, the IRA declared its second ceasefire.

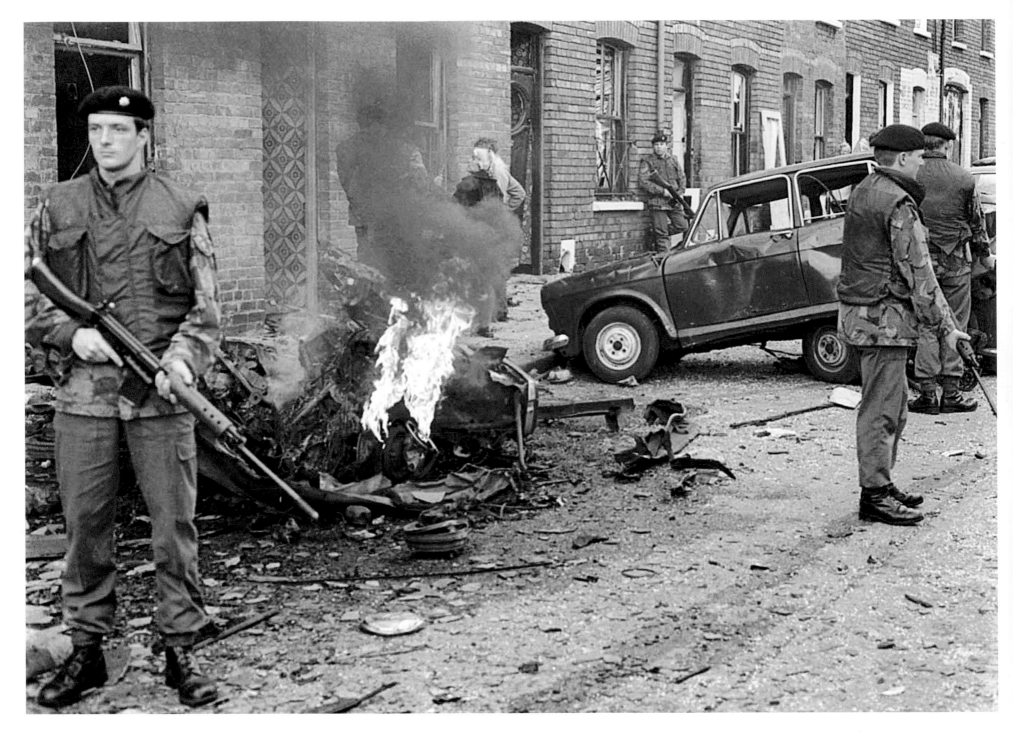

EXPLOSION, DUNLEWEY STREET
August 1975
A bomb in a car exploded in a tiny street off the Falls. It was a miracle no one was badly injured. Houses all around were wrecked, yet within minutes people were out boarding up windows and clearing the debris.

CITY-CENTRE BOMB
January 1977

The aftermath of an explosion at Queen Street. Getting to the scene was difficult. I had to climb through a building site. Another night when a bomb went off, I looked up to see the engine of a car dangling precariously about seventy feet above me from a shattered gantry.

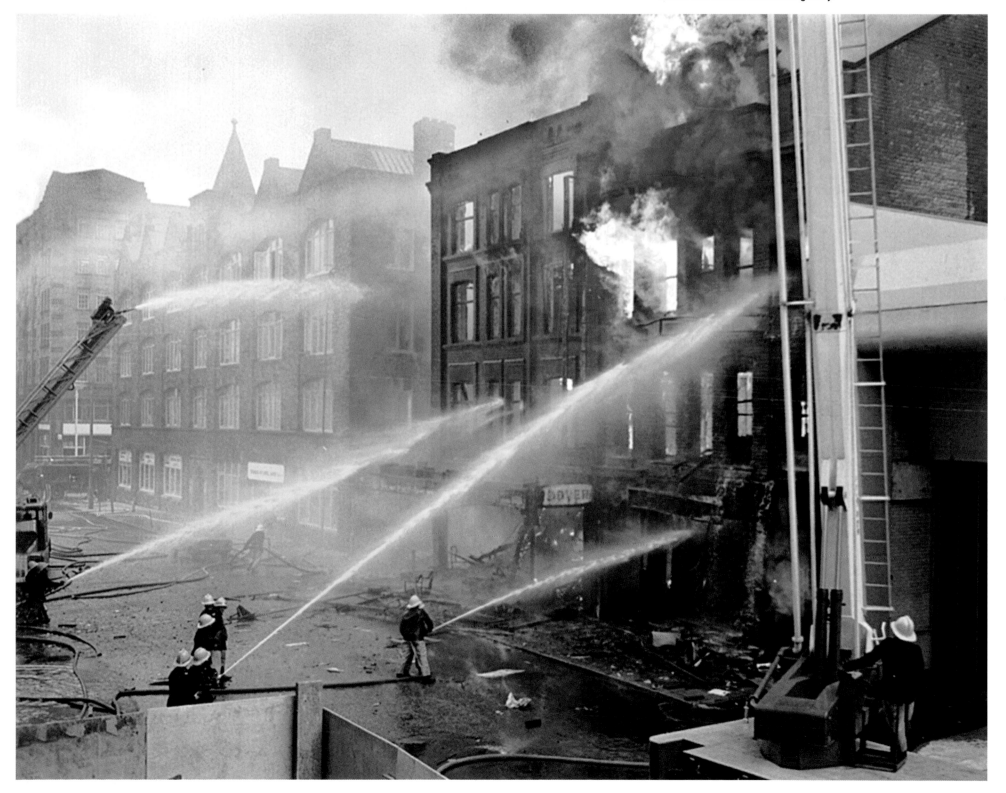

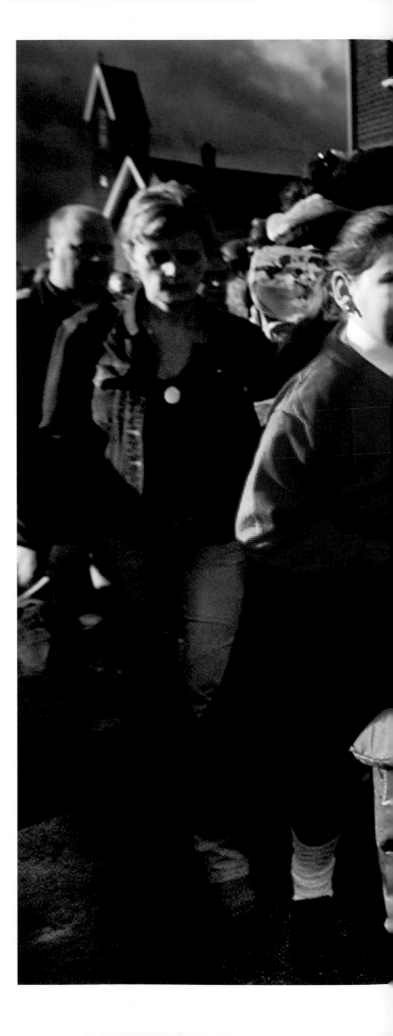

FIRST DAY BACK

September 2001

Children at Holy Cross Girls' Primary School were the focus for a loyalist
protest. Protestants claimed they'd been unable to go to nearby shops,
and retaliated by barracking girls going to the north Belfast primary.
This was the girls' first day back to school. They were terrified. At the
height of the protest, loyalists, who had been shouting abuse, turned their
backs. Only one man faced the children. He was blind; a bizarre moment.

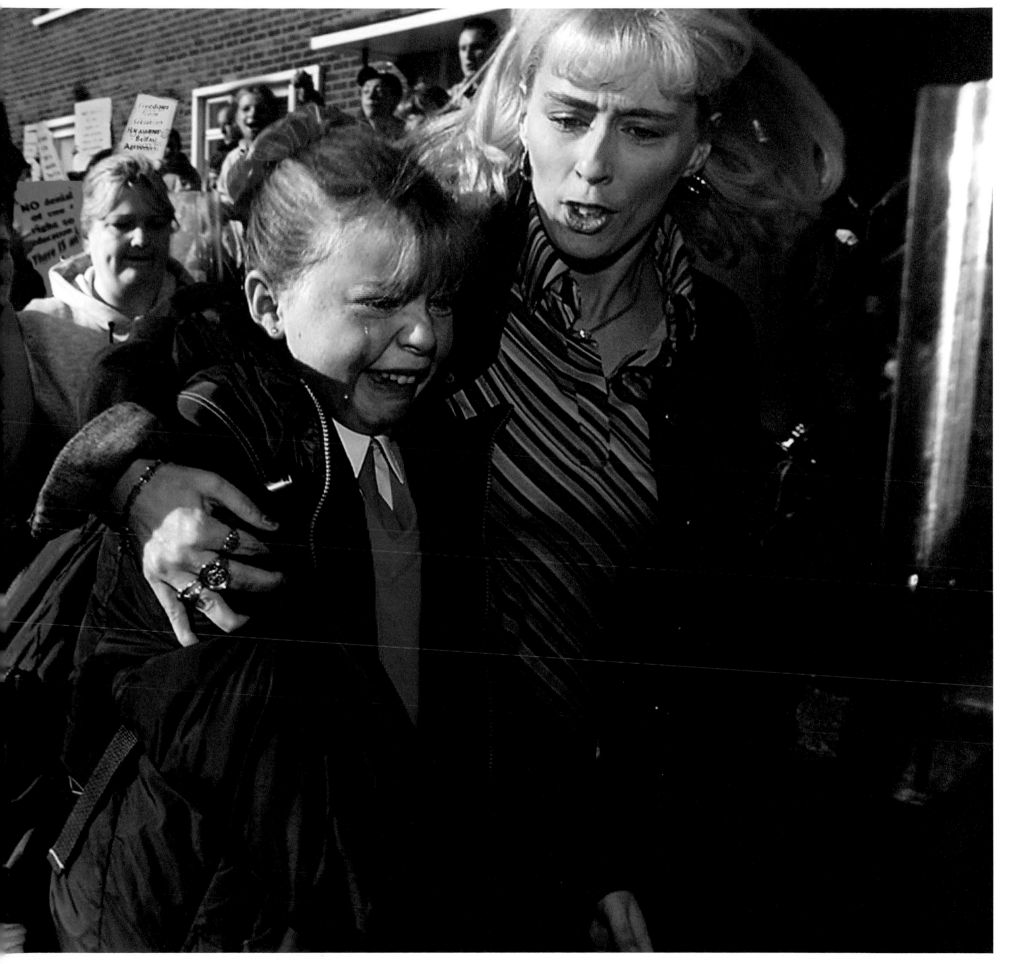

BOMB SUSPECTS

July 1987

There were bombs all over Belfast. Police had arrested these men near the city centre. I was driving to work and came upon the scene. Viewfinders on the old cameras go darker the further away you are from the subject and the longer the lens. This was so far away that the viewfinder was totally black.

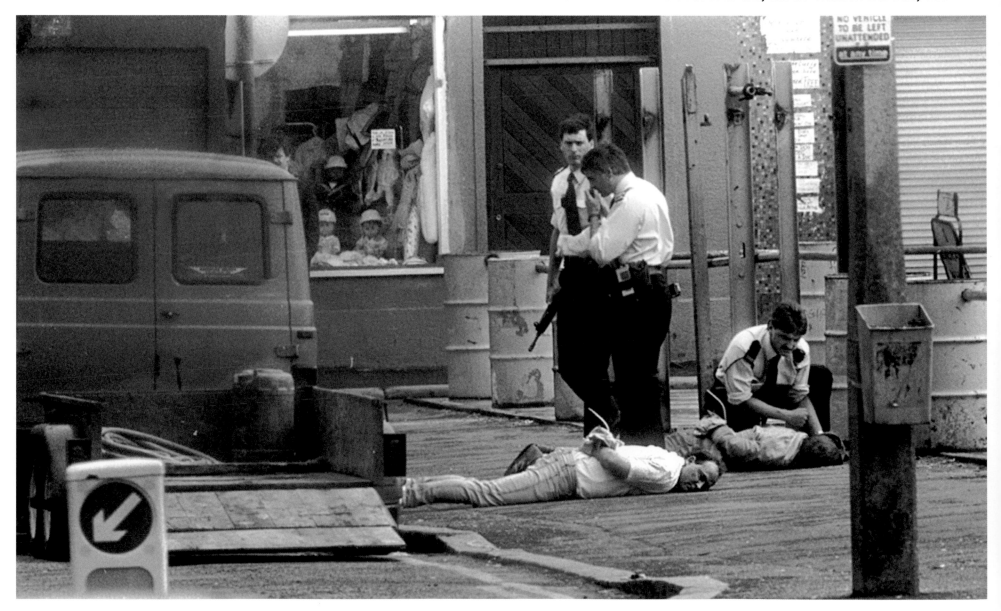

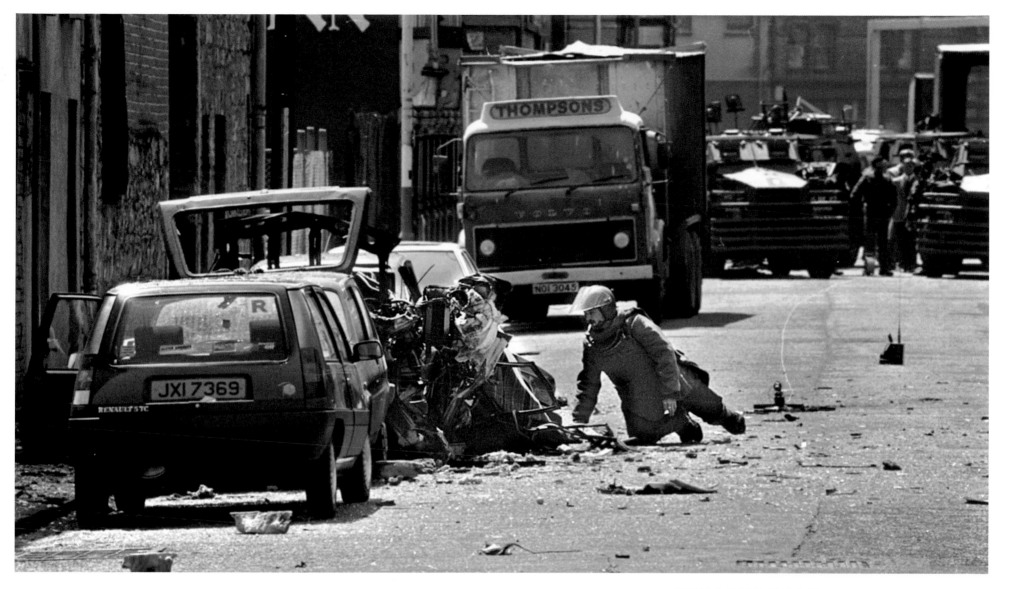

THE LONG WALK
June 1987

I've known even hardened republicans who have a sneaking admiration for the courage of the bomb squad. Soldiers describe approaching a suspect device as 'the long walk'. This guy was out there all by himself in the aftermath of a booby trap explosion. There was still a body in the car.

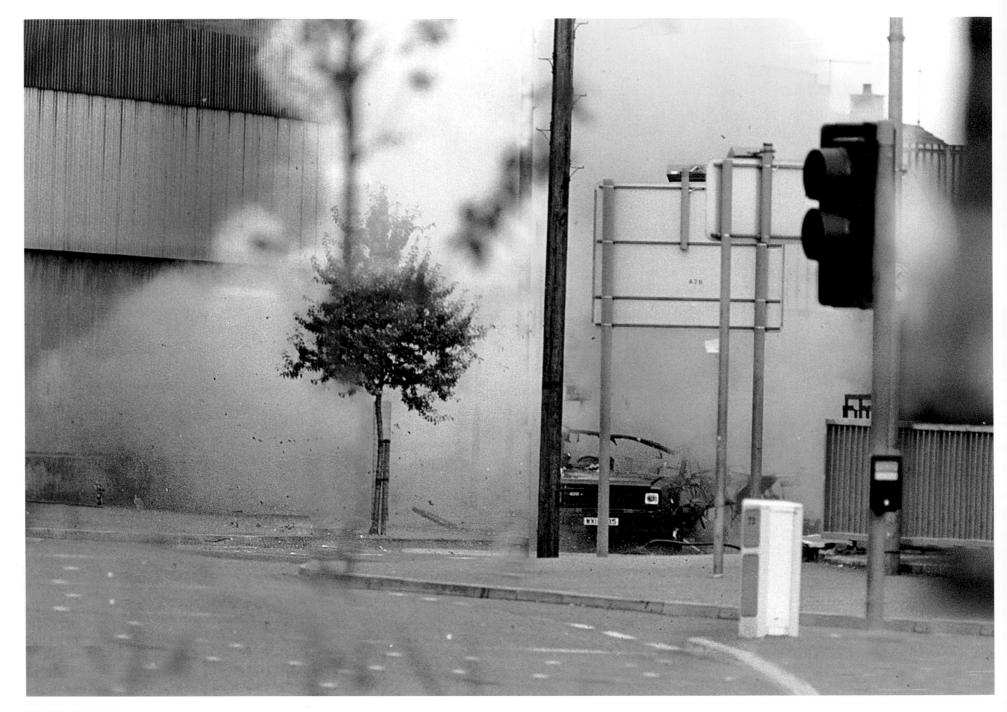

EXPLOSION

August 1993

This picture shows a bomb as it explodes, leaves shaking from a little tree as the blast hits. It's a picture that almost cost me my life. I was far too close. A policewoman had tried to move me but I ignored her, almost to my cost. The bomb exploded soon after I arrived. Shrapnel landed all around me and a big jagged shard of metal took a chunk out of the road just two feet in front of me.

THE SCHOOL RUN

September 2001

I spent several weeks in Ardoyne covering the Holy Cross protest and its impact. On the third day of the protest, a blast bomb was thrown towards the children as their parents and riot police escorted them to school. The fear was very real.

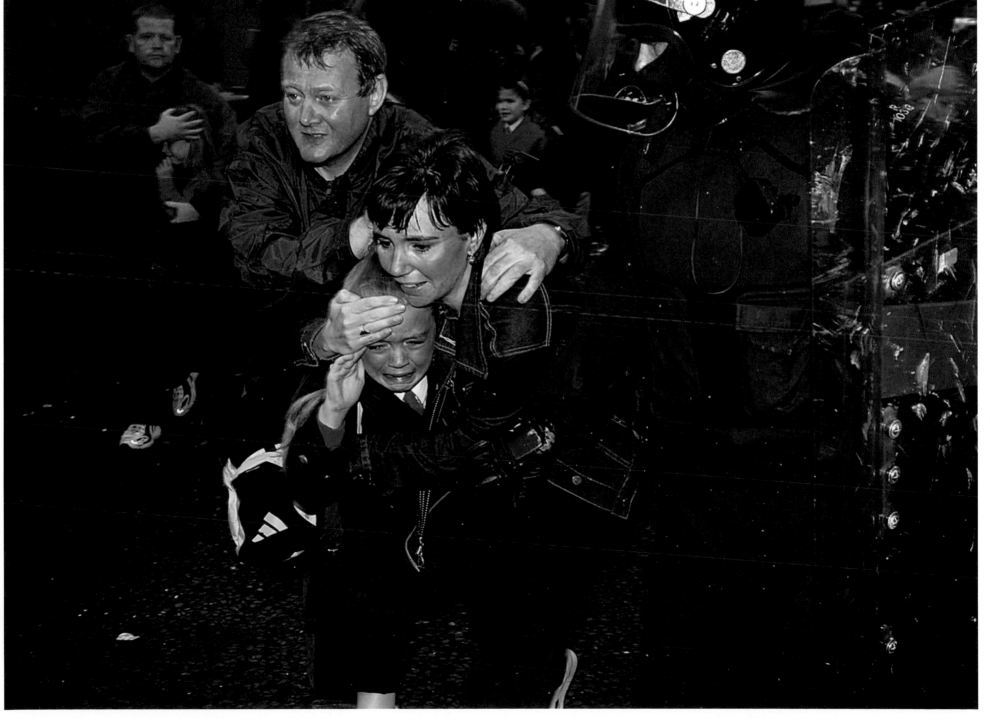

We stopped just on the other side of a hedge. There I took the picture of the former Stormont Prime Minister, in a linen jacket in the back garden of the family home he was about to leave. To me he had an air of quiet despair, like a king exiled from some eastern European state.

CHAPTER 7: POLITICIANS

Politicians are a weird breed – almost as weird as journalists. The two professions are mutually reliant. Politicians rely on journalists to cover their comments, while journalists rely on politicians to give them their comments. Both are continually in the public eye, subject to endless scrutiny. Sometimes it all feels like a game, laughable if it wasn't such a risky business.

With a name like Brendan Murphy, you wouldn't be surprised to learn my background is nationalist and Catholic. Funnily enough, if I said I'd photographed Terry O'Neill, most people would think I'd taken a picture of someone with similar roots. No one, however, called this man Terry. He was Terence O'Neill, Lord O'Neill of the Maine, the foremost Unionist politician of his generation. I didn't quite know what to expect as I set off to take his picture at his County Antrim pile.

Lord O'Neill greeted the reporter accompanying me, offering us the hospitality of his home. A former prime minister of Northern Ireland, he was too liberal for some within his own community but not liberal enough for nationalists. In 1968 he had famously warned, 'Ulster stands at the crossroads,' and he was right about that. When I photographed him at his house near Ahoghill, he was standing at his own personal crossroads. By this stage the Troubles were well underway. He was leaving for England, resigned to having the worst of his vision come to pass.

From his family tree hung the Chichesters, English invaders who came to Ireland during the Plantation. His line was also that of the O'Neill's, High Kings of Gaelic Ulster. School, in its neutral nationalist way, had taught me all about these figures – the viciousness of the Chichesters, the heroism of the Gaelic chieftains. Their descendant was a little disappointing at first. There was no outward sign of the magnetism of the great men of his clan, nor did I note any particular savagery.

Like his predecessors, Captain O'Neill had a military bearing. His accent was cut glass and clipped, but there was also warmth, civility and humour. He belonged to an era when politicians did not have to be personable and could survive a lack of charisma. I liked them better then. On television Terence O'Neill was stiff and wooden. In the flesh I found him intelligent, sharp and, in the true sense of the word, witty. He and his wife offered us tea and sandwiches. Generous with his time, he seemed genuinely sad to be leaving.

'Would you like to take the photograph in the arboretum?' When he asked I quickly replied yes, that would be perfect. It was my attempt to conceal the fact that although I had been educated as to his ancestry, I had not a clue what an arboretum was – we didn't have many arboreta where I grew up in the Newington area of north Belfast, or in Albert Street where I'd run the bar. He offered me a pair of his Wellingtons, so I knew it must be outdoors.

I wondered where we were going as he led me out towards a tiny clump of trees in the back garden. 'Would this be okay?' he asked, probably sensing my uncertainty. We stopped just on the other side of a hedge. There I took the picture of the former Stormont prime minister, in a linen jacket in the back garden of the family home he was about to leave. To me he had an air of quiet despair, like a king exiled from some eastern European state. It was poignant.

Less poignant was the story when I read it in the *Sunday Press*. It recounted how Lord O'Neill had loaned me his Wellingtons, stating: 'Thus Brendan from the Falls has the dubious distinction of being able to claim he once stepped into the boots of O'Neill of Maine.' Reporters like their jokes.

I mention Lord O'Neill because he was one of the first unionist leaders I encountered as a working press photographer. It was an entirely pleasant experience, not at all what I might have anticipated.

I might have my own political views. They are not important. I have no special insight. They are no more valid than those of the next man. Certainly they were never there when I loaded film into a camera. I think most press photographers tend to judge politicians by the same criteria they apply to everything else – how easy will they be to picture and how amenable will they be to make that image. People like Lord O'Neill are a joy to photograph.

Few politicians are deliberately awkward with reporters. Still fewer are prickly with photographers. The closer to an election, the friendlier they become. In their eyes, of course, a prominent picture wouldn't do any harm but my own theory is that it is slightly more complicated. As polling day nears politicians develop a craving to sound out those they think are in the neutral corner. By that stage they've shaken so many hands on the doorstep that all potential voters merge into a big, unfathomable block. Their own teams, they feel, will tell them a measure of whatever they want to hear. They can't trust reporters – one gaffe and they could be finished. The photographer appears the least biased. By that stage politicians can

be too fraught to realise the reason is that it is often the photographer who is the most disinterested in their fate.

Coming up to elections, during talks or in debate, politicians can exhibit all the signs of pressure. I've never set out deliberately to take a picture of a candidate looking wild-eyed and crazy though in some images that's exactly the way they've turned out. The captured moment can be cruel, yet in all my years I've never had a politician complain. A couple have actually bought photographs of themselves that appeared in the paper. The same genes that make people stand for election must enable them to take the rough with the smooth.

I have had a spin doctor suggest I could take a better picture of a certain senior party figure. Spin doctors talk to reporters and set up press conferences at boring tables in boring rooms. They then wonder why their comrades look boring. I resisted the temptation to suggest that maybe the press conference could be held in the circus with the rest of the clowns and instead offered what I thought was a helpful suggestion. I will mention no names, but this particular senior figure can be less than animated. I suggested to the spin doctor that were the senior figure to make the odd gesture it would lead to a less boring picture.

Given what happened next I fancifully imagine these words were taken, chiselled on tablets and carried to the senior figure as directions to the promised land. To my absolute amazement about halfway through the press conference the senior figure began gesticulating frantically. Fingers were poked in the air to emphasise every point, hands were held wide apart to show the gulf in the chance for agreement, karate-chop movements illustrated how the impasse could be solved.

Photographers were caught unawares. They had never had so many picture opportunities of this politician. They couldn't help themselves. Motor drives went into overdrive. Kodak's profits rose that day. It was a costly marking. One photographer went

through nearly a dozen rolls. Others, myself included, used almost as many. As I left, I couldn't help but suspect that the senior figure, known for a peculiar sense of fun, had had the last laugh. It reminded me of that old analogy of reporters and politicians having the same relationship as dogs and lampposts. This was another day when I wasn't quite sure who was who.

AT THE CROSSROADS
August 1975
The former prime minister of Northern Ireland, Lord O'Neill of Maine, prepares to leave his home for London. Too liberal for many unionists, not liberal enough for many nationalists, I found Terence O'Neill a decent and broken man. He offered me a pair of wellingtons and we traipsed into a field for a last picture at his home, Glebe House.

RHYTHM OF TIME

November 1986

Sinn Féin were opening their new office and I noticed Gerry Adams giving a drink to a child he was holding. When this photograph appeared in the *Irish News*, I got into trouble. There were complaints that it put a human face on terrorism.

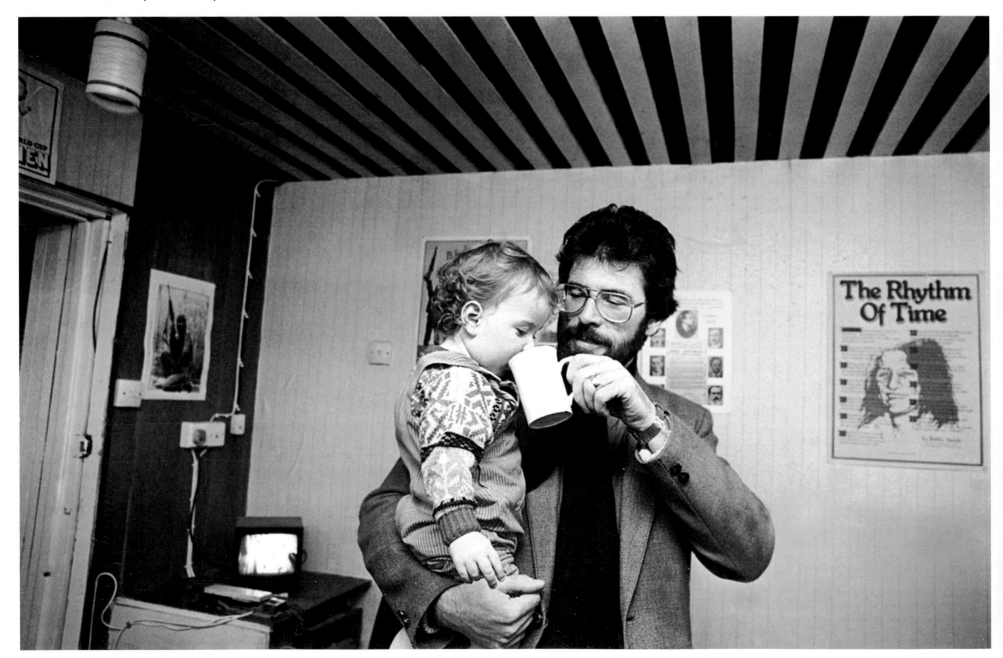

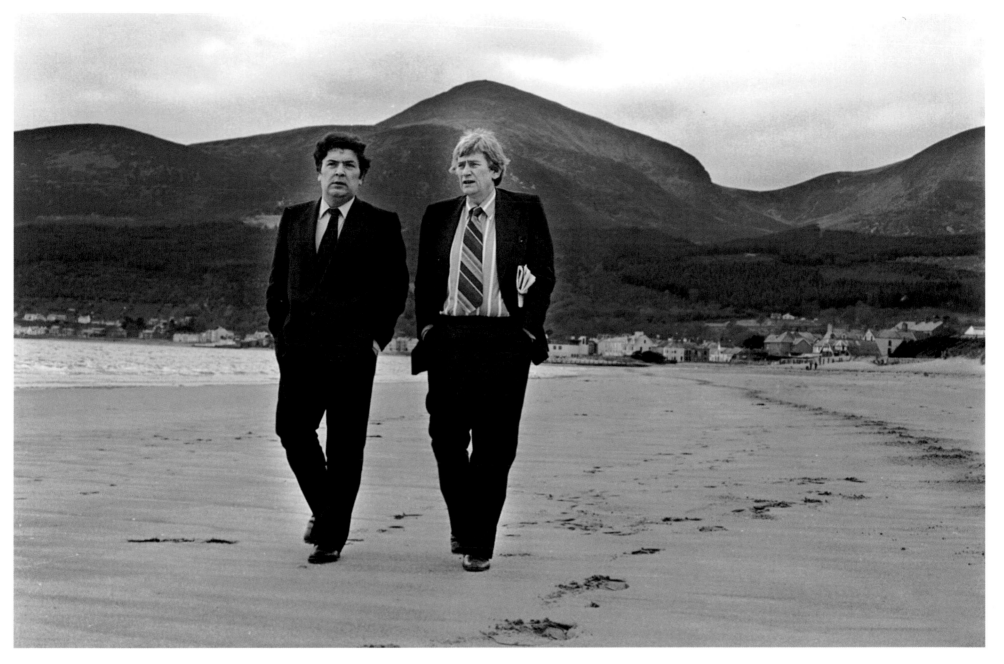

WHERE THE MOUNTAINS OF MOURNE ...
October 1980

SDLP leader John Hume and his deputy Seamus Mallon, out for a walk on Newcastle beach. A lot of the sand has gone from the beach now, replaced by stones. Hume, the Nobel prize winner, and Mallon, deputy first minister when the new power-sharing executive was first established at Stormont, have since taken something of a back seat. At the time this picture was taken they were the leading faces of northern nationalist politics.

IAN PAISLEY

June 2001

Unmistakable, even from behind, I have photographed the DUP leader so many times that on this occasion I tried something different. He was arriving at the general election Belfast count. His party won five seats in total.

PAINT-BOMBED

August 2000

SDLP councillor Margaret Walsh is one of those tireless political campaigners who soldier on through thick and thin. Her home has been targeted several times by loyalists – this was just one of a number of attacks. Despite her diminutive stature, she always manages to show pride and courage.

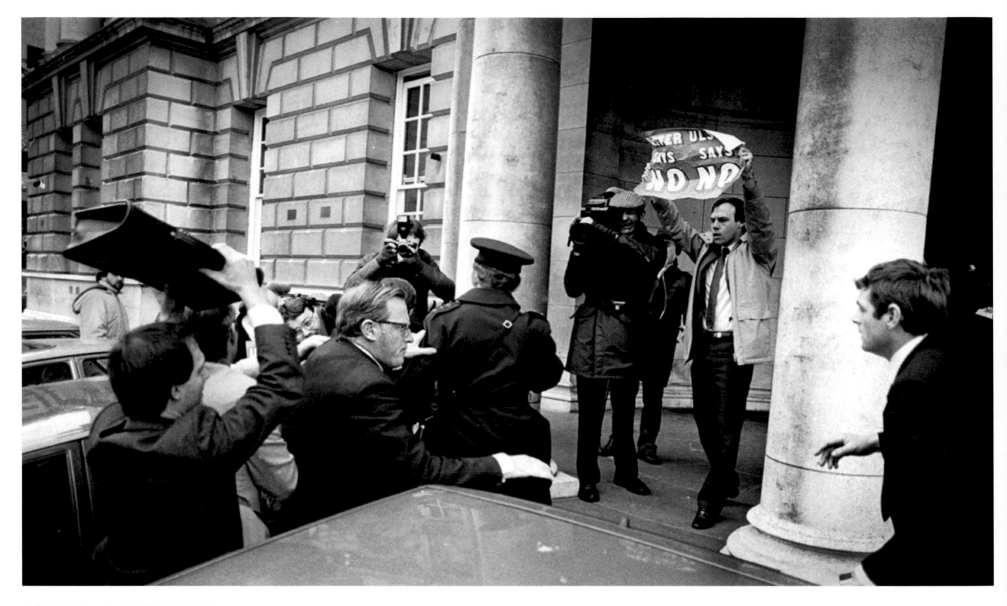

CITY HALL RECEPTION
November 1985

British secretary of state, Tom King, is greeted by anti-Anglo-Irish-Agreement
protestors outside Belfast City Hall. Holding the poster is Nigel Dodds, who
went on to become Lord Mayor and later MP for North Belfast.

GERRY ADAMS

September 1994

The Sinn Féin president speaks at a republican rally in the Short Strand district of east Belfast just days after the IRA called their ceasefire.

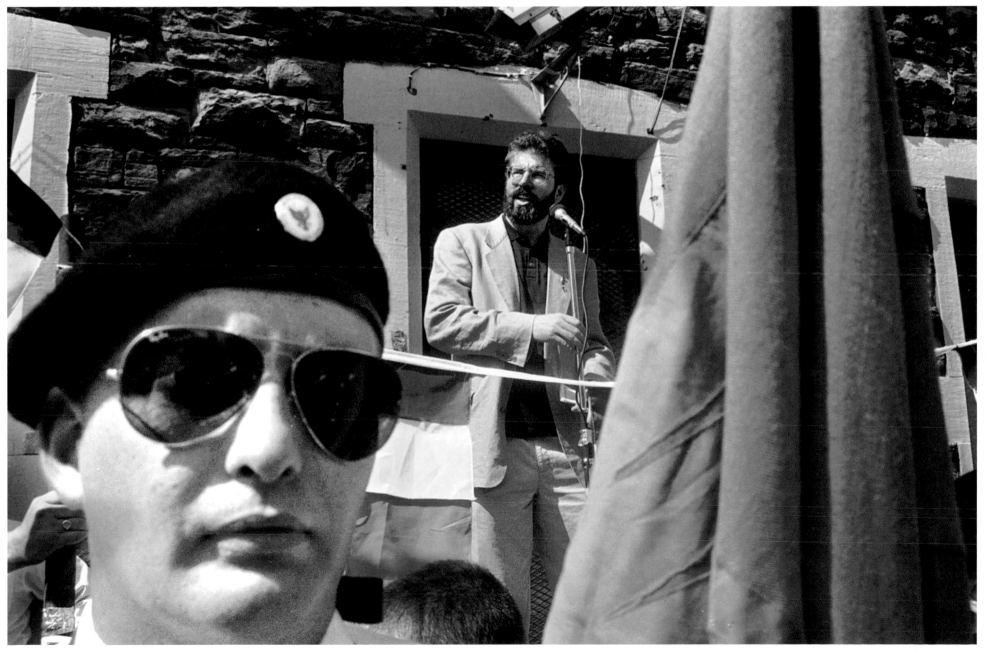

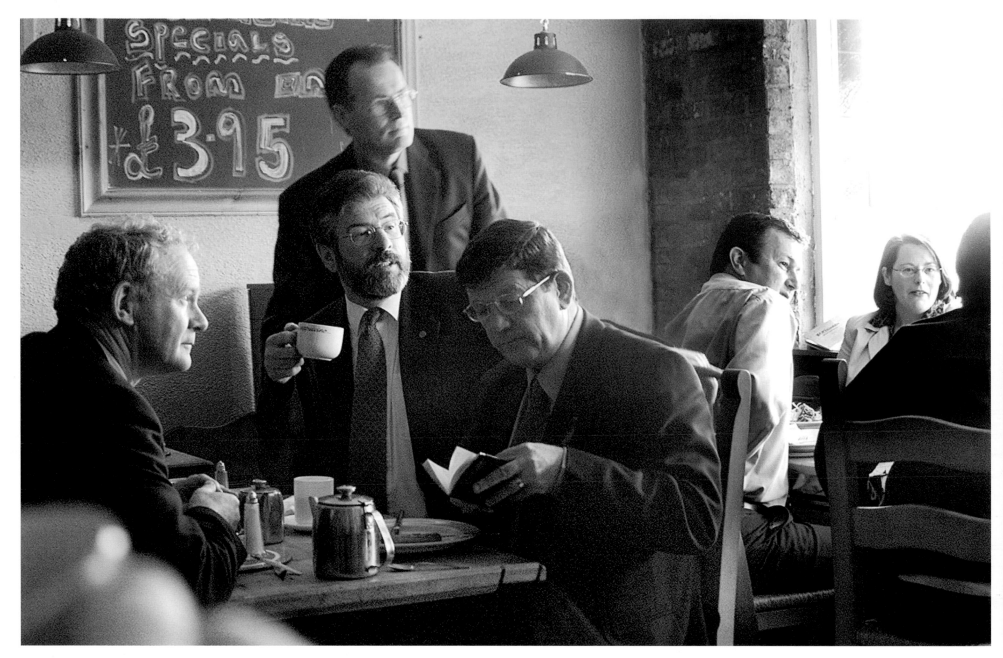

SITTING MPS

June 2001

The General Election was to take place within hours but this picture was published after Sinn Féin took four Westminster seats. As someone joked on seeing the picture, 'The only one without a seat is Gerry Kelly,' although that's not strictly true, as Conor Murphy was also seated. The MPs elected were Martin McGuinness, Gerry Adams, Pat Doherty and Michelle Gildernew.

THE MINISTERIAL CAR

April 2001

Martin McGuinness, appointed minister of education in the new powersharing Executive, leaves the Sinn Féin office on the Falls Road to go to his office at Stormont.

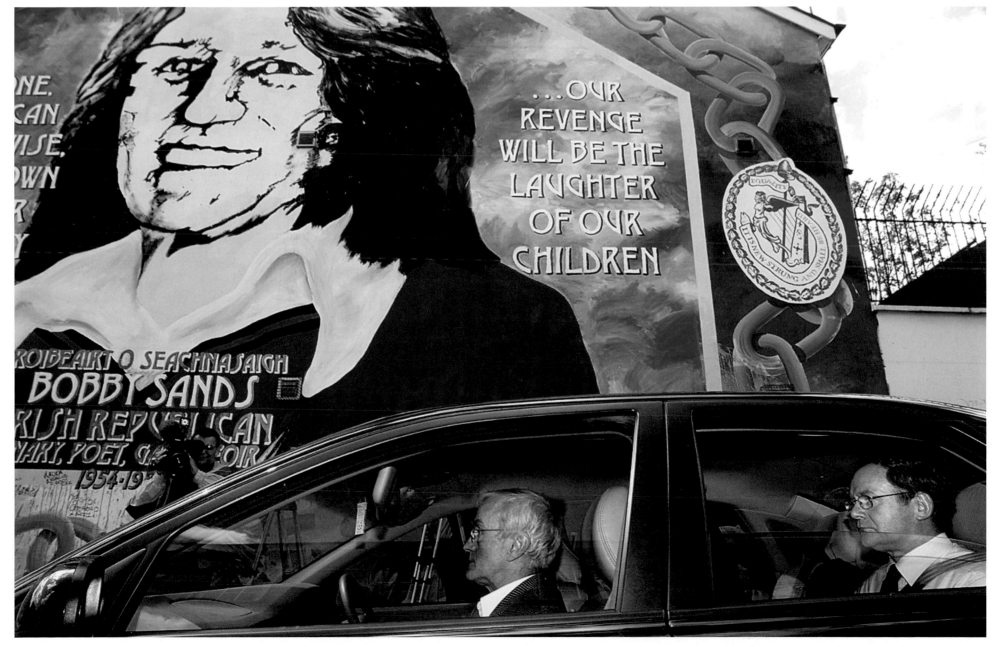

At ringside I felt the weight of the blow. I knew then what it meant when a boxer was described as being 'glassy-eyed'. He was gone. There was no expression in his eyes, just deep, dark pools.

CHAPTER 8: SPORT

Elbows on the canvas apron shudder with every punch landed in the ring. Blood spatters on your shirt, your lens and your face. Boxing is brutal. I love it. I know that's not fashionable. I was a fight fan long before I was a photographer. I remember the family glued to the radio when Belfast's 'Rinty' Monaghan won a world title. I still hear him singing 'When Irish Eyes are Smiling'.

During my bar room days boxing and horse racing would be the main topics of conversation. I was never fond of the horses and was never tempted to put on a bet. Maybe one vice was enough.

Gaelic games didn't feature much in the talk. Antrim were never successful enough to grab attention in even the most garrulous bar. My father came from Creganduff, outside Crossmaglen in Armagh, and my mother was from Shanmullagh, a townland a few miles away near Hackballscross. Armagh finally winning the All Ireland struck a deep chord, as did Antrim's appearance in the 1989 hurling final. Yet, where I was a late convert to the exceptional skills displayed in football and hurling, boxing was different. I had worshipped at its altar in my youth and, aside from actually going to the fights, the bar was a higher sanctum of boxing theology. I'd listen to knowledgeable men discuss the merits of every fighter, weighing each punch thrown. Their thoughtful conversation contrasted starkly with the frenzy of a fight night in the Ulster Hall, with everyone roaring support for a hometown favourite.

Belfast was a hometown with a lot of favourites. After Monaghan came the likes of Billy 'Spider' Kelly, John Kelly, John Caldwell, Freddy Gilroy, Jim McCourt, Hugh Russell, Dave 'Boy' McAuley and Wayne McCullough. Not all of them won world titles, but every one had a heart like a lion. I think that's why I've always admired boxers. They have to step through the ropes, face another man and put themselves on the line. In the ring there is no hiding place.

My own personal favourite was Ballyclare amateur Johnston Todd, the hardest-hitting boxer I've ever witnessed. Equally capable of knockout punches with his left or right hand, he was ferocious. Only brilliance could have beaten him. In the end he lost Ulster and Irish titles to Wayne McCullough, a very special boxer.

Another favourite is my own colleague Hugh Russell, undoubtedly the best Irish boxer not to win a world title. A classy performer, he fought in some magnificent contests and beat a string of great fighters. He has Olympic and Commonwealth medals, British titles at both bantam and flyweights and a Lonsdale Belt. Few people could boast Hugh's achievements and still, like most boxers, he is modest.

Of course, working at ringside, even when Hugh was fighting, you had to suspend all bias. You were there to get the picture. It is different from being a fan. A lot of boxers have pre-fight superstitions – lacing boots in a particular way, having the bandages on one hand signed by the referee before the other.

I developed my own routine: checking I had the right speed of film, checking the lenses, making sure the flash batteries were fully charged. Dimly lit halls allowed little margin for error.

Finding the best ringside position was purely a matter of luck. Boxers standing directly above you, dodging and ducking in a corner, could make it very difficult to get any sort of useable picture. When the bell rang anything could happen. Calculating exposure was a science, focusing was an art form and timing had to be split-second. All had to be accomplished with the crowd in your ear bellowing their excitement, passion and tension.

I've watched some moments of high drama. I saw one boxer floored by a particularly sweet punch. I'd rated him as an amateur, though he had a big reputation. If he was counted out it could all count for nothing. At ringside I felt the weight of the blow. I knew then what it meant when a boxer was described as being 'glassy-eyed'. He was gone. There was no expression in his eyes, just deep, dark pools. Through the viewfinder I could almost see his mind working, trying to figure out what had happened, trying to shake up every bit of energy. I thought it was over, but somehow he got up. He struggled through the remainder of the round and reached the bell. After the break he had collected mind and body. He came back out to win.

I'd always heard in the bar that anyone who could rise to win after being knocked down had the mark of a champion. Working as a photographer you don't have the chance to see a fight in the same way as someone sitting in the balcony, but that night I knew I'd watched some fight and some fighter. I had no doubt he was destined to be world champion. His name was Barry McGuigan.

The Clones man became world champion, transforming the job for photographers along the way. Prior to his ascent, halls were poorly lit. With McGuigan came television cameras and their lighting. Suddenly there was no need for a flash. The downside was that, as McGuigan's popularity spread, more photographers arrived. Some nights there was more hostility between local and visiting photographers than in the ring.

McGuigan also demonstrated how the Belfast fight crowd would back their man, irrespective of his religion or background. There was a lot of hype at the time about him uniting the two communities, as though this was something new. In my experience it was something you always found at fights. Irrespective of religion, local boxers have all been equally supported. The fights do unite Catholics and Protestants. I'm aware of the irony in that, but in all my years of going to boxing I've yet to hear a sectarian comment.

Nowhere is this more true than in the local amateur clubs. The highlight of their year is the Ulster Finals. Preliminary bouts are held in the Dockers Club – not a big venue, but always full of emotion. In the heart of a nationalist area, it succeeds in being the most neutral of venues. On fight nights it is packed. All the clubs are represented – they come from Holy Family/Golden Gloves, Cairn Lodge, Holy Trinity, Ledley Hall, Sandy Row, St. Malachy's, the Albert Foundry, St. Agnes's and a host of others.

In the hall, guiding their own youngsters and studying the form of opponents, are men like former Olympic coaches Gerry Storey and Michael Hawkins and my old schoolmate Sean Canavan, a former heavyweight and a true gentleman. Nationalists and Unionists, loyalists and republicans, police even, all crush in side by side. Any animosity is left at the door. The atmosphere is no less charged for all that. Only once have I seen something happen which even approached a reference to the politics of the outside world.

Following the paramilitary ceasefires, the RUC made a return to 'the Ulsters'. I think their man was a middleweight. He got a good reception, but in the opening round of his bout he and the other fighter were nervous, gingerly feeling each other out without many blows exchanged. As they circled, someone in the crowd warned the opponent, 'Keep

moving or he'll give you a f**king parking ticket.' Moments later, when both boxers were involved in a prolonged clinch, someone else yelled, 'Move yer arse or yon boy will hold you for three days,' a reference to police detention procedures. Both remarks brought the house down, easing any tension.

That's typical of the boxing crowd – decent, honest, warm people. Religion doesn't matter. All that's important is a man's ability. In that, it is a fairer world. I know it's not politically correct to like boxing. But in Belfast the fact is that the boxing arena is one of the few truly politically correct places.

DOWN BUT NOT OUT
September 1981

This was Barry McGuigan's fourth professional fight. Much to the horror of the crowd in Belfast's Ulster Hall, a Belgian boxer, Jean Marc Renard, floored the Clones man. Renard, a classy fighter in his own right, went on to win two European titles but that night McGuigan got up from the canvas to win.

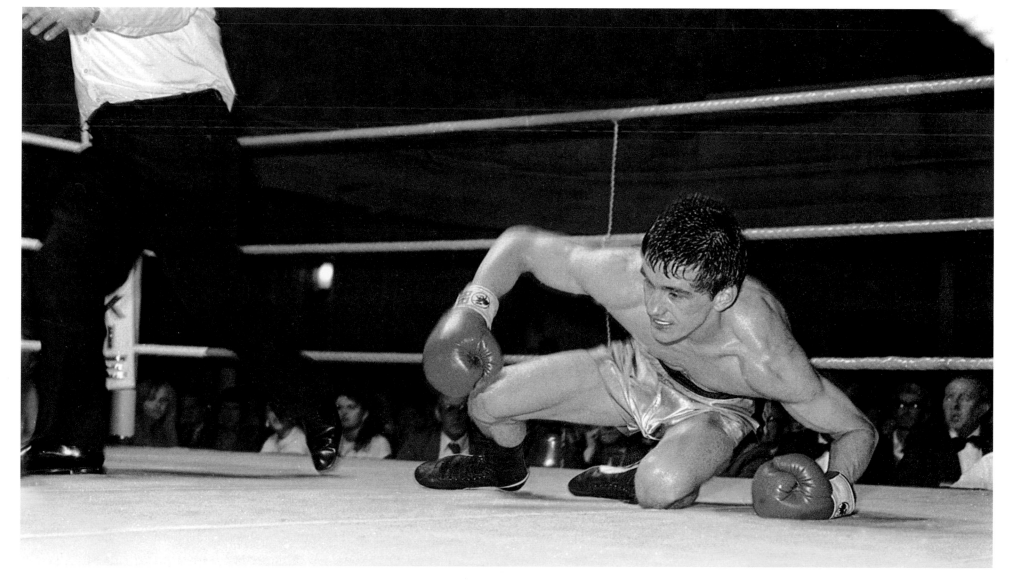

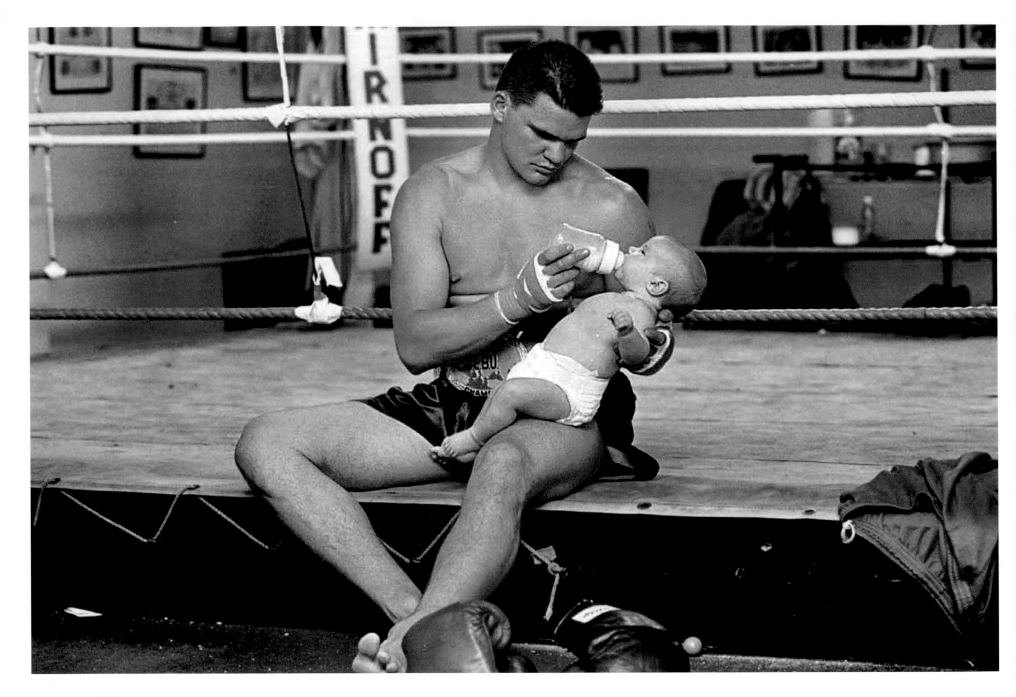

BABYFACE

October 1993

European super middleweight champion Ray Close takes a break
from training to feed his baby daughter. The picture was taken in
the famous Eastwood's gym in Belfast. Soon afterwards, Close had
a world title fight against Chris Eubanks and was considered by
many observers, myself included, to be unlucky only to get a draw.

BEGINNING OF THE DREAM

March 1981

Three legends of Irish boxing: Barry McGuigan trains at the Oliver Plunkett gym in Andersonstown, while legendary trainer, the late Eddie Shaw, and manager Barney Eastwood sit in the background. McGuigan had just signed as a professional. No one knew he was in town, and I think 'BJ' might have been asking Eddie Shaw how I'd known to turn up.

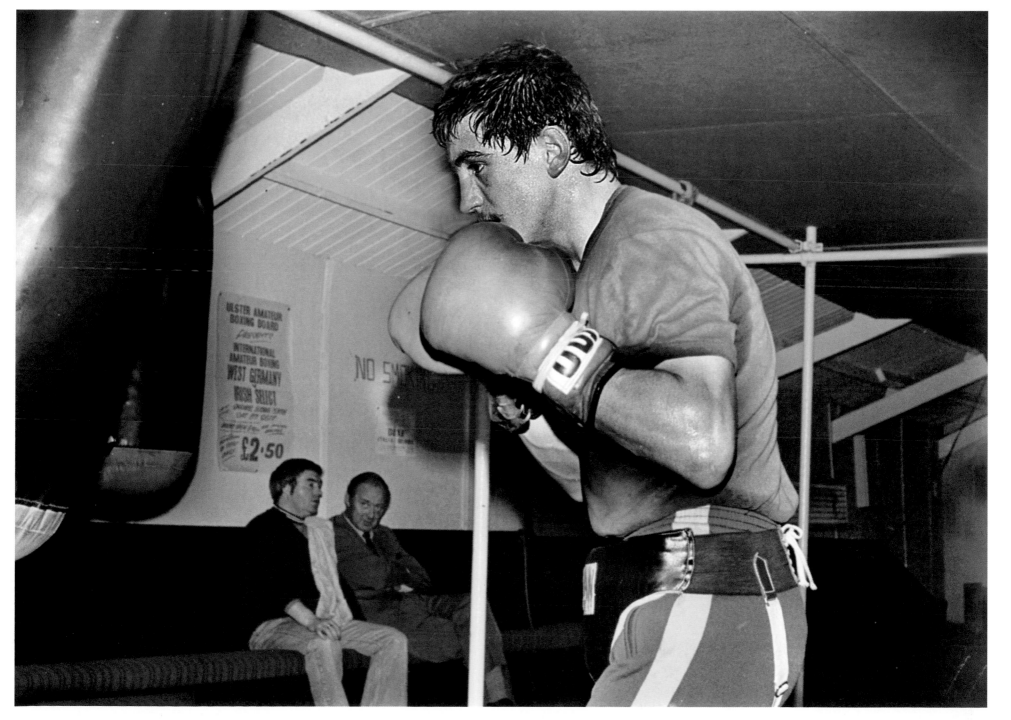

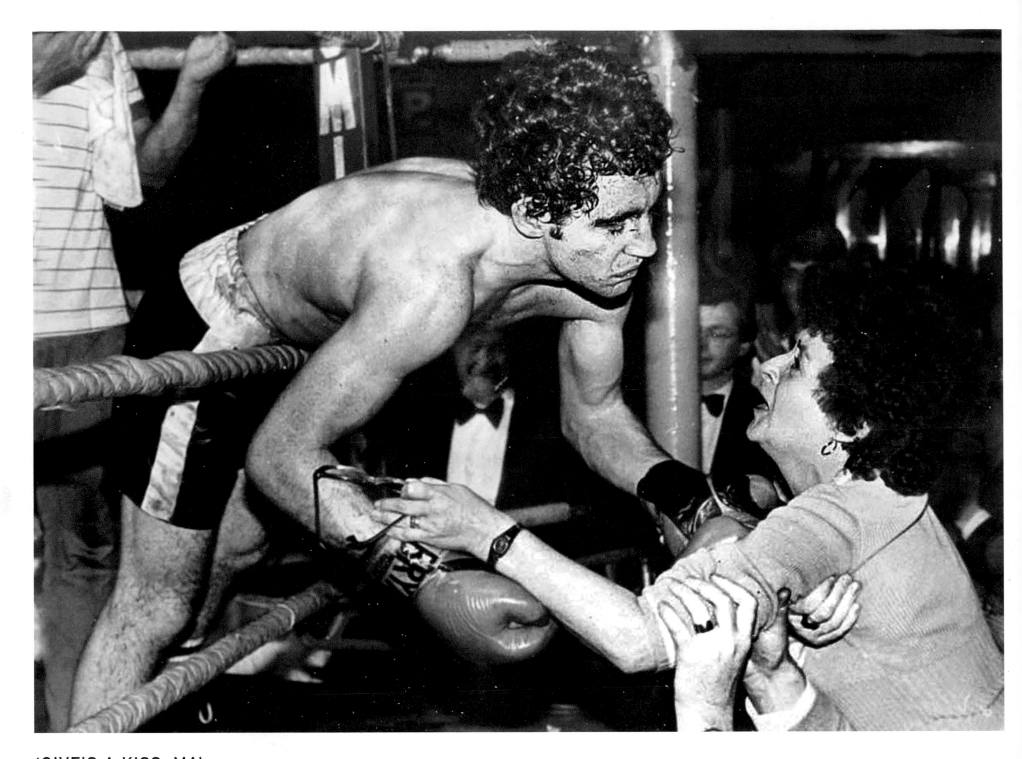

'GIVE'S A KISS, MA'
October 1982
Boxer Hugh Russell reaches through the ropes
to kiss his mother, Eileen, after beating fellow
Belfast man Davy Larmour. It was a British title
bantamweight eliminator at the Ulster Hall.
Russell went on to win the title.

BIRD'S EYE VIEW

October 1986

When Armagh beat Kerry in the All Ireland Gaelic Football Final in 2002, the defeated manager was asked how they'd lost. He told a reporter Armagh hadn't beat them – thirty years of helicopters had beat them. I knew what he meant. Crossmaglen Rangers' pitch was at the centre of a long-running controversy, because the British army occupied part of the ground. As I covered this match the chopper went straight up and right over the pitch.
The players didn't seem to notice.

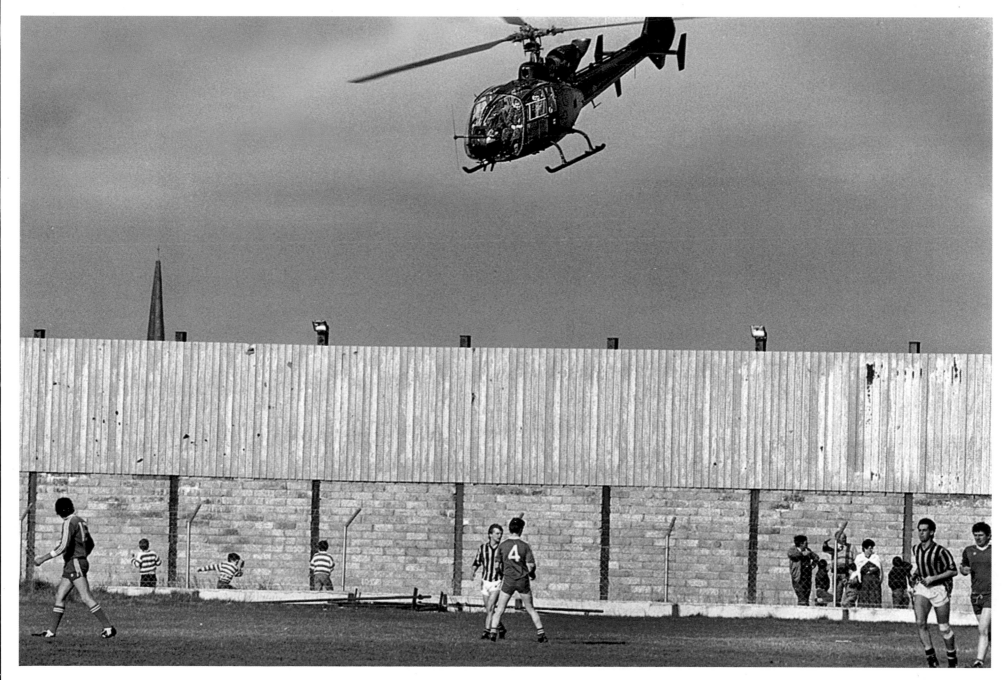

OLYMPIC WRING

July 1995

Swimmer Michelle Smith had just won her event, the butterfly, at the Irish Swimming Championships in Belfast's Grove Centre of Excellence. Every time I tried to take her picture she turned away. As she wrung out her hair, I settled for a shot showing the power of her physique. The following year she won three Olympic gold medals.

THE HURRICANE
June 1997

Former world snooker champion Alex Higgins plays at a benefit in Belfast. Behind him, a poster of one of the images that made him famous – holding his daughter after winning the world championship for the second time.

THE HURLER

August 2000

This youngster was running across the rocks towards the beach.
He tossed the sliotar to puck it at just the right place to get his
reflection in a rock-pool on the Antrim coast.

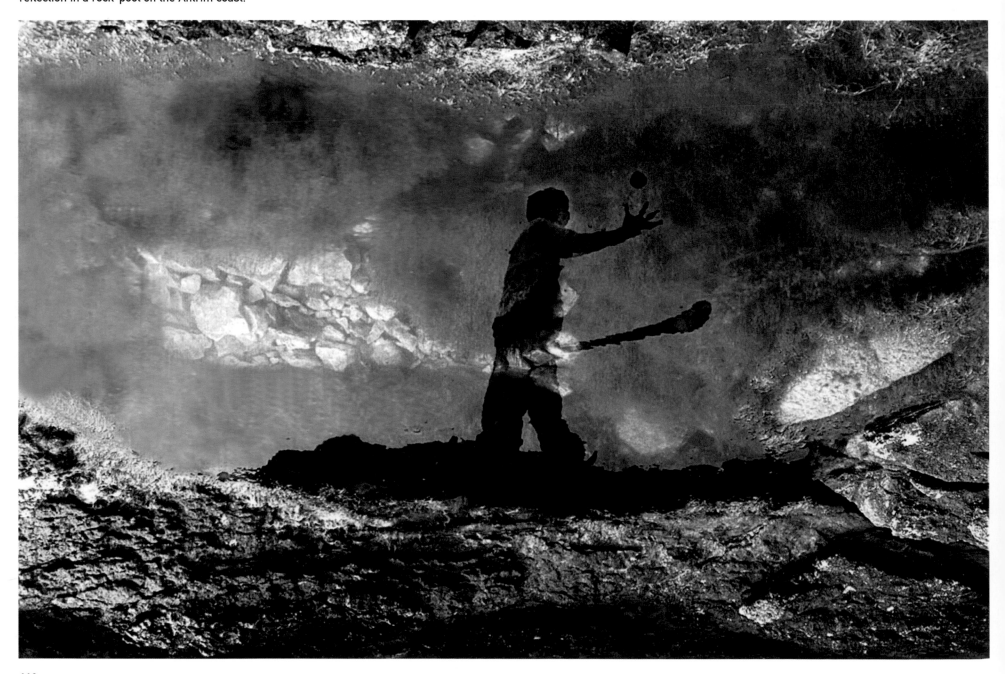

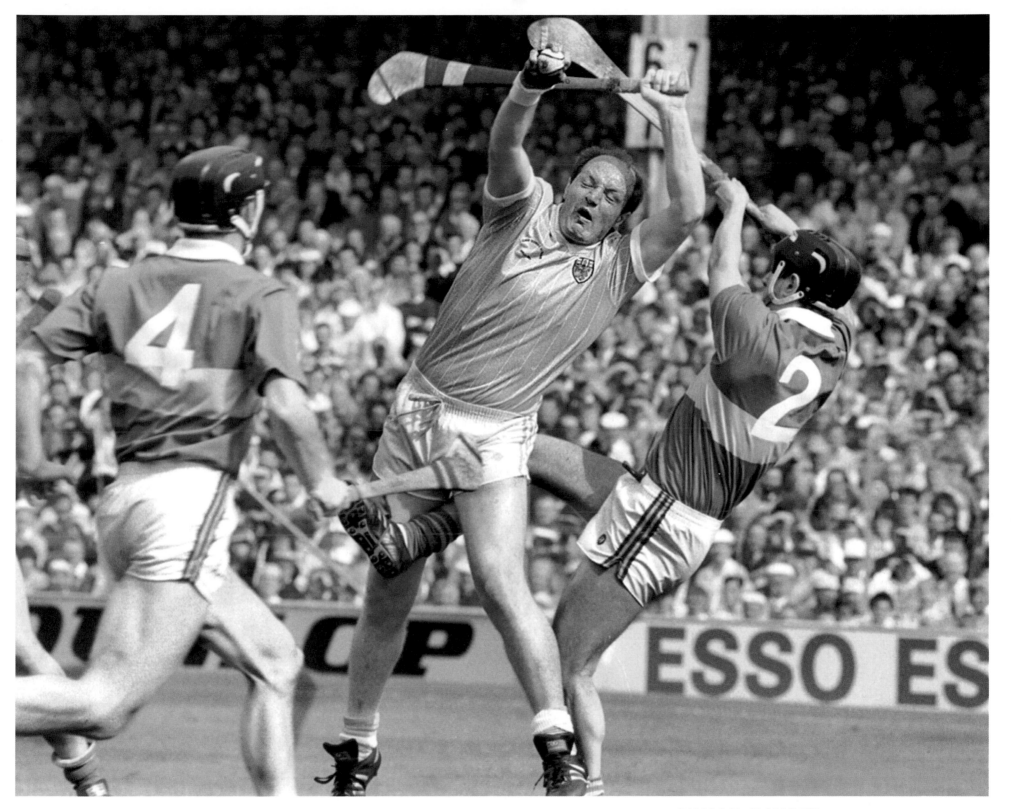

SINGLE-HANDED

September 1989

Terence 'Sambo' McNaughton of Cushendall and Antrim
rises to snatch the sliotar ahead of two Tipperary hurlers.
The result at Croke Park was never in doubt though.
Tipperary won by a hefty margin.

You could end up that worried about your own skin, your own need to get a picture and get the hell out, that you forgot that the woman crying behind the coffin, holding her baby, was a widow at the age of twenty-two.

CHAPTER 9: FUNERALS

I am ashamed of things I have done in the course of my work. Much press work stems from violent death. We cover riots, shootings, explosions and murders. We also cover funerals.

Marrying the conflicting desires for a good picture and for respect for the dead can produce frictions to haunt your conscience. Maybe I'm making excuses but, for the most part, recording funerals seems to have its place. Most families, even in the utter depths of their despair, will not object to our presence. The number of relatives who have asked for pictures of loved ones' funerals has surprised me. I've been to hundreds of funerals. I've been to too many.

In the early days we stayed back, remaining unobtrusive, not wanting to disturb people at the point of their grief. I wouldn't necessarily have tried to take a picture of the immediate family. They had enough to contend with, without having to cope with us. Editors would have to be content with pictures taken from a distance.

Editors in London would show more interest in paramilitary funerals – rare opportunities to gather images of armed men and women. The general rule that republicans were friendlier than their loyalist counterparts tended not to apply when it came to the press covering their funerals. Early on, no one was allowed to photograph republican funerals. Even later, when the IRA might have permitted photographs, you knew you were always liable to be thumped. Women in particular seemed to have some

sort of instruction that if a photographer raised a camera they were to hit him over the head. I got thumped with many umbrellas. Raining or not, there would be umbrellas. These were used to shield colour and firing parties from prying eyes.

It wasn't paramilitaries themselves who necessarily posed the greatest threat. Wary about the possibility of being pictured in a paper, anyone attending a paramilitary funeral could react angrily to the presence of a photographer. In the midst of a huge crowd, feeling threatened by the presence of a photographer, the most mild-mannered could become very aggressive. In fairness, in times when scores of sectarian killings happened each year, the mourners had a point. Belfast was always a town where little excuse was needed for murder. For that reason, as the momentum of the Troubles built and ran its crazy course, we would try to avoid needlessly identifying mourners. There were also occasional attacks on funerals – something of a battlefield in themselves when security forces adopted a policy of refusing to permit paramilitary trappings.

It all made for a tightening in the pit of your stomach when you were told you were marked down to cover a funeral. I'd sometimes have felt less nervous covering a riot. Seeing the world through a viewfinder concentrates your eye but obscures your peripheral vision. It can also obscure something much more important – the fact that funerals are about very real suffering. You could end up that worried about

your own skin, your own need to get a picture and get the hell out, that you forgot that the woman crying behind the coffin, holding her baby, was a widow at the age of twenty-two. You could forget that the man carrying the coffin was burying a son he'd bounced on his knee. You could forget maybe that there was nothing in the coffin but sandbags. Truth be told, the biggest danger in covering funerals was that they could become routine.

You got to know the undertakers. They'd tip you off about the route the cortège might take – valuable information for a press photographer in a hurry. You'd meet other photographers and most times be glad to see them, because there was safety in numbers. Belfast being a small place, you'd inevitably meet people you knew and pass the time of day. That was all part of the routine as well.

Coverage of funerals changed over the years. Early on, everyone observed a certain etiquette. The mourners, the press, the paramilitaries and the police would all have their positions. By the summer of 1976, with stories in Belfast continuing to attract international interest, a breed of younger, hungrier photographer arrived from Fleet Street and Europe. At a funeral of several children who had been killed, I couldn't believe how close they went to grieving relatives. Back at the office, my editor would want to know why I hadn't the same quality of picture. More portable television cameras were also getting in our way so that even funerals could turn into scrums. We all gradually moved closer. It was disgusting and I was as much a part of it as anyone else. One funeral, more than any other, for me illustrated just how low we could sink.

In 1980 the body of Thomas Niedermayer, a German industrialist, was discovered in a shallow grave. Seven years earlier the IRA had abducted him from his home on the outskirts of west Belfast. His body was recovered and he was to be reburied in a churchyard not far away. It was a story of obvious international interest. Up to that time, it was the largest assembly of foreign press I'd seen in one spot.

A lot of them were just off a plane. Younger locals mixed with them. Before the funeral began, I noticed that many of these guys seemed to be on short lenses, 28mm wide-angles. Mentally smiling at their inexperience, we thought they'd switch to longer lenses when the funeral got underway.

There is, at any event, an imaginary line. Photographers will stand at a distance naturally determined by the focal length of their lenses. The lens used to take a picture of a cheque presentation is different to the lens used at a funeral. In the former case, you need a short lens, to fill the frame with the two or three people involved. In the latter, at a funeral, you use a long lens to allow you to work from a discreet distance.

On the day of the Niedermayer funeral, the press were standing in a line some distance away from the church. The older, local photographers all had long lenses fitted. As Mrs Niedermayer appeared, foreign photographers and a couple of younger locals rushed forward, ignoring that invisible line separating the media from mourners. The rest of the locals then also ran forward, swapping, as they did so, long lenses for short.

Of course, there was a feeling of competition that day. Locals resented those who they saw only as interlopers attempting to beat them to their story, their picture, in their city. There was cursing, pushing and shoving as around thirty photographers jostled for position. Short, 28mm lenses ended up almost in Mrs Niedermayer's face as she walked behind her husband's coffin. It was unsavoury.

To get a shot, one of the foreign corps crawled to the grave's edge as the remains were reburied. This is what can happen when taking a photograph becomes so important that you forget what is going on around you. We all lost a little of our humanity that day. I went to Mrs Niedermayer afterwards and apologised. She was very ladylike. I don't think she even knew I had spoken.

I am ashamed of things I have done in the course of my work. And I have been to too many funerals.

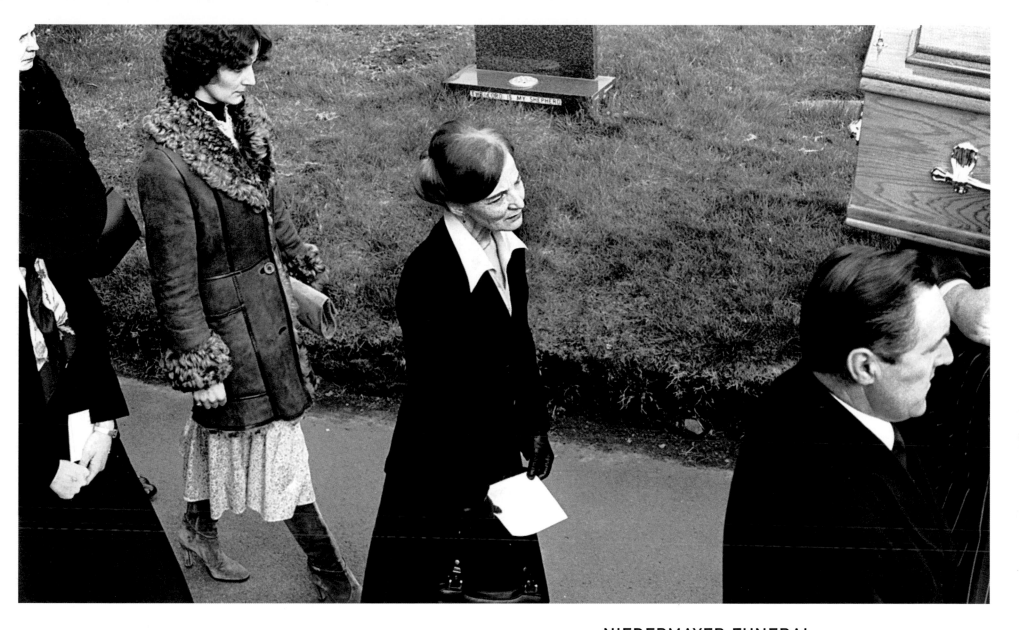

NIEDERMAYER FUNERAL
March 1980

Mrs Ingerborg Niedermayer walks behind the coffin of her husband, German industrialist Thomas Niedermayer. The IRA had buried his body in a shallow grave, where it was found seven years later. Mrs Niedermayer was a very dignified, very refined woman. Our behaviour as photographers at the funeral was disgraceful. Mrs Niedermayer went back to Germany, but returned to Ireland in 1990. She checked into a hotel near Dublin, and her body was found washed up on a beach a week later.

WEDDING DAY

March 1975

Billy McMillen was known as 'the wee man'. Over a decade earlier he had been the Sinn Féin candidate in west Belfast. On the wall of his Divis Street headquarters a poster read: 'Let the orange lily be the badge of you, my patriot brother, but the everlasting green for me, and us for one another.' At the time of his wedding, he was the Official IRA commander in Belfast. It was engaged in a feud with the INLA. Official IRA members guarded the church where the wedding took place.

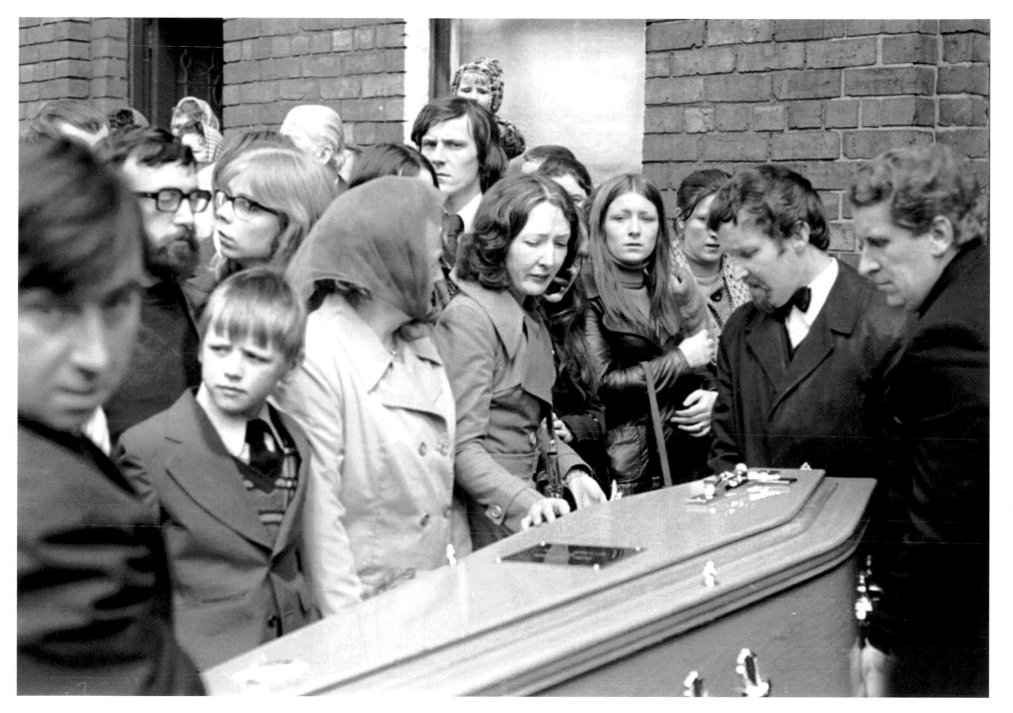

FUNERAL OF BILLY MCMILLEN
April 1975

Six weeks after I took his wedding picture I was photographing his funeral. He had been shot outside a paint shop as he waited for his wife. That was the way of the news photographer. One day you'd see extreme happiness, the next utter despair. Billy McMillen was forty-eight years old.

HUNGER STRIKE FUNERAL

July 1981

There were thousands of people at Joe McDonnell's funeral.
Photographers really couldn't see what was happening.
Glimpsing the hunger striker's son, I grabbed a few frames.

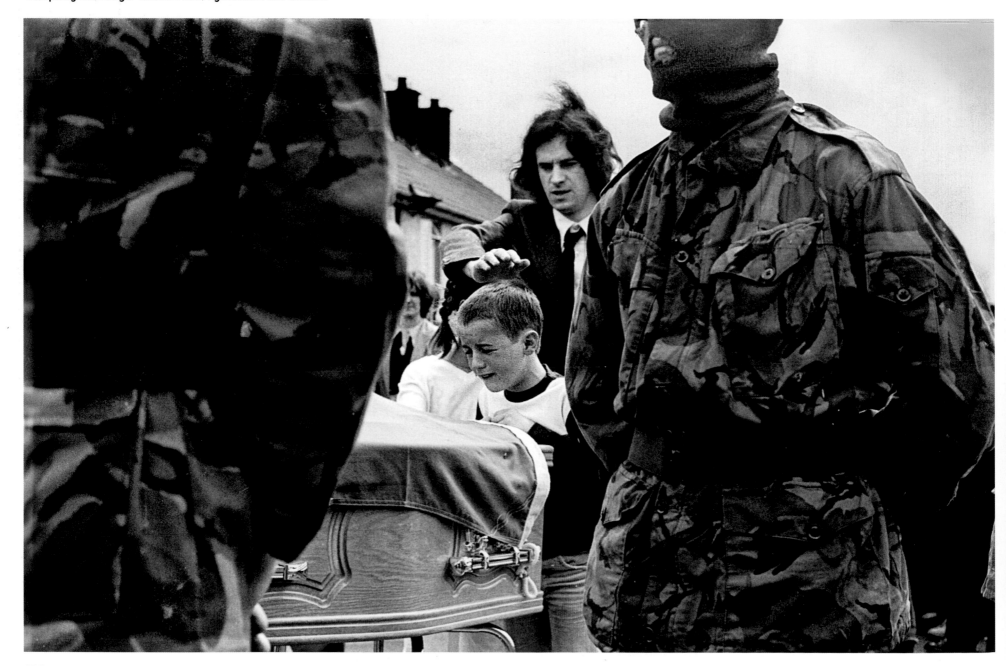

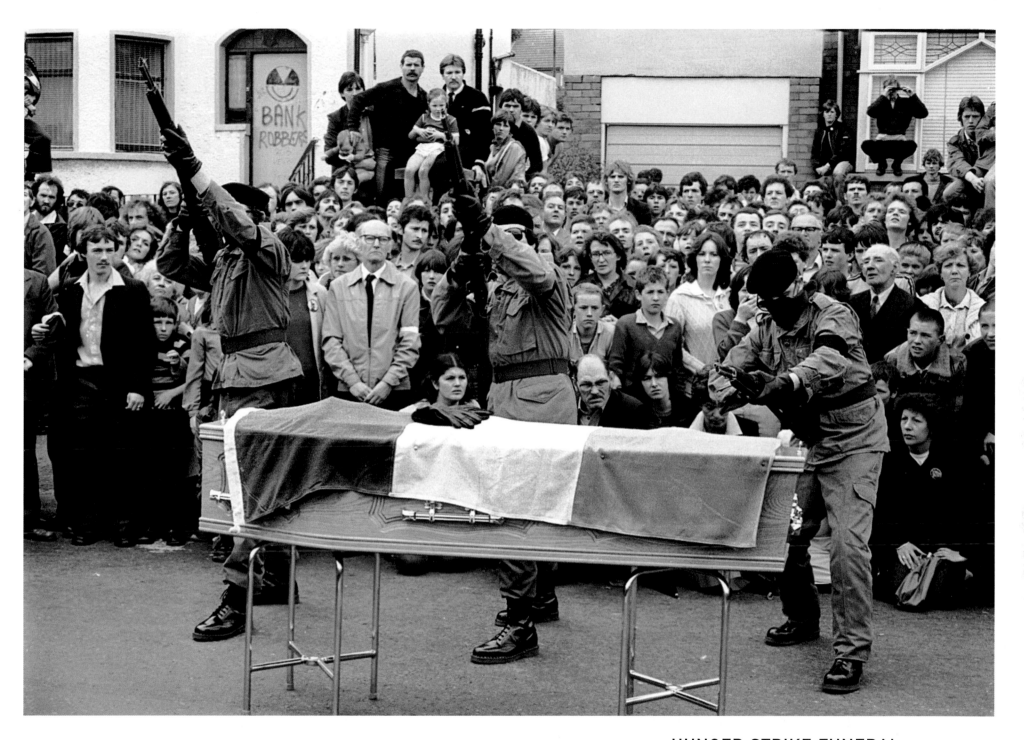

HUNGER STRIKE FUNERAL

July 1981

Near St Agnes's Church on the Andersonstown Road, armed men emerged from the crowd to fire a volley of shots over Joe McDonnell's coffin. The man to the right appeared to have difficulty firing. Within a few moments, RUC officers flooded the area in an attempt to arrest the firing party. People scattered as plastic bullets were fired, some of them hitting the church. The crowd was very calm when this picture was taken, despite the great crash of rifle fire.

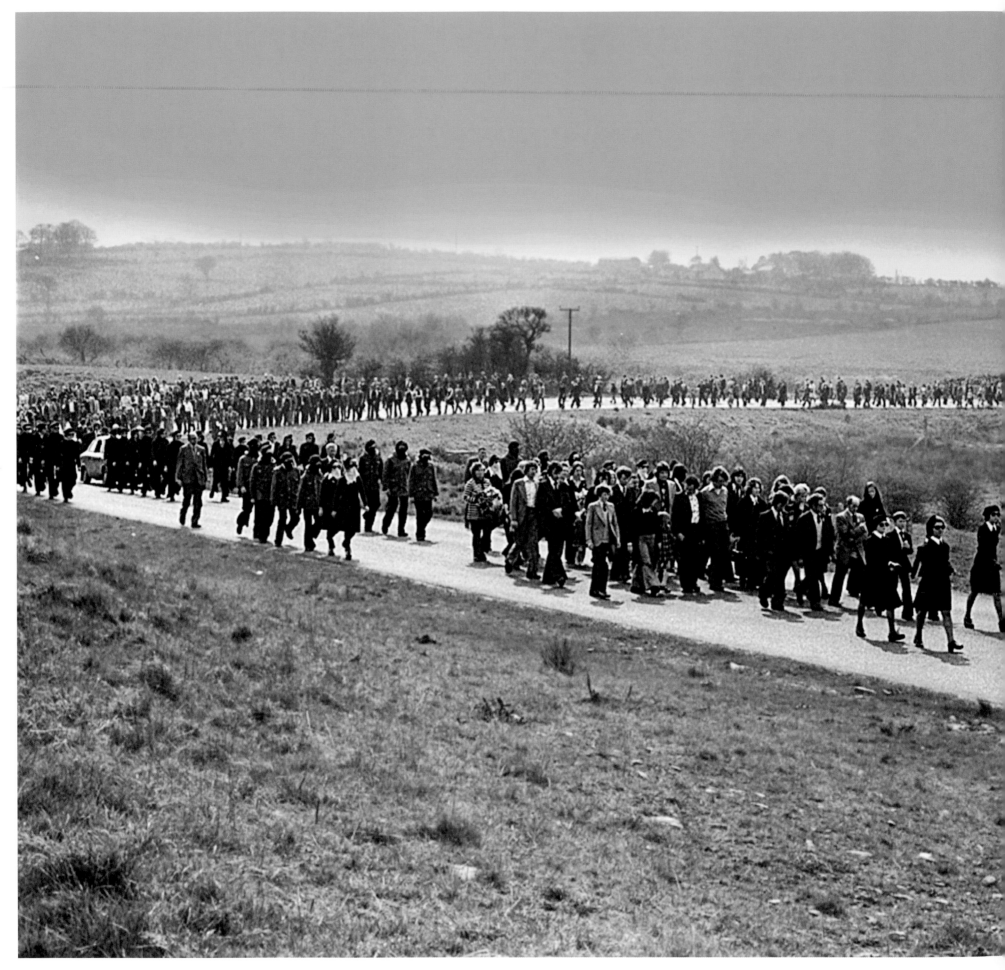

SOUTH ARMAGH FUNERAL

April 1976

The SAS shot dead a leading member of the IRA.
He was unarmed and the Army claimed he was shot while
attempting to escape. It was subsequently claimed that
Captain Robert Nairac, himself later killed by the IRA, had
fired the fatal shots. On this day it seemed as if the entire
nationalist population of the area attended the funeral.

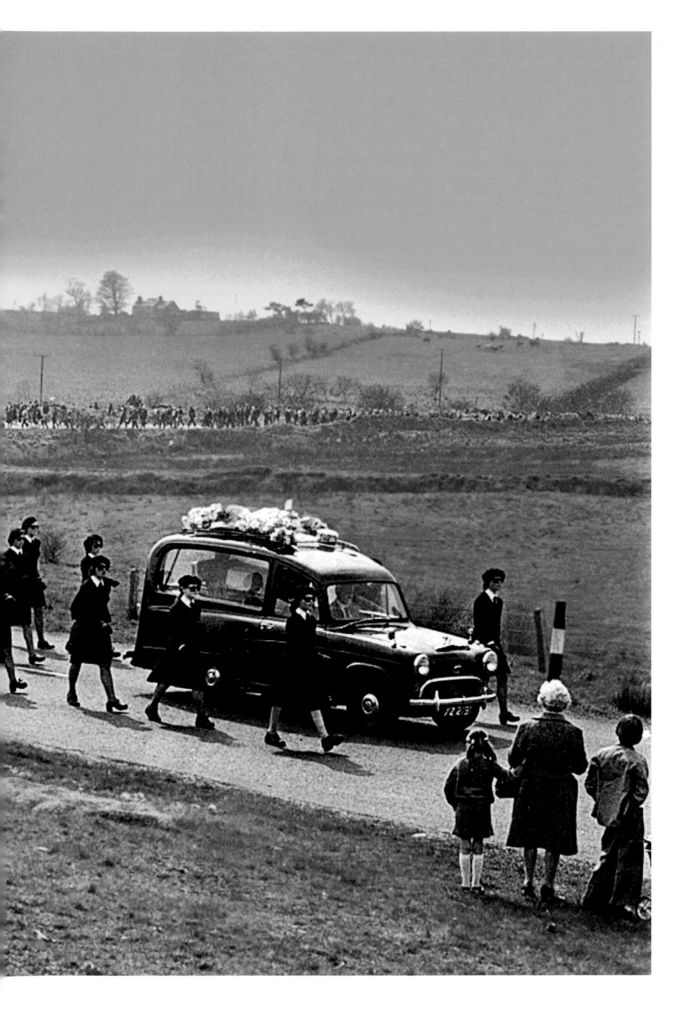

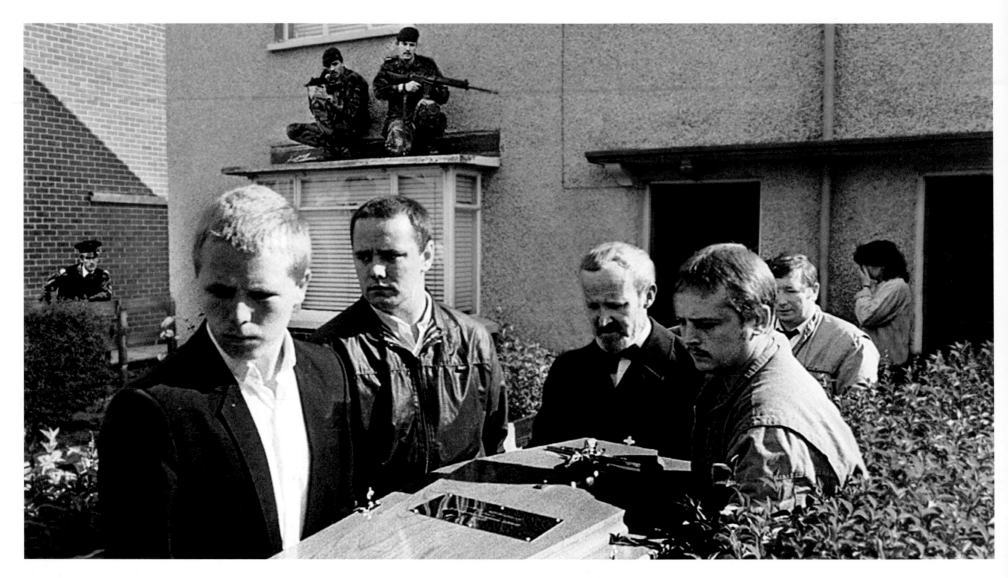

WEST BELFAST FUNERAL
September 1986
Funerals became something of a battleground during the
1980s, as police and army refused to permit paramilitary
displays. This was the funeral of an IRA man shot
by a Royal Marine in Andersonstown.

RUC FUNERAL

April 1986

This was the funeral of an RUC inspector. The IRA shot him as he walked his dog in Newcastle, County Down. I thought the women in this picture somehow displayed incredible dignity and support for each other.

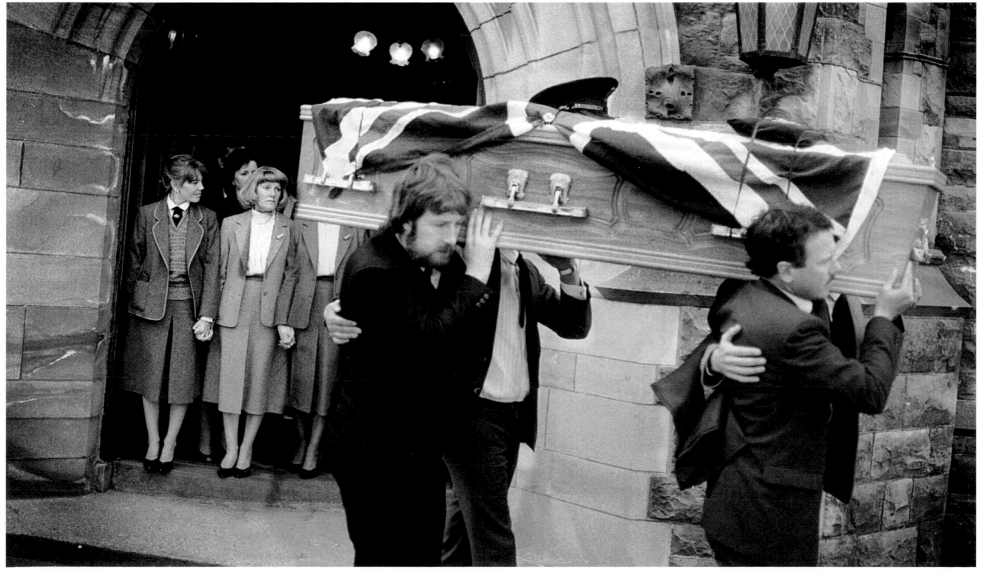

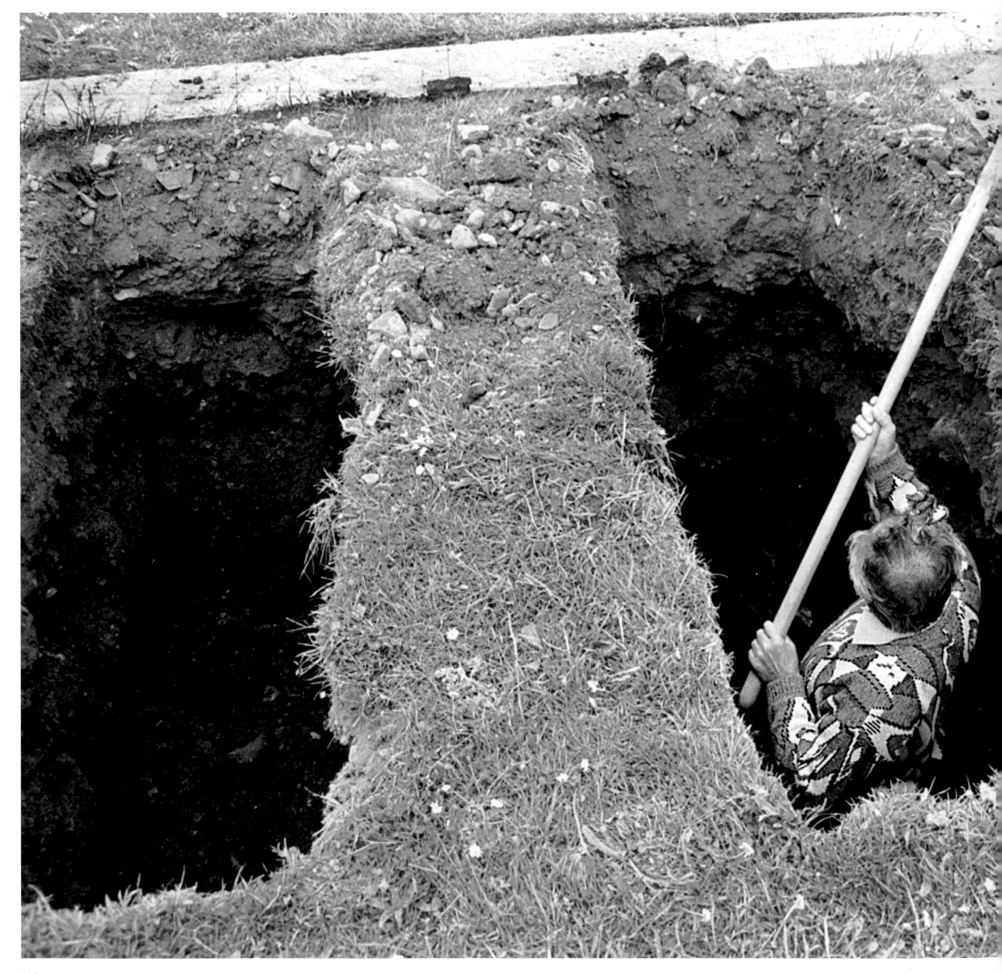

GRAVE DIGGER, LOUGHINISLAND
June 1994
Loyalists machine-gunned a bar in a quiet County Down village as customers watched a World Cup match. Six died. I thought a long time before taking this picture, somehow so brutal, so final. It seemed appropriate in this area where neighbours still dig graves, where the dignity of the place had been so shattered.

The card school had very definite views, some of which seemed to be expressed in tattoo form. Paddy wasn't long getting a few comments.

CHAPTER 10: BEHIND THE HEADLINES

I have been fortunate to work with talented reporters – courageous men and women of real integrity, able to turn a stylish phrase under pressure. That's not the way a lot of people think of journalists. Sure, there have been those I wouldn't cross the street to speak to, but most have tried to do an honest job. I like them.

Reporters are vital to the photographer. I only realised that when I began accompanying them regularly. At first I often found myself alone, covering all manner of stories. Gradually, partnering more reporters, I came to appreciate the worth of having another pair of eyes alongside. It is particularly useful, of course, in cases of street violence. The reporter can watch your back or drive a car. Yet in a lot of stories involving no violence, reporters have still proved their value.

A good reporter will visualise how a picture can illustrate their story. That's the very reason the reporter and photographer will go to a job together – words and pictures in harmony. The great reporter brings something more – almost a sixth sense about what will happen, the knack of finding an angle thought of by no one else. They possess a vital skill – the ability to get behind the headlines.

Pictures that distil a news story are difficult to come by. Invested in them are knowledge, experience, patience and luck. It can be a real team effort. Reporters point out things you may have missed; they'll be able to tell you the best place to stand to get the shot; they'll know when to be at a certain place at a certain time. The extreme form of this partnership, of course, can be unhealthy. A photographer suddenly thinks he could ask better questions than the reporter, or a reporter becomes convinced he could take better pictures than the photographer.

One of the best I've worked with was Paddy Reynolds, a human dynamo with a sharp nose for a story. As Northern Editor of the *Irish Press*, a grand title didn't stop him being a working journalist wise to every twist of the street. Unfortunately some of his colleagues at the paper's Dublin headquarters were less savvy about the whims of Belfast. They went through a period of pushing the northern office for stories about working-class loyalists. They weren't being sectarian – it was simply a glimpse of life novel to the paper's southern readership and, if truth be told, a fair number of their northern counterparts. The practicality of how to get these stories for a paper still influenced strongly by its Fianna Fáil roots was left to the Belfast office and its ever-resourceful boss.

'We're going up the Shankill,' Paddy Reynolds told me as I arrived for a shift. A new mural was being unveiled in the heartland of working-class loyalism. It would be an opportunity to interview and picture unionism's underbelly. A regular visitor to the bars of the Shankill during my drinking days, I knew its people well and held them in high regard. Times had

changed though and in this era of vicious sectarianism an out-of-place word could prove costly.

Announcing that we were working for the *Irish Press* was unlikely to open many doors. Worse again, the fact that our Christian names were unmistakably Catholic seemed not to be the best introduction. People were being killed on the strength of less. It was a dilemma Paddy and I discussed on our way to the location. Our plan, therefore, was to adopt an innocent deceit. He would be Sammy, I would be Billy. It was a simple strategy, one employed occasionally out of necessity by reporters and photographers. I've seen the staff of the *News Letter*, a paper which is to unionism what the *Irish News* is to nationalism, affect different names from time to time.

With hardline loyalists it never paid to take chances. Our cover story devised, we disembarked from the car and strode confidently up to the mural, its paint barely dry. It was at this point that I noticed a rather large group of men sitting on the opposite corner of the street. They were playing cards, barely showing any interest in us. We had a feeling that the unveiling might not have been as formal as we had anticipated. Paddy Reynolds, however, could not easily be shaken off a story. With a jaunty, 'You get your pictures,' off he went to talk to the card school. I heard the conversation. Things seemed to be going well. 'It's a grand day,' said Paddy, introducing himself as a reporter in such a personable manner that he avoided having to furnish a name.

As Paddy proceeded to explore the views of these wily representatives of hardline unionism, I eagerly set about my work. I should mention that my enthusiasm about the job that day had little to do with its location. In my camera bag was a gleaming new, state-of-the-art 24mm ultra-wide-angle lens. I attached it with care. For the first time I was able to really get up close to a subject. What better subject to fill the frame than a fresh loyalist mural? The 24mm allowed me to stand much nearer the wall than the standard 50mm or a longer lens. I began banging off shots with abandon.

The card school had very definite views, some of which seemed to be expressed in tattoo form. Paddy wasn't long getting a few comments. I remained engrossed in the beauty that was my 24mm lens. The card school and reporter observed me go about my work. Then Paddy noticed how close I was to the wall. Paddy was no mug when it came to pictures and he knew my 50mm couldn't possibly work so near the wall. For my part I had neglected to tell him about the new lens. He was concerned about the picture and his concern was about to become my concern. 'Brendan,' he called across the street, 'Brendan, are you sure you're getting that all in?' My reply was as instinctive as it was ill-judged. 'Ah, for Christ's sake, Paddy, you're supposed to call me Billy.' The card school rose.

'Right, lads, we better be off now,' Paddy waved at his new friends. 'Take care now,' I added, just a little too hastily. We made straight for the car. They were just a bunch of guys out of work, passing their day. But this had been alien territory for us. We had ventured in and had emerged unscathed. Our nerves turned to laughter as we sped down the Shankill.

Paddy's story appeared the following day, accompanied by the picture of the mural, and complete with quotes. I marvelled at its insight. He saw what my lens could not. And that is the other measure of the great reporter – the gift of being able to break down ignorance come what may, the facility to see what's happening beyond the picture, behind the headlines.

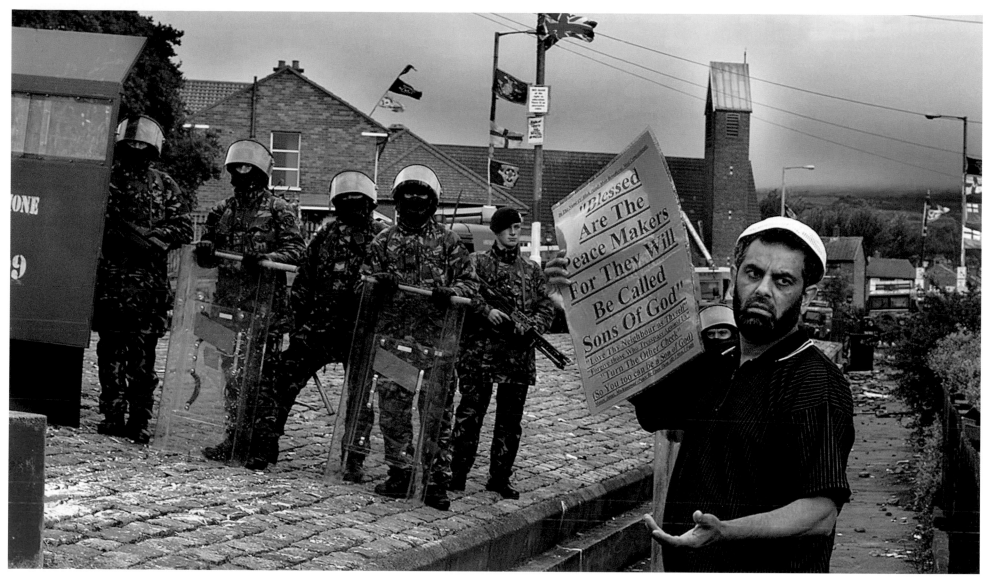

BLESSED ARE THE PEACEMAKERS
September 2001
One day, as the Holy Cross dispute continued, I turned around and there he was. My eye has always been drawn to the bizarre, and there was an unreal quality to this image. Until 11 September, the story surrounding the girls' primary school was making world headlines.

GUTTED CHURCH

November 1991

Bishop of Down and Connor, Dr Patrick Walsh, stands inside the Church of the Virgin Mary and St. Brigid at Magheramesk, near Glenavy, burnt in a sectarian attack. Over the years I've lost count of the number of similar incidents. Both Protestant and Catholic churches have been destroyed. It's always very sad, because you see the impact it has on a community.

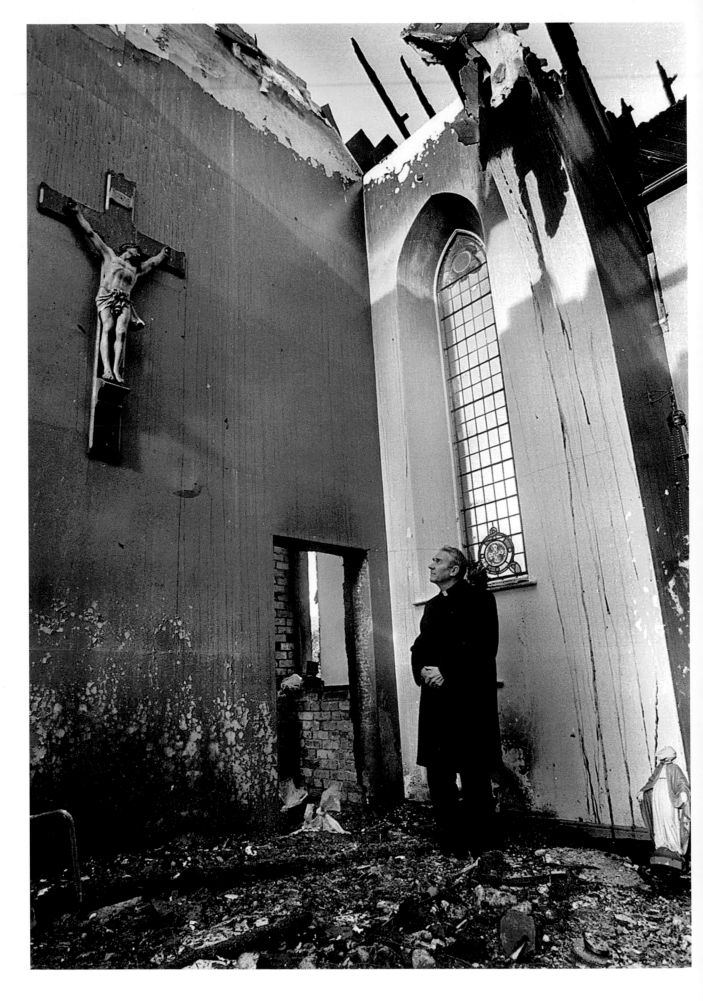

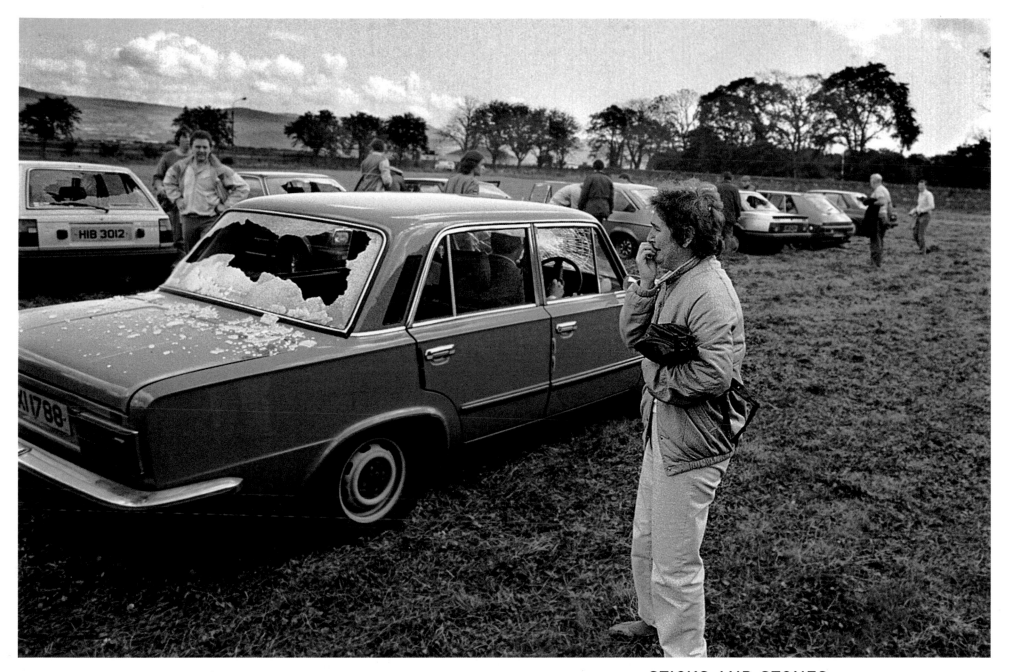

STICKS AND STONES
August 1986
DUP deputy leader Peter Robinson appeared in court in the
Republic, charged in connection with a loyalist takeover of a
County Monaghan village, Clontibret. Supporters travelled across
the border to Dundalk for the hearing. They were ambushed with
bricks, stones and petrol bombs. They returned to the field where
their cars were parked, only to discover they had all been
damaged. This woman was badly shaken.

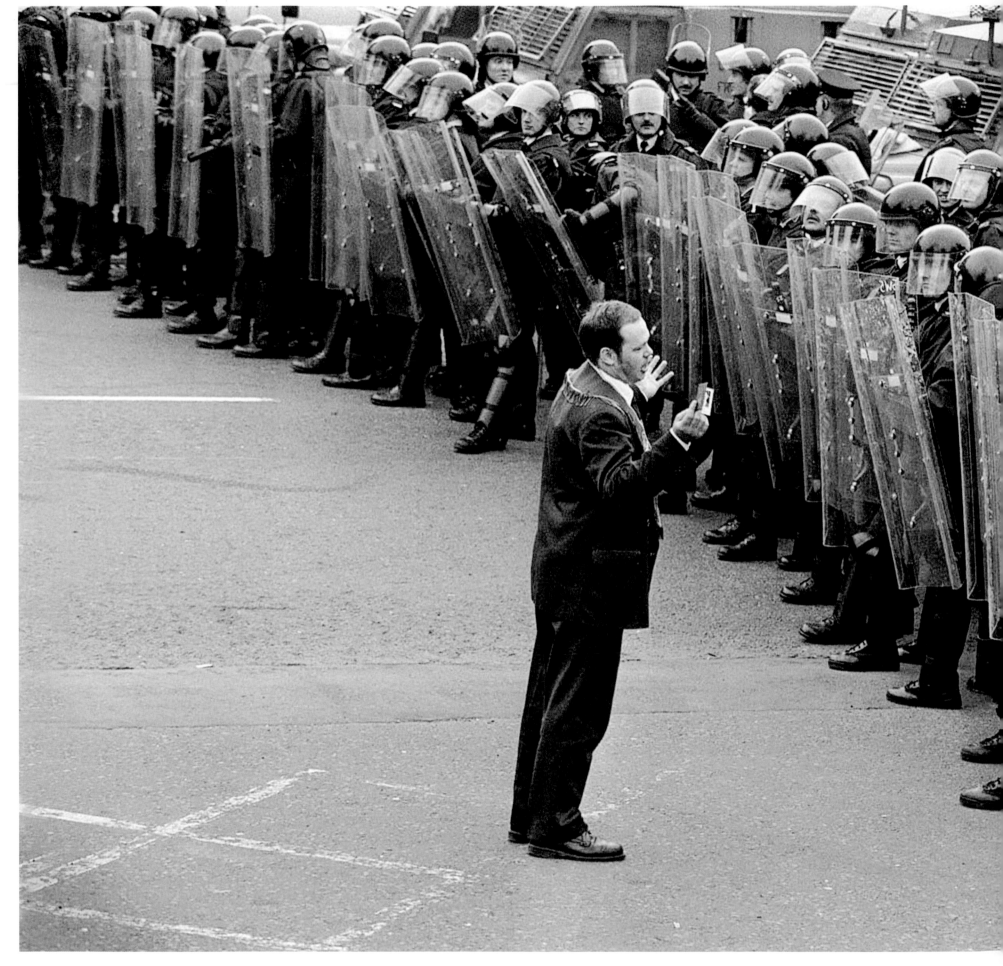

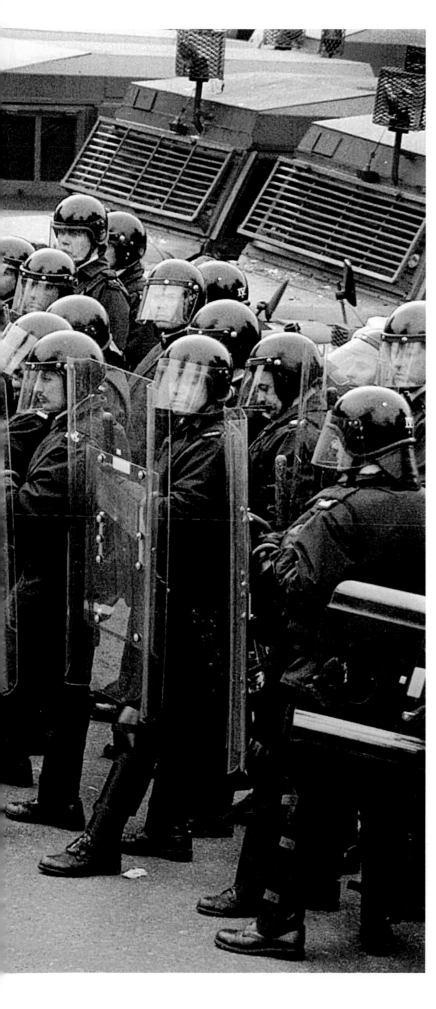

CHURCH PARADE
August 1996
A lone member of the loyal orders unsuccessfully appeals to riot police
to stand aside and allow his brethren to cross the Ormeau Bridge.
They wanted to walk down the main road past a nationalist district.

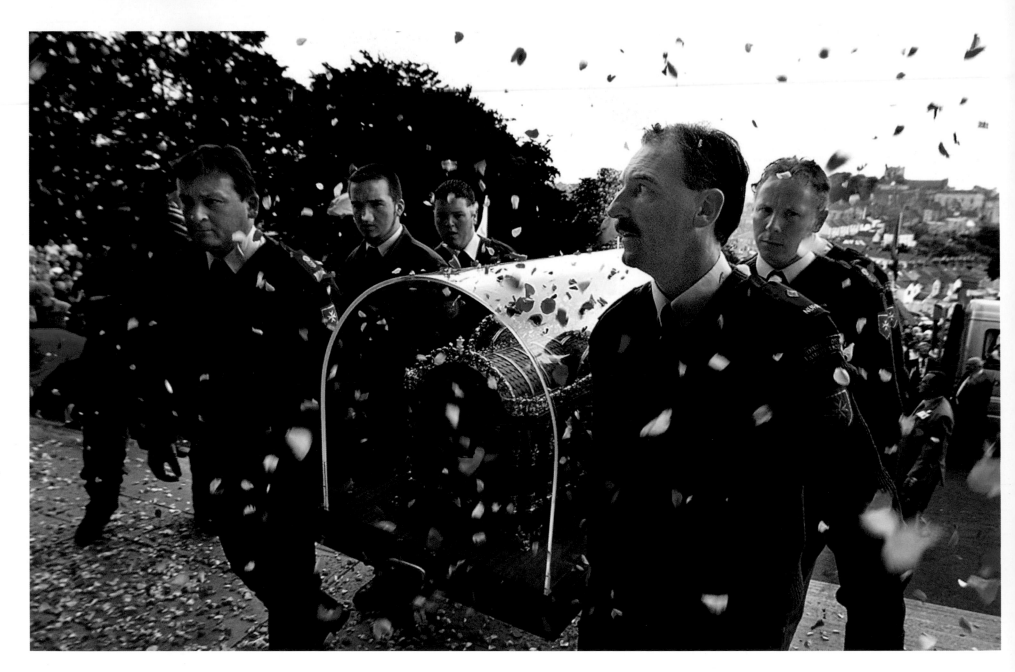

LITTLE FLOWER

May 2001

The relics of St. Thérèse de Lisieux created something of a sensation when they visited Ireland. Nearly three-quarters of the population turned out to see them. As they arrived at St. Patrick's Cathedral in Armagh, petals cascaded from high above.

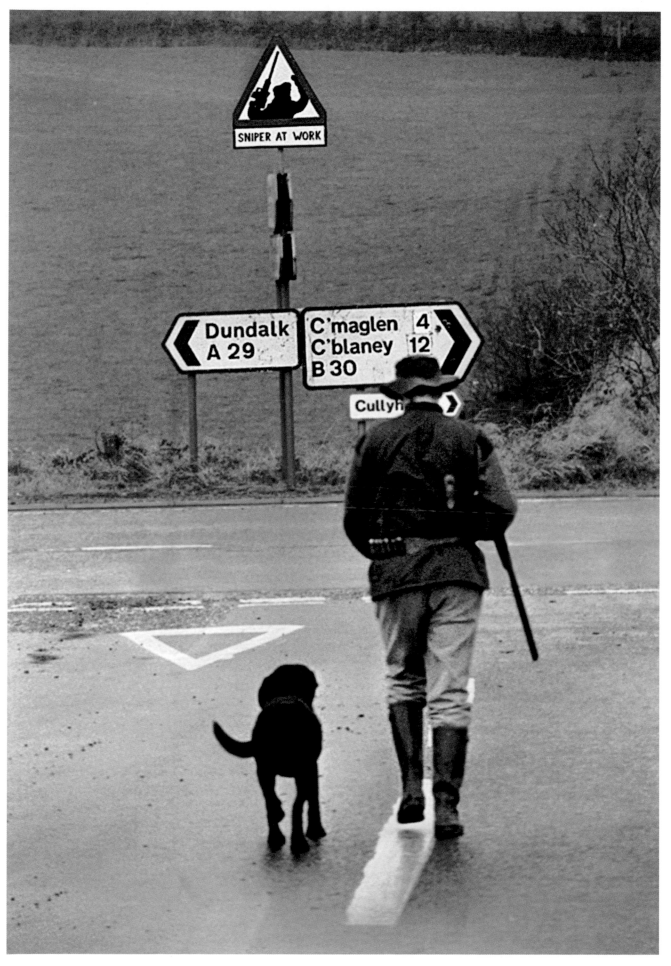

SNIPER AT WORK

September 1993

I'd been told about the sign, but it didn't make a picture in itself. I waited, nervously, for several hours. Nothing happened. Tractors passing were the best I could get. Suddenly this rabbit hunter appeared on the road. I couldn't believe it. I had time to take only a few frames. The sign had a certain black humour for many locals, but others found it intimidating. IRA snipers had killed several policemen and soldiers along the border.

HOME AT LAST

October 1989
Gerry Conlon of the Guildford Four returns to his family in Belfast a few days after his conviction was quashed. Only myself, photographer John Harrison and a reporter were there when he came to the house. No one else knew he was coming home. We'd interviewed Mrs Conlon a number of times over the years. The circumstances weren't always hopeful. I was glad to be there at the conclusion.

NEWLY-WEDS

February 1994

The whole world was looking for this picture. Paul Hill of the Guildford Four was in Belfast for the first time with his new bride, Courtney Kennedy. I put the word out that I'd like to get a picture but no one knew where the couple were staying. Lo and behold, just as I was about to go off shift, they showed up outside the *Irish News*. Someone had done me a good turn and passed on my request. I just had time for a few shots in the back of their taxi. The *Irish News* had always supported the Maguire, Guildford Four and Birmingham Six campaigns, and I think this might have been Paul's way of saying thanks – a world picture exclusive.

They hadn't seen us. 'Get down,' I hissed at the reporter as I myself went on to my hands and knees. Down he went, fearing perhaps another paramilitary invasion of the paper. 'What's wrong?' he whispered. 'Bloody Gandhi,' was all I could reply.

CHAPTER 11: CELEBRITIES

Saying, I know now, that I ended up crawling to get away from an Oscar winner sounds odd. To me it seemed perfectly sensible. Maybe that's what's most frightening. It started innocently.

The *Irish News* hosted an annual film lecture. For a while, the paper would annually book a reasonably famous actor to deliver a talk in Belfast. This had proceeded for several years without a hitch under the guidance of the paper's admirable film critic, Colin McAlpin. So it was that one year a particularly prominent actor, Ben Kingsley, was booked to do a turn.

It should have been a coup. It was a coup. To be fair it was actually a considerable coup. Mr Kingsley was an Oscar winner. He had received the golden statuette for his role Gandhi. That meant Ben Kingsley was not just an actor but also a celebrity.

That word 'celebrity' means so much more than just being famous. I've photographed quite a few. A small-town paper will cover the famous and the not-so-famous as they pass through. There is the usual mixture of the good, the bad and the ugly. We can make them look more ugly if they demonstrate a lack of manners. The wide-angled lens was invented for portraits of ungracious people. In my experience it's been true that the bigger they are, the nicer they are. I have to also say that when Ben Kingsley arrived to deliver the lecture he was universally regarded as a genuinely nice guy. Crucially though the Oscar had raised his status beyond that of being

just a very good actor – he was sought after and we had him to ourselves. In news terms he was that prized commodity, an exclusive.

A marketing manager with a shrewd eye saw the opportunity. He wanted to promote our coup for all it was worth. In marketing terms he was exactly right. It was the professional and sensible thing to do from a marketing point of view. All that the manager needed was for the photographic department to supply as many pictures as possible of this famous actor, taken during his two-day stay in Belfast – a fair and reasonable request. This was where my problems began.

By this stage I had been round a few corners and fancied I knew a thing or two. Some reporters and photographers would argue I have a contrary streak. I don't necessarily agree. But you wouldn't expect me to.

The truth is, if I had been told I wasn't allowed to photograph Mr Kingsley, I would have done my damnedest to picture him from every conceivable angle. I'd have bluffed my way through the tightest security, I'd have risked life and liberty, I'd have gone the extra mile to get a single picture of this famous actor. I suppose we all have that in us. But somewhere, deep inside, my contrary streak – or whatever you want to call it – kicked in. I decided that half a dozen photographs of Mr Kingsley taken on the first day of his visit would suffice. Was it because someone insisted: 'You can't have enough

pictures of an actor like this'? Was it because someone was telling me what I had to do? Was it the fact that there are a limited number of conceivable angles of even the most famous actor? I just don't know. Having taken pictures of Ben Kingsley several times on the first day, I fancied he was starting to regard me as a stalker. At that point I came to a decision. I determined that I should make no more images of him.

It was no one's fault. I don't blame anybody. It happened and I, Brendan Murphy, former proprietor of Murphy's Bar, picture editor of the *Irish News*, felt that I should make a stand. That's how I ended up on my knees. I suppose my view on the matter would have been clear had I said outright: 'I'm not taking any more bloody pictures of bloody Gandhi.' I have to admit it. I took the cowardly way out that Sunday.

Only a reporter and myself were on duty. Most staff didn't start on Sundays until around teatime. The *Irish News* is a great newspaper. It covers everything, and Sunday afternoons can be very busy. There are sports markings, political rallies and maybe a mop-up of some news event. This Sunday was quiet though, very quiet. I had to invent something to do to be out of the office. Ben Kingsley, Colin and the marketing manager were due to arrive for yet another publicity portrait *à la* 'Famous Actor Visits Newspaper'. I dragged the reporter with me, wet behind the ears, telling him we were embarking on a story of utmost importance. I ignored his bemused expression as we wandered round a cat show.

It was a cold day. We stayed out of the office an awfully long time. The hour for the portrait sitting came and went. This was well before the awful advent of the mobile phone, and I was not contactable. I wasn't trying to be rude – I simply thought that, as Mr Kingsley was a very famous actor, they would simply wait for a few minutes, make some excuse for my absence and move on. A full two-and-a-half hours late, we returned to the office. And, as I walked into the newsroom, there they were – Colin, the marketing manager and the Oscar-winning actor.

The newsroom was big. They hadn't seen us. 'Get down,' I hissed at the reporter as I myself went on to my hands and knees. Down he went, fearing perhaps another paramilitary invasion of the paper. That had happened a couple of times during the early stages of the Troubles. 'What's wrong?' he whispered. 'Bloody Gandhi,' was all I could reply. The reporter's eyes were wide as saucers. I had to think quickly.

A plan sprang to mind. At that stage a long, shoulder-high line of metal filing cabinets partitioned the newsroom. It would be easy. We could crawl on hands and knees along the line and then, covered by still more filing cabinets, make it to the door of the darkroom. 'Quiet,' I ordered the reporter. 'Follow me.' Off we set.

Unaware, Ben Kinglsey, the marketing manager and Colin McAlpin stood on the far side of the cabinet, chatting. Behind me, in my wake, crawled the reporter. Showing considerable stealth, we reached the halfway point. I glanced behind, only to see the reporter's rear end disappearing back to whence he had come. Evidently the pressure of freelance existence and, were we to be detected, possible termination of shifts had caused him to think better of my plan. He was retreating. He told me later it had dawned on him that he could simply think of no excuse to explain our position should the famous actor and the others wander round the corner.

I was on my own. I resolved to continue and slowly, measuring each movement, reached the darkroom door. This was an ordered, tranquil world, where every piece of equipment was known to me and had its place. It was my domain. This day it would be my sanctuary. Triumphant, I dived inside. And it was at that moment, my moment of high triumph, that I experienced defeat.

I could blame others. I could blame the colleague who left the kettle sitting where it wasn't supposed to be, on the chair that wasn't where it was supposed to be, in the middle of the darkroom. But I alone take the blame. 'Sprockle' is a word unique to areas

of the north of Ireland. It means to fall in a particularly ungainly fashion. That day I sprockled. The noise a semi-full kettle makes when it hits a hard floor, combined with the yell of a fifty-something picture editor laden with two cameras toppling over a chair, is not insignificant. For a moment I lay, trying to collect my thoughts, tangled in the debris. I was regaining my feet when the light went on. The marketing manager and Colin were peering down at me. Behind them appeared Ben Kingsley. None showed emotion. 'Ah, Brendan,' said the manager, 'we were wondering where you'd got to – would you like another picture of Ben?' Mr Kingsley looked at me. I looked at him. I picked up my camera.

I tell this story because it sums up my attitude to celebrities – they are fine as long as they don't cause you too much hassle.

SUPERSTAR
September 1978
Along with his wife, designer John Z DeLorean arrives to open his car factory at Dunmurry on the outskirts of Belfast.

NOBEL WOMAN

August 1976

One of the co-founders of the Peace People, Betty Williams, shows a sheaf of letters from supporters. She and Mairead Corrigan went on to win the Nobel Peace Prize.

PHIL LYNNOT

October 1978

Another very down-to-earth guy. Thin Lizzy were playing at the Whitla Hall at Queen's University. This was taken during rehearsal with 'Snowy' White and Scott Gorman. I asked for a picture and they just held up the guitars.

LIVING SAINT

June 1996

Mother Teresa had been to Ireland before, but this was her last visit. Photographing her in Armagh, I said I was sorry for all the flashes going off in her face. 'Don't worry,' she replied, smiling. 'Every time a flash bulb goes off, a soul goes to heaven.' I think she paraphrased the line from the film *It's a Wonderful Life*.

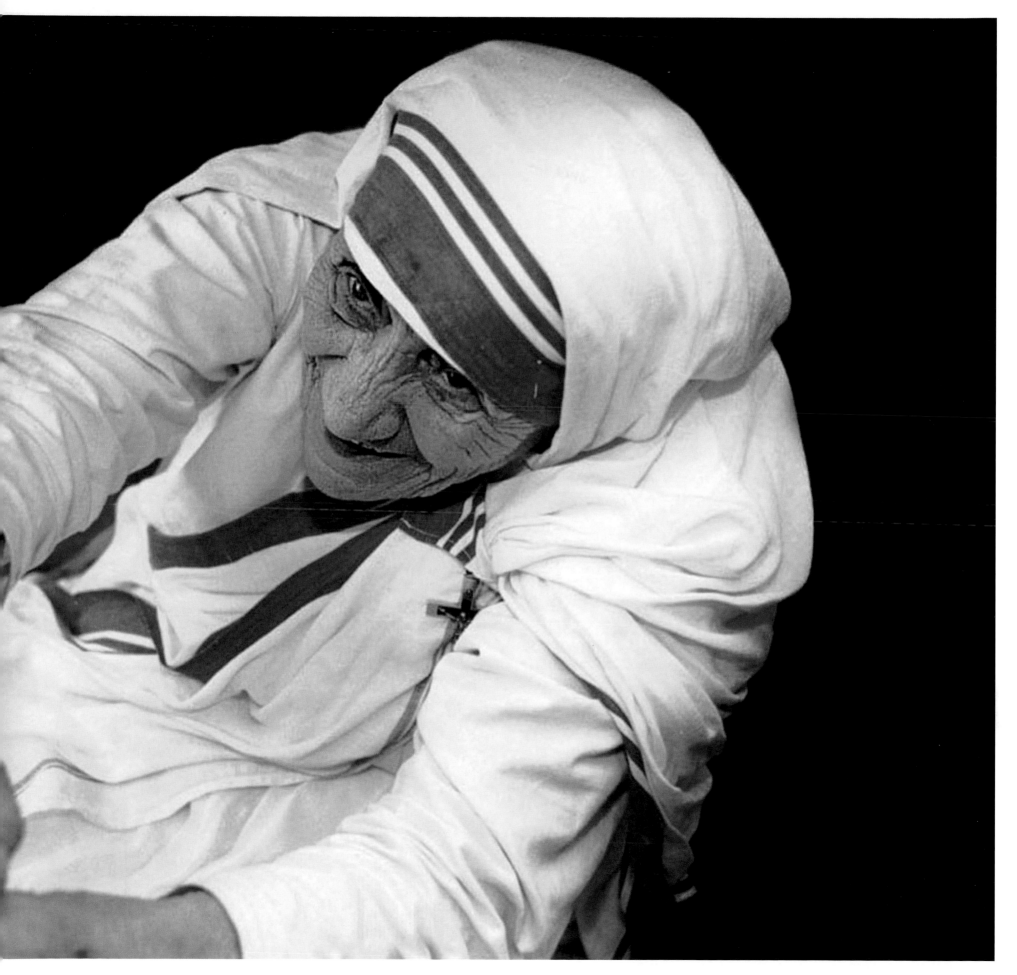

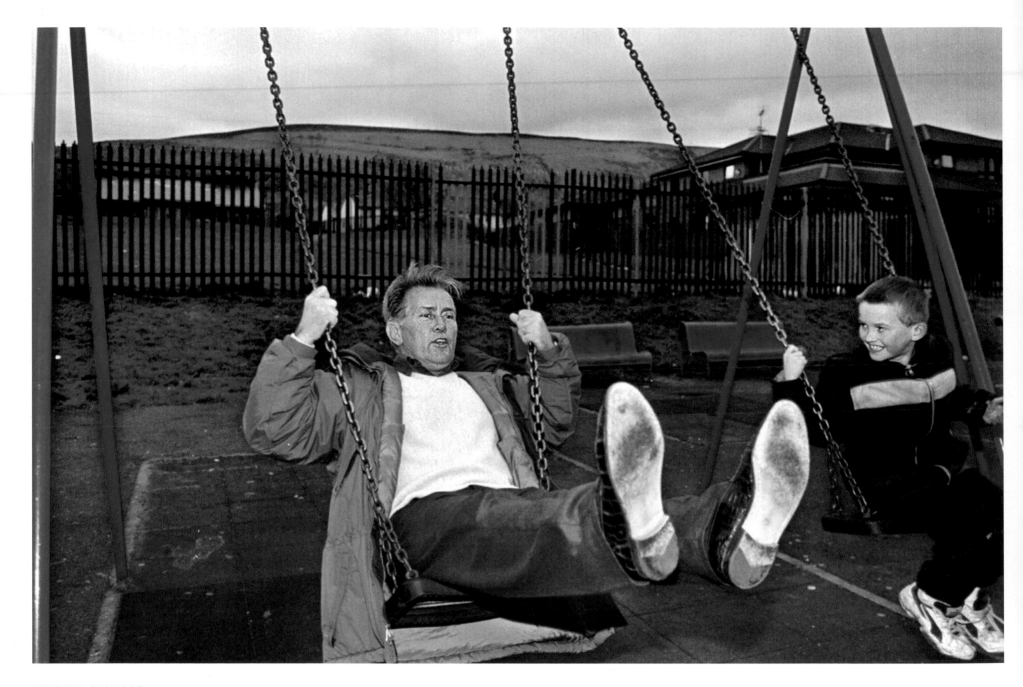

WEST SWING

March 1999
Actor Martin Sheen came to a film festival in west Belfast,
and made an impromptu visit to the Ballymurphy area.
Relaxed and happy to pose for the cameras, he was a
genuinely nice guy.

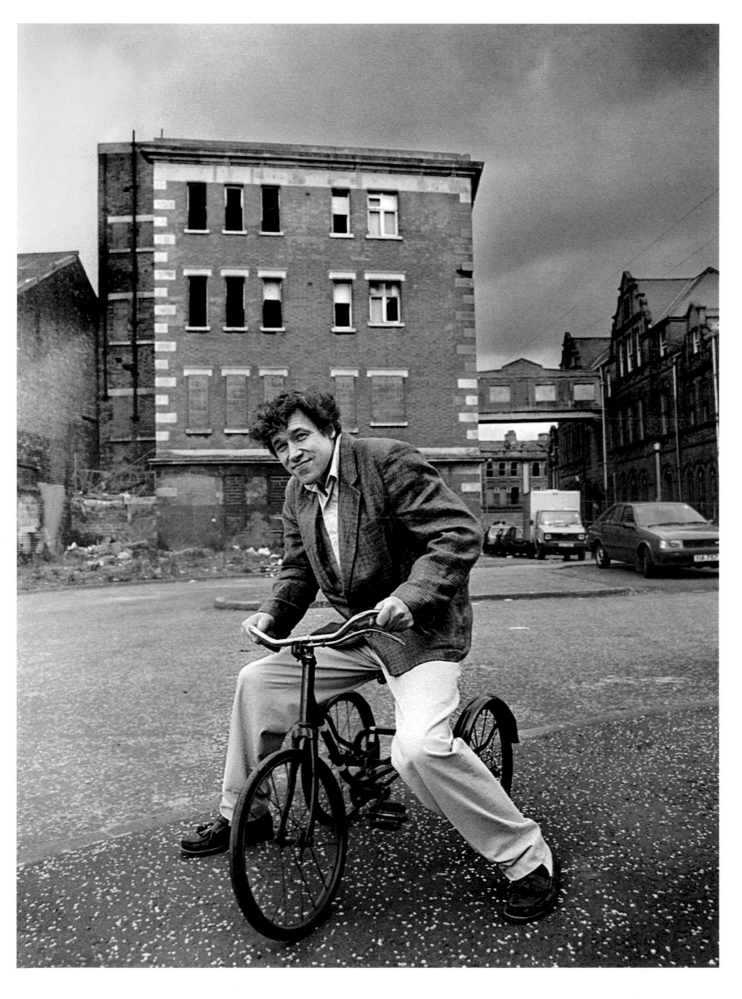

ON YER BIKE ...
September 1987
Actor Stephen Rea has always been one of my favourite people to photograph. Star of *The Crying Game* and countless other films and plays, he's unassuming and down-to-earth. Here he was willing to sit on a forty-year-old bike at an exhibition about the history of the Carrick Hill area.

ALL THAT'S MISSING IS BARRY FITZGERALD ...
May 1980

Cardinal Tomás Ó Fiach was deeply intelligent, but had the common touch. Always affable and ready with a joke or a laugh, he would remember your name even if he hadn't seen you for a while. He greeted me one night saying, 'Here's the "dacent" man from Crossmaglen.' Not a lot of people know I have south Armagh roots. 'Are you really from there?' someone asked me afterwards. Here, the Cardinal is posing with Church of Ireland Primate John Armstrong at a Tourist Board function. The men were close friends. It looks like a scene right out of *The Quiet Man.*

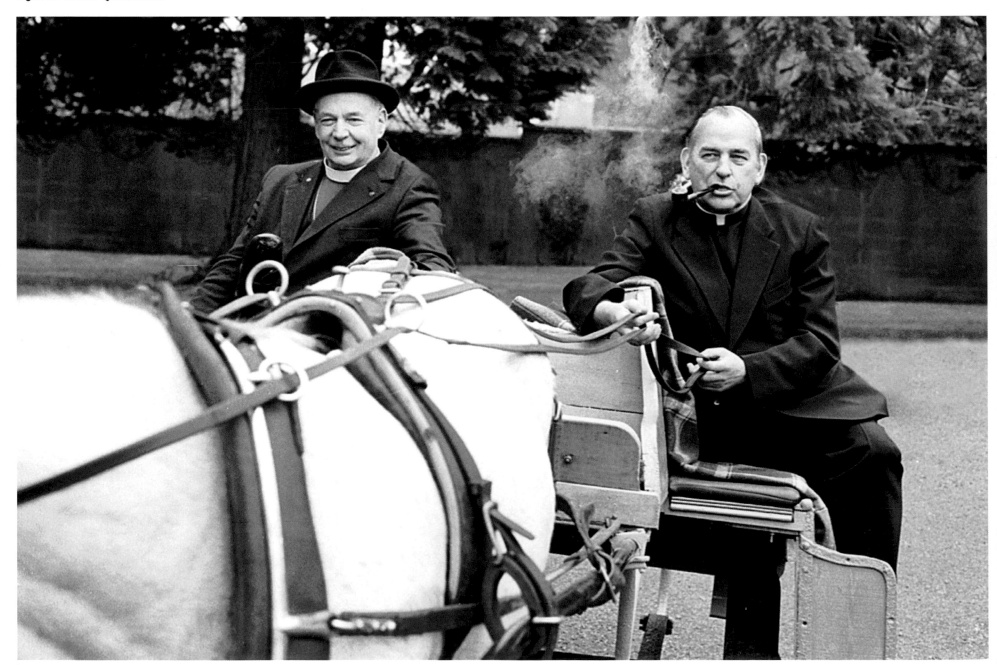

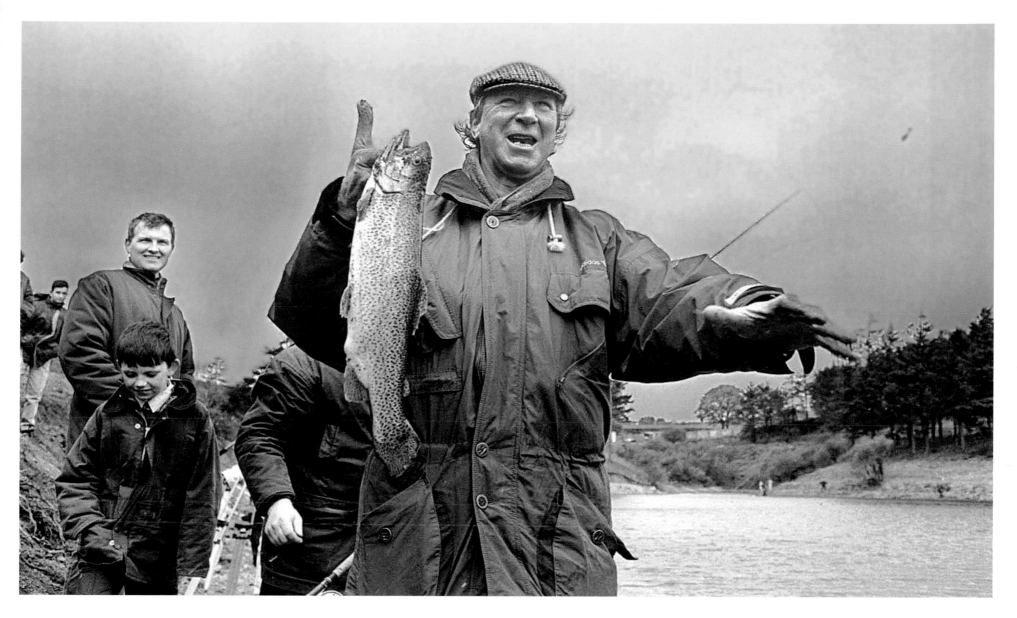

OVER THE RAINBOW

November 1996

A World Cup winner with England in 1966 – but more importantly, Jack Charlton was the manager of the Republic of Ireland international soccer squad. He could do no wrong. Here, at the opening of a reservoir in Derry, he lands a 2lb trout.

We would feel angry going into these houses, seeing what had been done. We would sympathise with the family's predicament. Attention would be concentrated for a moment on these survivors. Ultimately, though, our visit would be fleeting. There would always be another attack or another tragedy. We'd move on to the next carcass.

CHAPTER 12: SURVIVORS

We stood chatting in the hallway of his home, broken glass still on the floor. Members of his family had been in the house when the gunmen called, smashing their way through the front door looking for him. He wasn't home. They left behind a wooden cross. Carved on it were the initials 'RIP' and his name. About thirty years old, soft spoken and articulate, he was clearly concerned about his family, and clearly very angry. He pointed to surveillance cameras further along the street, at the back of a police station. He insisted that the army had been involved in what was evidently an attempt on his life. This time he had survived.

I listened to the reporter interviewing him and to his measured responses. One question was unasked. That can happen. Reporters are trying to jot down notes, process what's being said and think of the next question all at the same time. So I asked the question, perhaps because those who had tried to kill him were making allegations, perhaps because they had gone to a lot of trouble to carve his name on the cross. 'Are you in the IRA?' He could only respond one way and denied involvement. At that time he was a survivor. Six months later he was dead.

When the interview was carried out, we had no way of knowing Danny McCann had been convicted of rioting when he was fifteen. When he was twenty, Amnesty International reported on the ill-treatment he received inside Castlereagh holding centre. Seven years before I met him, he had been charged with murdering a policeman and spent a year in jail. The charge, brought on the word of an informer, was then dropped. Danny McCann – a leading member of the Provisional IRA – was later shot dead in Gibraltar by the SAS.

When you go to people's houses to photograph the survivors of an attack, for the most part you don't really know who they are. There are, nevertheless, indications as to whether someone in the house is 'involved'. Things have become more relaxed since the ceasefires, but in republican households there are still the memorabilia of the Troubles – Long Kesh harps, pictures of the dead, that sort of thing. During the years of doorstep killings, iron drop-bars on doors, welded cages in hallways and bulletproof windows would provide less subtle clues.

Often there was no need for probing questions – the motive behind the attack would be obvious. If you live on an interface like Bryson Street in the Short Strand, the fact of your religion is still good enough reason.

In another district, there was a guy whose home must have been attacked nearly 200 times. I covered about twenty of those attacks. He and his family were still living in the house. The pictures became boring – damaged door, damaged windows, damaged car. I would continue to go, though, developing as I did a fascination for this man's attitude. I'd arrive thinking, 'Why doesn't he get out?' and leave

admiring his resilience and determination. When he eventually did leave, I did not think any less of him.

Of course, in many of the stories we covered, we found those who did not have the option of getting out. People survived attack after attack in these areas because they had no other choice. Few bombings or shootings ever happened in middle-class areas. And when we went to those scenes, the people often wouldn't be around. They had friends and family living elsewhere and could move away. If they remained at home, they usually wouldn't want the attack highlighted. They would want to get on with their lives.

Working class areas are different. Friends and family mostly live in the same area. Any refuge would still be in that neighbourhood. When targeted, people would rarely see the point in moving to another house that might be as little as 200 yards away. The entire community was in the same boat. The community would provide support and strength. This might be why, as journalists, we usually find ourselves welcomed more openly in working-class areas. Perhaps someone had tried to kill them with pipe bombs, petrol bombs or guns. People would be shaken, yet would want to show they had nothing to hide. They would insist what had happened could not be swept away with the broken glass.

Even in recent years, I've covered a lot of sectarian attacks. You are almost always guaranteed to get some sort of a picture. The term we use is that it would 'make' – it would make a picture, it would make a story, it would make the paper. We would feel angry going into these houses, seeing what had been done. We would sympathise with the family's predicament. Attention would be concentrated for a moment on these survivors. Ultimately, though, our visit would be fleeting. There would always be another attack or another tragedy. We'd move on to the next carcass.

For the most part, the *Irish News* wouldn't have been welcomed in loyalist areas. That has changed slightly, since the ceasefires, as we have come to photograph more of the loyalist political leaders. Gradually we also highlighted more social issues within loyalist areas. The loyalist feud on the Shankill Road in 2001 and 2002 was really the first time we could go into people's homes in that area and say we were from the *Irish News* without trepidation. For the victims and survivors of those attacks, there was a different enemy, closer to home.

During the trouble surrounding the Holy Cross Girls' Primary School, we not only highlighted the plight of those children, their parents and the broad nationalist community, we also photographed damaged Protestant homes. Talking to a pensioner, her living room window smashed by a brick, you'd feel no less angry for knowing the victim was Protestant. It was the individual you empathised with. For me, their religion has always been an irrelevancy. The stories you hear and your pictures are similar on either side of the divide, the only obvious difference being in the number of Catholic victims.

When I first started I thought I was doing some good, taking pictures to show how victims and survivors had suffered. Then I noticed the attacks weren't stopping. They didn't stop doing it. After a while I realised the perpetrators probably didn't read, and certainly wouldn't heed the likes of the *Irish News*.

I'm older, more cynical now. Most of the time, I don't think these pictures do much good at all. We take them as a matter of routine. I think historians in years to come will find them of value. They will be able to marvel at the senselessness and stupidity of this time. Pictures and stories do allow people to somehow express their views, anger and fears, and maybe that is of some service to them, but beyond that I would not argue that they achieve anything.

Then I grab a few shots of hostage Brian Keenan arriving back from captivity in Beirut, surrounded by the love of ordinary people. Or I take a picture of someone like Tracey Devine, a survivor of the Omagh bombing, who displayed so much dignity and courage with just a smile. And – for some reason – I still want to take more photographs.

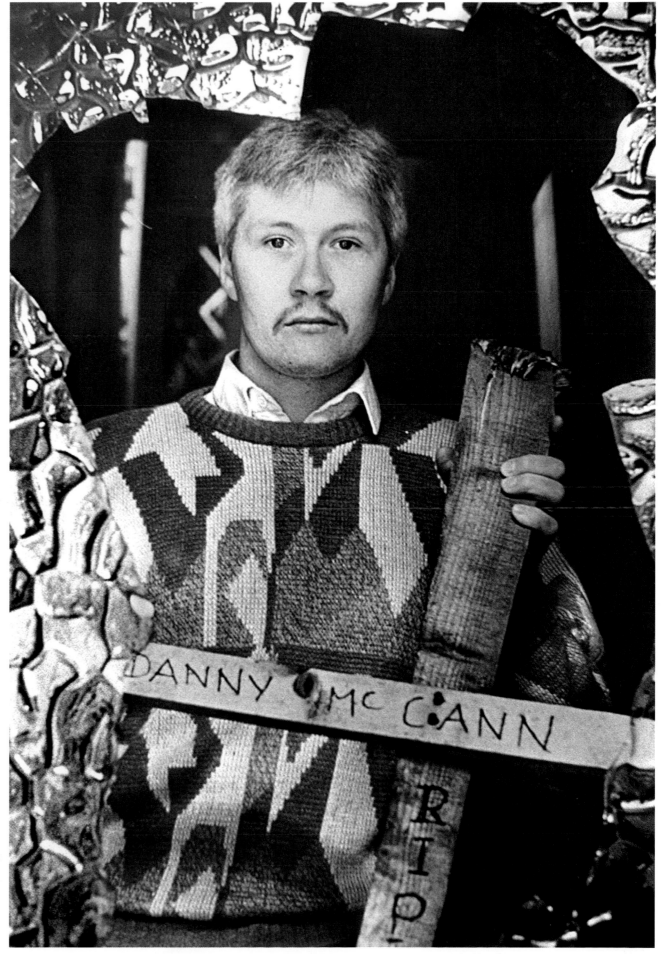

DANNY MCCANN

October 1987

This cross was left at Danny McCann's house in Cavendish Street, off the Falls Road, when gunmen arrived to shoot him. He was out and escaped, but within a short space of time he and two other IRA members were shot dead by the SAS in Gibraltar.

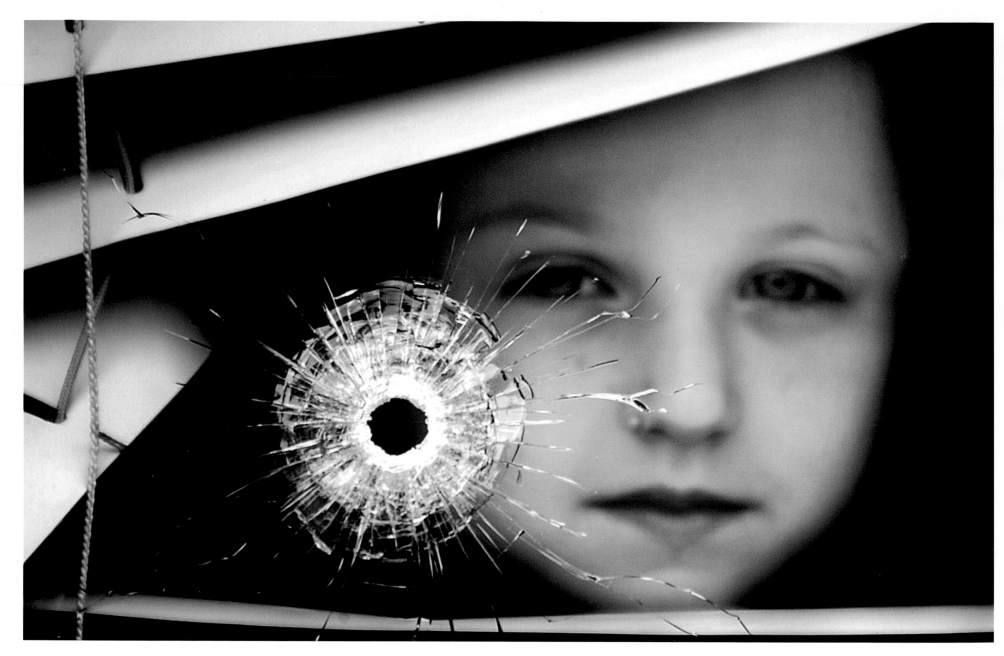

BULLET HOLE
June 2002

A family in the nationalist Short Strand district were victims of a loyalist gun attack. This child looked through the broken blind as I took the picture.

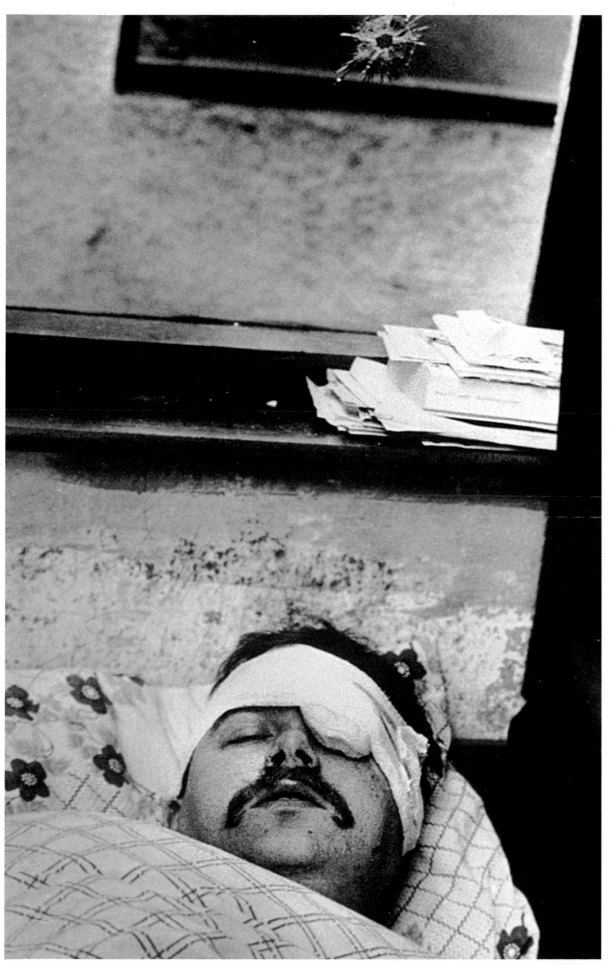

LUCKY TO BE ALIVE
March 1987

IRSP member Kevin McQuillan was the target of several assassination bids. Here he recuperates after being shot in the head in an attack at his home. In July 2003, the forty-four-year-old was told by police that his personal details had been found on loyalist intelligence documents. Even included was his nickname, 'Bap'. The one-time IRSP member criticised police for only informing him in July about the discovery, made in January.

A DIFFERENT CRADLING

September 1990

Brian Keenan's return from captivity in Beirut prompted an incredible outpouring of kindness. I think people just wanted to show him they cared. He was mobbed when he went to City Hall in Belfast. I was always struck by how the little boy remained calm.

SHOOTING VICTIM
December 1999

Loyalists shot Andrew Peden in the legs. They probably intended to kneecap him, but used such a heavy calibre weapon that they blew his legs off. He has a young family. This image shocks me.

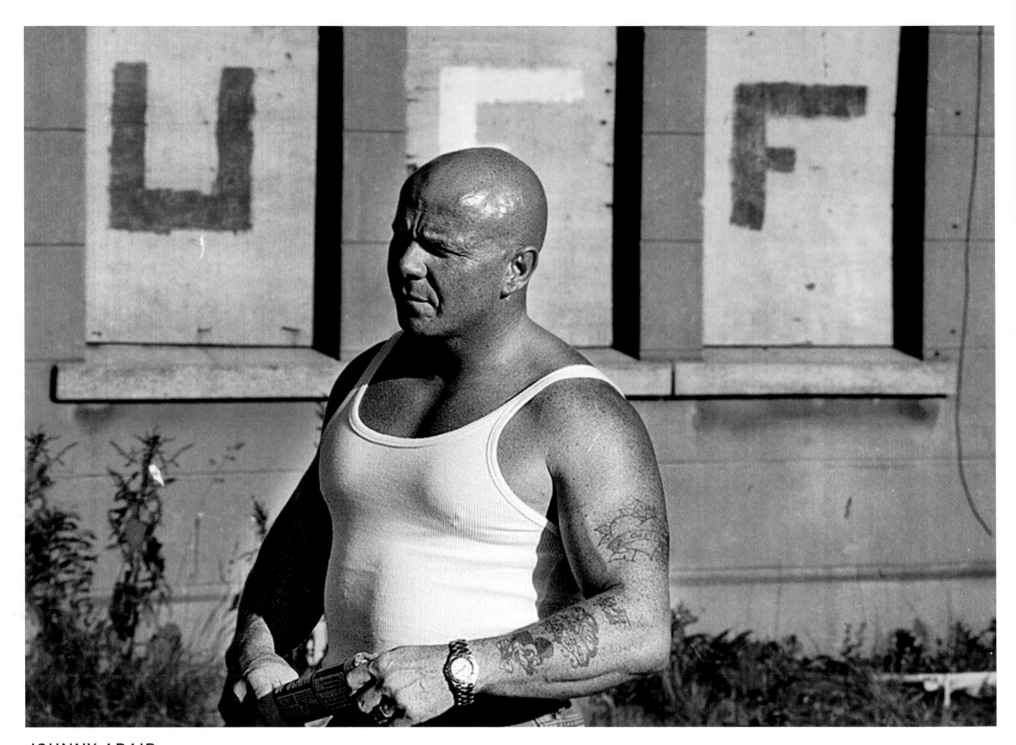

JOHNNY ADAIR
June 2000

Few people would have bet on him surviving two loyalist feuds. At the time of writing, the head of the UDA's notorious 'C' company, Johnny Adair, is back in prison. His followers and associates have been forced out of the Shankill Road streets he once ruled. Here he is standing at Clifton Park Avenue, waiting to see the 'Tour of the North' Orange parade that winds across north Belfast every marching season.

TRACEY DEVINE

December 1998

Pictured four months after the Omagh bombing, she was the last survivor to leave hospital. She had learned of her twenty-month-old daughter Breda's death six weeks after the atrocity – the worst of the Troubles – while still under sedation for her own injuries, which included sixty-percent burns. 'She will always be in our thoughts,' she told reporters as she left hospital three days before Christmas, to be with her three other children and her husband at their family home near Strabane. Her courage was simply inspirational.

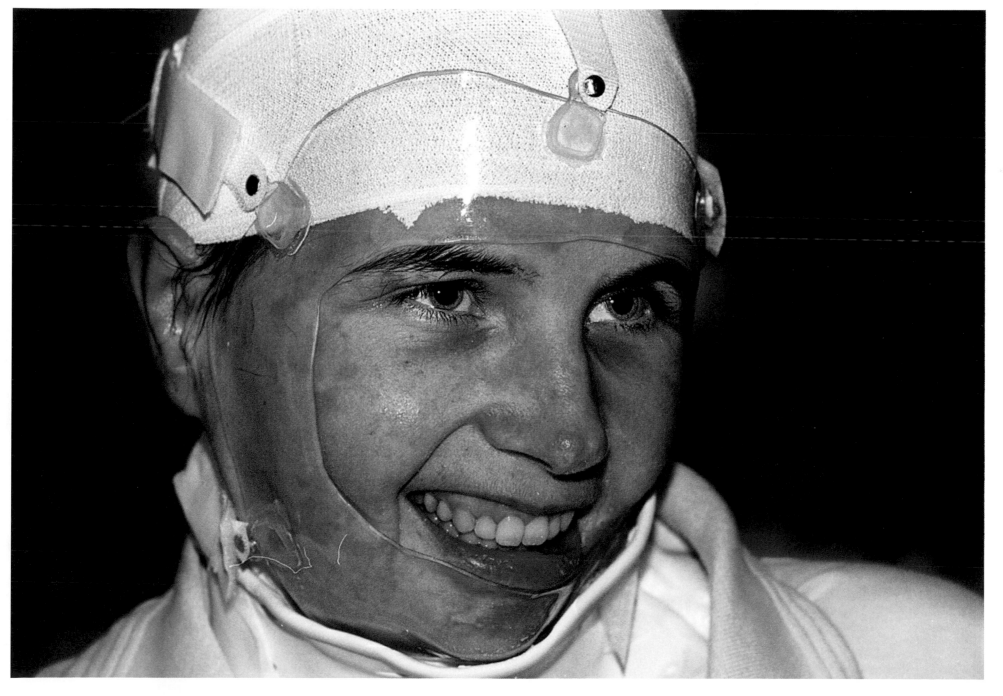

The way Brendan tells the story, he thought of jumping from the car. He held his nerve only because he didn't want to abandon me. He says that when he managed to glance in my direction, he noticed with alarm my hand already taut on the door lever.

CHAPTER 13: AT THE END OF THE DAY

I've had my share of threats and scares; too many to count and not enough to worry about. I was glad to make it through to retirement largely unscathed. When you look at the scrapes you get into over the years, you don't always think that will be possible.

A policeman one day told me he'd blow my head off if I lifted my camera to take another picture. A wildness in his eyes convinced me he wasn't joking. Deciding to remain silent about the freedom of the press, I put the camera down and withdrew to a safe distance.

All sides have threatened me. In September 2001, on the first day of the dispute at Holy Cross Girls' Primary School, two loyalists shouted across the police line, demanding to see my press card. When I refused, one threatened, 'We'll beat the s**t out of you.' His mate's contribution to the debate on the freedom of the press was to yell, 'Ya lanky big c**t.' I didn't resent them as much as the two police officers standing alongside, who suddenly affected deafness and an interest in the formation of passing clouds.

One early experience involved republicans. They were unhappy with a picture they said I had taken. In August 1976, they questioned me. They didn't lay a finger on me, but it was not a pleasant experience. They asked me if I had taken the picture. I said I had not and was let go.

Soon afterwards, I was due to work my first shift for Associated Press, one of the truly global news agencies. Loyalists had killed a prominent republican, and I was to cover the funeral for AP. On the morning of the funeral I got a phone call from an acquaintance. 'I don't know what the hell you've done, but I heard them talking about you last night,' the source said. 'They're not happy. They said if you turn up today they're going to make an example out of you.'

I knew the source well enough to know the information would be accurate. I didn't know quite what 'being made an example of' would entail, but it didn't sound like something I'd enjoy. The IRA in Derry had already forced out a BBC reporter.

I telephoned AP to tell them I couldn't work the shift. At such short notice, they couldn't get anyone else to cover the funeral. I had let them down. They never called again, and I don't blame them. The freelance exists in a dog-eat-dog world.

My more pressing concern was for my own safety. It was ten months before I went back to cover another republican rally. On the platform were masked IRA men and a woman holding a machine gun. It was a typical summer's day. Steady rain had started when we were halfway up the road – parades either went up the Falls or down the Falls, depending on the occasion – and I was soaked. The rally had finally started. Water dripping from my clothes and gear, I crawled under another platform for shelter and to sort out my equipment.

Someone crawled in beside me – a senior republican. He was grinning. 'I'm surprised to see

you. I thought you were barred [from republican events] over taking that picture.' Some people have long memories. 'Nobody told me,' I replied. Strictly speaking, this was true. I'd never 'officially' been told anything.

The scene under the platform became like confession all over again. The thrust was the same – you know you've done wrong, just come clean and everything will be okay – except in this case I wasn't going to be admitting to any sins. He prompted me repeatedly: 'You did take that picture.' I denied all knowledge. Absolution wasn't in Latin but it was just as big a relief. 'Anyway you can come back now,' he told me.

I'd always liked this guy – he had a human side. As I hastily packed my bag, we exchanged remarks about the weather and stared at the rain dripping from a sheet of plastic. He looked at me again. 'But you did take that picture, didn't you?' This time it was me that grinned. I stepped out into the rain without answering. It was the first time in almost a year that I didn't have a threat hanging over me. The cloud lifted.

That was long ago but even recently I admit I've been scared. An *Irish News* reporter – Brendan Anderson, a gentle giant and superb journalist – and myself were one night told to get into a car. We sat ourselves on the back seat. The car's occupants said they would take us to a press conference being given by dissident republicans. As always, we were told to keep our heads down. As always, we tried to sneak glimpses of where we were going. We travelled across the town. As the car pulled away, we realised we knew neither where we were being taken nor who was doing the taking. There had been a number of sectarian shootings around the time, and the unspoken suspicion in both our minds was that our two front-seat chauffeurs might not be all that they seemed; the fear was that they might be loyalists. Our suspicions were reinforced when we both noticed we had passed a gable with a huge loyalist mural. It was a heart-stopping moment.

The way Brendan tells the story, he thought of jumping from the car. He held his nerve only because he didn't want to abandon me. He says that when he managed to glance in my direction, he noticed with alarm my hand already taut on the door lever.

The men who were transporting us turned out to be legitimate – in a dissident kind of way. They bundled us out at a press conference. This was quite bizarre in itself. It was held in complete darkness. I had to ask Brendan to light a match to attempt any sort of photograph. Afterwards we were again taken by car, although I'm not sure if we retraced the journey through a loyalist area. To this day I couldn't tell you much more about that press conference. I certainly can't remember what was said. But that trip in the car is burnt into my memory.

Days such as those are, I hope, behind me. Now that I've retired, I'll work at a slower pace. I'll be happy if I never have to cover another murder, another funeral, another riot or another dodgy press conference.

I take more than pictures though from these last twenty-five or more years. I am a Belfast press photographer. I am proud of that. I had, on a single roll of film, a Gaelic football team, a murder scene, a cheque presentation and a funeral. That was our way of working – jumping from one job to the next to ensure our papers had maximum coverage. We had no time for art, no time to dally. We covered news, features, sport, advertising – we were press photographers.

I can honestly say that I could not have wished for better colleagues than the local photographers working for the host of newspapers and picture agencies up and down the country. Competition was always fierce. At times it was a solitary existence, yet we helped each other in every way possible – providing counsel, sharing technical know-how, saving careers. On a daily basis, photographers showed courage, going into situations and areas where they would not necessarily be welcome. Like the boxer climbing through the ropes, they had no way of knowing what to expect when they reported for duty.

I've witnessed people demonstrate great bravery in the face of impossible pressure. Alan Lewis stayed on his feet while the rest of us scattered and took a picture of someone being hit by a plastic bullet. It was a fearless picture and would not have been taken but for Alan's courage. Basil McLaughlin of the *Andersonstown News* was himself hit by a plastic bullet in the neck while doing his job, and somehow continued covering a riot that was going on all around him. Had the round struck a couple of inches higher he could have been killed. Cyril Cain had his leg broken by a plastic bullet.

Photographers have walked alone at night along border roads to photograph bodies dumped there. A photographer called Martin McCullough did that – it was one of the bravest things I've known. Photographers have unwittingly stood next to booby traps to get their shots, only to have a bomb go off moments after they've moved. Paul Faith of the Pacemaker agency stood his ground to get a magnificent picture of an explosion. Others, like Fred Hoare and Stanley Matchett, showed similar courage well before I was taking pictures.

Photographers have been threatened and abused. Back in the 1970s, the IRA ordered a reporter and photographer from one British newspaper to stay out of nationalist districts. Shortly afterwards, the journalists received a memo from management at the paper's headquarters across the water. Greeted with laughter, for years it was pinned to the Belfast notice board. It ran something like: 'The London office of this paper refuses to be intimidated by the IRA.' In the end it was their local colleagues who stood alongside them until the threat evaporated.

My colleagues have always shown, and continue to show, a great spirit of camaraderie. I remember a time in the 1970s when if you covered something exclusively, the unwritten rule was that you got the best picture for your own paper, but the other negatives went to your colleagues on the other papers. That way, the only thing hung out to dry was the negatives. We all had days as king of the castle, and so were wise enough to know that these moments were short-lived. The next day you could be looking up from the bottom, so help and trust were vital.

People who don't know how we work, strangers, would expect Catholic and Protestant photographers to be at each other's throats. That was never the case. Nothing was further from reality. Protestant photographers have told me to stick close to them when we've been in fiercely loyalist areas. I've returned the favour. If they have faults and frailties, local press photographers also have great strength and integrity.

For most of my career as a photographer I've been at the *Irish News*. From childhood, it was a paper that came into my home every day. As a newspaper it is unequalled, simply an institution. Working for the *Irish News* was to me like playing in a World Cup final. It is a paper built on high standards, gifted workers and undiluted integrity. It has a tradition of real worth.

I stumbled into press photography by accident and, at first, wandered around in ignorance. For the first few years I missed more photographs than I got, due to technical incompetence and inexperience. Gradually I picked up a few tricks. I was helped along the way, and was lucky enough to meet people like Tom Lawlor, Cyril Cain – who taught me more about photography than anyone – and John Harrison, one of the most decent guys in the business. There were others. Marty Wright of the Pacemaker agency was a wily operator and skilled photographer. Allan McCullough, who started working around the same time as me, would always share information. He was a gentleman, as was Brendan McCann. Sadly Allan, Marty, Cyril and Brendan are no longer with us.

The quality of work was always high. The press photographers who covered the events of the last four decades could have worked anywhere in the world.

The technology used to record images has been revolutionised. Where once the process of taking pictures involved hours on the road and in the darkroom, digital gadgetry now enables us to beam our images back to the office in seconds. When, around 1990, my eyesight was failing, I unsuccessfully tried stronger glasses and a special magnifying viewfinder, before discovering the wonders of the auto-focus lens. For me, that was a career-saving innovation. It's all a very long way from my £22 Zenith B.

Along the way we've witnessed amazing changes – people's whole way of life has altered in what seems like the blink of a shutter. We've seen huge political upheavals, some terrible times, absolute heroism from ordinary people, and much more. For myself I've been lucky. I have been eyewitness to some momentous events. I've met wonderful, amazing characters, gaining in the process an insight into their lives and my own. I remember still the words of the reporter who gave me a start: 'Aye, you can be a photographer,' he told me, 'You'll do okay at that.' And that's what I hope now. At the end of the day I hope I've done okay.

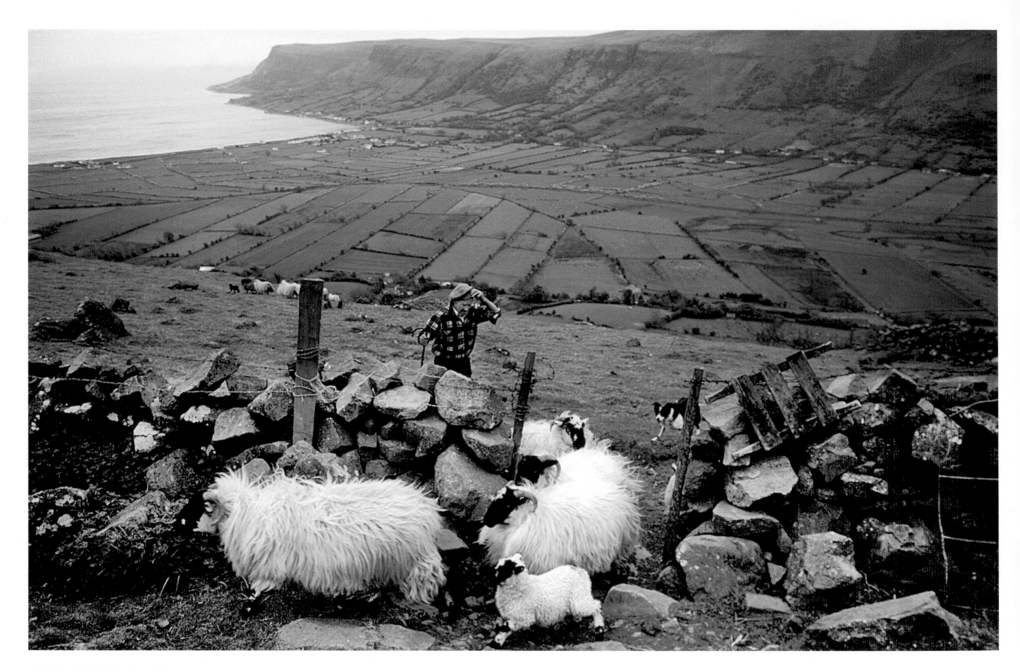

THE QUIET MAN
April 1991

Alex O'Boyle owns a sheep farm on the slopes of Glenariff, one of the most
beautiful of Antrim's glens. He's lived there all his life. Hail, rain and snow,
he climbs the steep hillside with a speed that would shame men half his age,
the dog his constant, though scarcely acknowledged, companion.

GATHERING FLAX

July 1986

A man gathers flax in the traditional way. These days this is only done as a demonstration, to show schoolchildren how the crop once dominated all of northern industry.

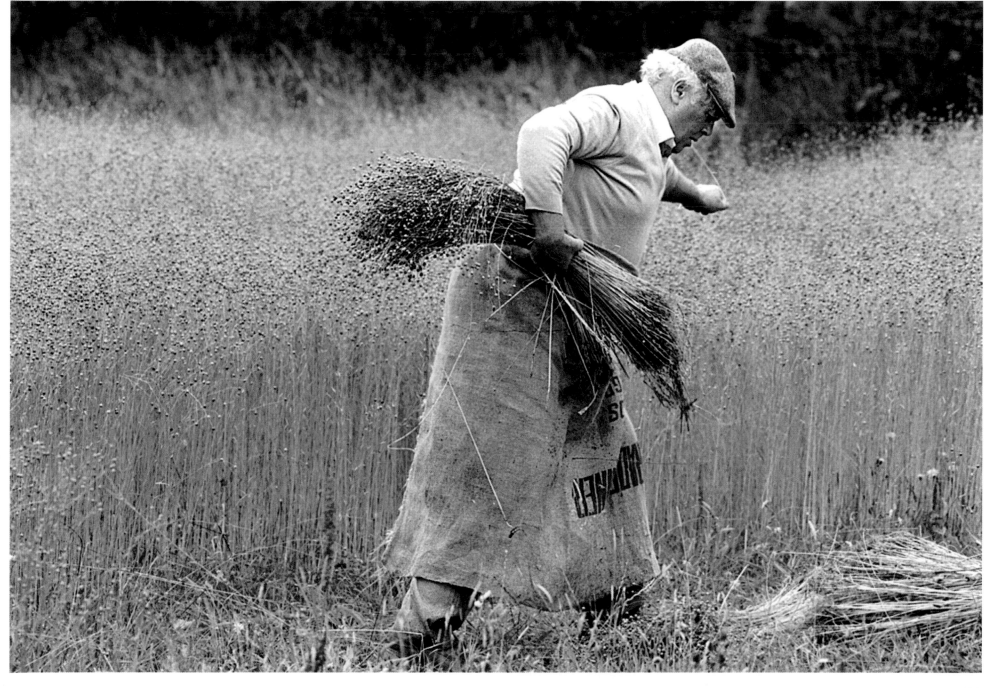

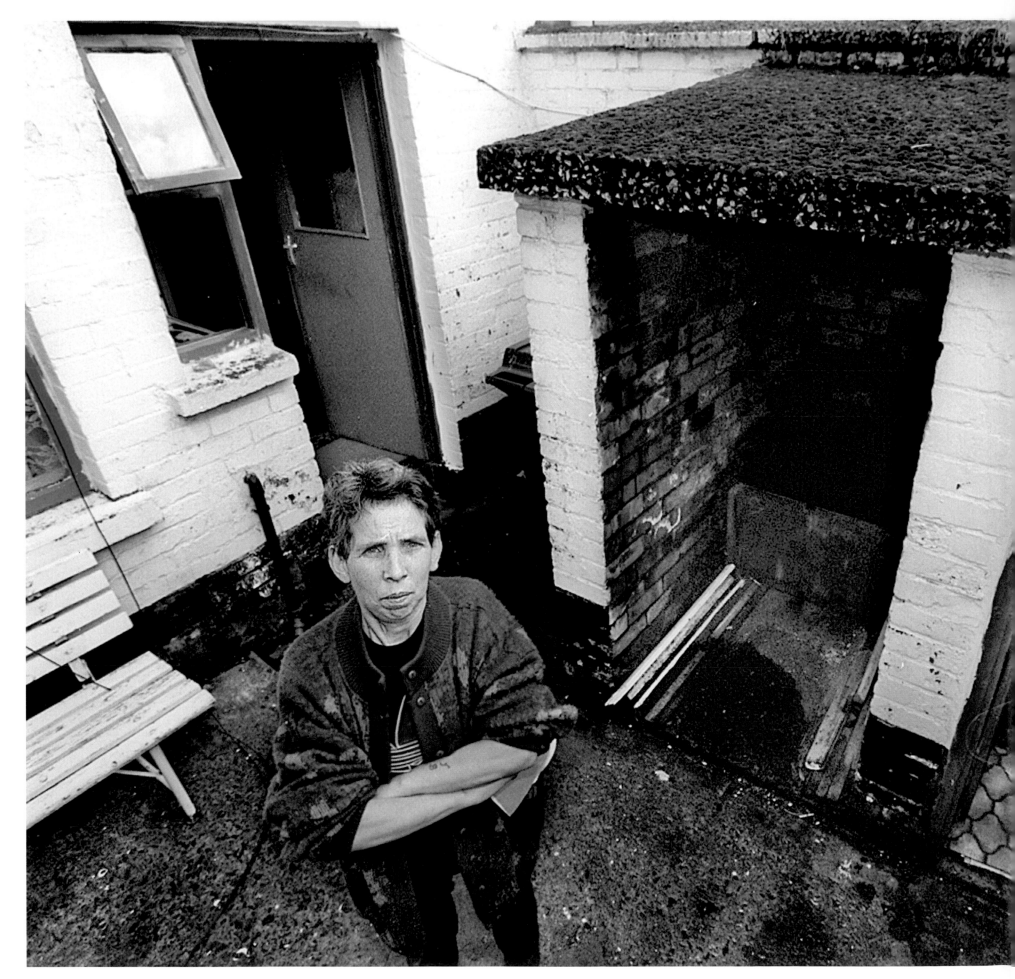

OUTSIDE TOILET

December 1999

It was the eve of a new millennium, but this picture seemed like a trip back in time. This scene was once typical of working-class Belfast terraced houses, where a trip down the yard on a winter night filled young and old alike with trepidation. This woman and several neighbours couldn't get their homes refurbished, due to difficulty tracing an absentee landlord.

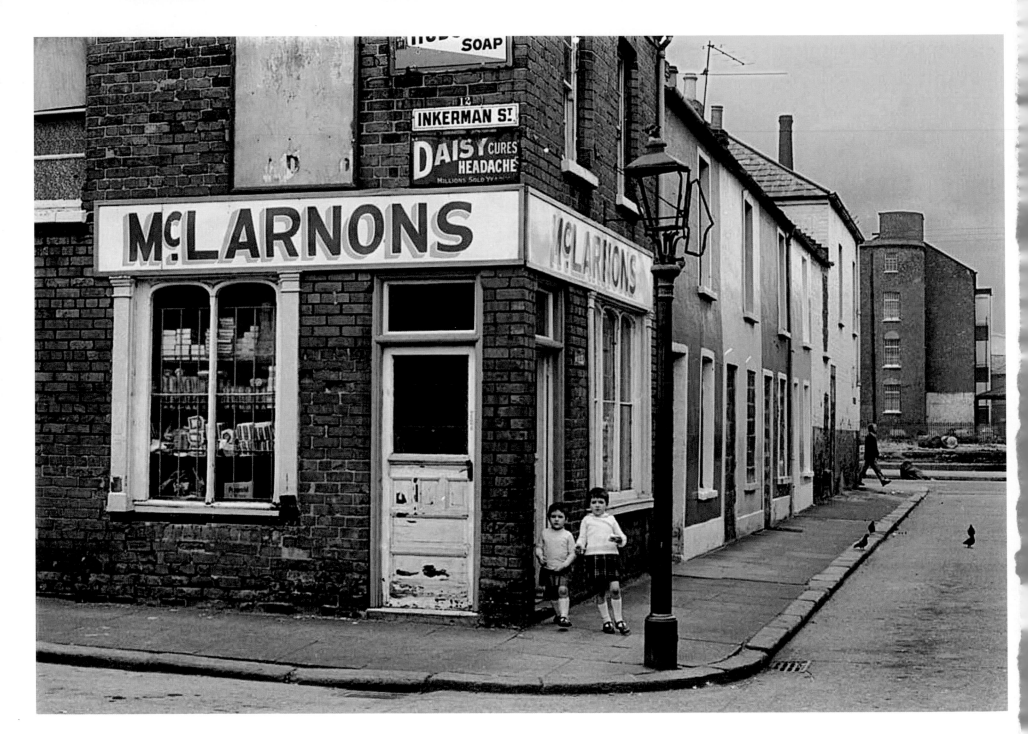

CORNER SHOP

September 1974

The corner shop and bar were the hub of a community. Battered
and run-down they may have looked from the outside, but inside
they stocked your every need. More social work went on in these
places than a host of government agencies. They were lost to
redevelopment and supermarkets. With them went a way of life.